A HISTORY LOVER'S
GUIDE TO
NORFOLK

A HISTORY LOVER'S
GUIDE TO
NORFOLK

EDITED BY JACLYN A. SPAINHOUR
Introduction by Peggy Haile McPhillips, Retired City Historian

THE
History
PRESS

Published by The History Press
Charleston, SC
www.historypress.com

Copyright © 2021 by Jaclyn Spainhour
All rights reserved

First published 2021

Manufactured in the United States

ISBN 9781467147170

Library of Congress Control Number: 2021931154

This book is dedicated to all lovers of history—past, present and future. May we all work to preserve and learn from the history that surrounds us.

CONTENTS

CONTENTS

PREFACE

W hen we began working on this guide as a group, the world was much different. Many of us envisioned that this book would act as a travel guide for history lovers from faraway places who would come to visit our beloved city during the busy tourism season over the summer. Then the coronavirus pandemic struck, and much of the research needed for this guide to come to fruition was inaccessible. The most invaluable resource we had at our disposal, our city archives in the Sargeant Memorial Collection at the Slover Library in downtown Norfolk, was forced to shut its doors to the public for more than half of the calendar year. We honestly weren't certain if this book would ever see the light of day.

Luckily for us, restrictions lifted, and at the end of August we were able to hustle to the finish line to submit this manuscript. Books don't write themselves, and each of the authors in this work has people in his or her corner who meticulously edited text for content, prose and style. There are truly too many people who helped us with these chapters to list them all by name, but we want to acknowledge that this work has been the effort of countless historians, tour guides, librarians, museum professionals, city employees and history buffs who love our city of Norfolk. This was a team sport from start to finish.

When I first pitched this idea to The History Press of a guide with many authors, I was unsure of how it would respond. Having published my own solo works previously, I knew that this guide would be valuable but also that I did not have the expertise to cover everything. In order for this to be accurate

and educational, it would be imperative that I use the voices of others to tell the tales of the mermaid city. Thankfully, The History Press agreed (thank you, Kate Jenkins!), and I set about bribing and begging the many authors in this work who I admire and respect. I cannot thank them enough for agreeing to provide their expertise during a global pandemic, when many of us were unsure if we would still have work in our fields. To my fellow authors, you are a credit to this field, and we are indebted to you for helping preserve the history of Norfolk on these pages for all to enjoy.

Because this was written during such a tumultuous time, it is imperative that I remind the readers that some of the buildings and special places mentioned in this work may not be standing by the time you get your hands on a copy. Times are changing, perspectives are shifting and the pandemic is forcing the closure of many museums, historic sites and businesses. If you find that this is the case when you open this work, we hope you will still visit the sites where these places once stood and give them a moment of silence to celebrate their impact on our community. After all, it is our job to help keep the memories of such places alive.

Finally, to Troy Valos and his team at the Sargeant Memorial Collection, I have no words. There are simply not enough words in the English vocabulary to express our collective gratitude for your assistance with helping each of us research our topics and locate the images for this book. Quite literally, this would not exist without the archival collection you preserve. Thank you for being a worthy custodian of our city's historical treasures.

Dear reader, every author in this work hopes that the following pages allow you to learn something new about our historic city of Norfolk, Virginia. If you are a local "staycationing" during the aftermath of the pandemic, thank you for celebrating our hometown. If you are a globetrotter lucky enough to travel during these strange times, thank you for picking this up on your travels. History only lives on in our world because of the interest of people like you. Happy exploring!

Introduction

A BRIEF HISTORY OF NORFOLK

Peggy Haile McPhillips

In the beginning, there was a river. A river and a natural, deep, ice-free harbor. This harbor, the harbor of Hampton Roads, was described by nineteenth-century American journalist Anne Royal as "one of the most spacious and safe harbors in the world; all the fleets that ever floated might be anchored in them and the waters beyond."[1]

The harbor and the waters beyond are Norfolk's reason for being. They have shaped and directed the city's path from the beginning to the present. They are a recurring thread as the story of Norfolk unfolds.

The Chesepian Indians occupied the region before the arrival of the first Europeans. They took their name, which translates to "Mother of Waters," from the great body of water that bordered their territory. Their main town, Skicoak, is believed to have been near the site of today's downtown. Because the Chesepians were gone by the time the English arrived, the two cultures never intersected.

The first permanent English settlers who arrived in April 1607 landed briefly at what is now Virginia Beach before proceeding up the river they would call the James to settle at a place they would name Jamestown in honor of their king, James I. They passed between two capes they would christen Henry and Charles after the king's young sons; King James's daughter, Elizabeth, is remembered in the naming of the Elizabeth River.

COLONIAL YEARS

In 1619, Virginia colonial governor Sir George Yeardley incorporated the developed portion of the colony of Virginia into four jurisdictions, which he called "citties." Representatives from each jurisdiction met at Jamestown in July 1619 as the newly minted House of Burgesses, the first elected legislative assembly in the New World. What would become Norfolk was part of Elizabeth Cittie, which included land on both sides of the Hampton Roads waterway.

When King Charles I reorganized the colony into a system of eight shires in 1634, Elizabeth Cittie became Elizabeth City Shire. Two years later, the land on the south side of Hampton Roads was separated from Elizabeth City Shire to form the county of New Norfolk, which encompassed the modern-day cities of Norfolk, Portsmouth, Chesapeake, Virginia Beach and Suffolk. Further subdivisions resulted in the formation of Upper and Lower Norfolk Counties (1637) and Norfolk and Princess Anne Counties (1691). Upper Norfolk County became Nansemond County in 1646. It is now the city of Suffolk.

Today's Norfolk was settled by the English on five hundred acres along the Chesapeake Bay, on land granted to Thomas Willoughby (circa 1600–1657) by King James I in 1624. Adam Thoroughgood (1604–1640), another English immigrant, is generally credited with christening the area "New Norfolk County" in honor of his native home, King's Lynn, Norfolk County, England. He also named the Lynnhaven River. Thoroughgood established America's first ferry system on the Elizabeth River in 1636—a system that continued uninterrupted for more than three hundred years.

Norfolk was officially designated a port in 1680, when the English Crown under King Charles II directed the purchase of fifty acres of land in each of Virginia's then-twenty counties for the "building of storehouses to receive imported merchandise…and tobacco for export." In Lower Norfolk County, county justices purchased a narrow plot of fifty acres stretching along the Eastern Branch of the Elizabeth River from Nicholas Wise Jr. for ten thousand pounds of tobacco "in caske." County surveyor John Ferebee was employed to survey the land and lay out a street grid, with half-acre lots designated for houses and public buildings. The deed establishing the Towne of Lower Norfolk County was recorded in August 1682. The little town, almost completely surrounded by water, was tethered to the rest of the county by only a narrow strip of land that appears on the 1680 survey as "the road that leadeth into the woods." It would be renamed Church Street

after the Borough Church (today's St. Paul's Episcopal Church) was built there in 1739. In modern terms, the property was bounded on the east, west and south by the river and on the north by a navigable creek that is now City Hall Avenue.

Norfolk was granted borough status in 1736. A mayor and council were appointed and given limited responsibilities, including holding mayoral elections annually, appointing councilmen, enacting regulations governing daily life and even levying taxes "from time to time" when public money was needed for such things as street lights or watchmen. In 1741, the Borough Council conferred the title of honorary citizen on royal customs official Robert Dinwiddie. When Dinwiddie returned as royal lieutenant governor in 1754, he presented a silver mace to the borough on behalf of the Crown as a token of England's esteem. The original mace is on permanent display at the Chrysler Museum of Art today, and a replica is carried in official ceremonial events. It is the only English mace in America, still in its original form, that remains in the possession of the municipality to which it was originally presented.

But goodwill with England did not last, and relations with the mother country became increasingly strained during the coming years. In November 1775, after the editor of Norfolk's newspaper printed allegations of treason against the father of the royal governor, the paper was shut down rather dramatically by the British, who seized the presses and three of the workers and carried them aboard ships lying offshore. That governor was John Murray, Earl of Dunmore, Virginia's last royal governor and, arguably, the least popular.

Dunmore's fleet was still anchored offshore on New Year's Day 1776. In addition to the Sailors and Soldiers on board the ships, there were local Tories and former slaves who had fled there for refuge. They were cold. They were terribly overcrowded, hungry and thirsty. Many were ill. Dunmore's requests to send a landing party ashore for food, water and supplies were rebuffed. Before leaving the Norfolk harbor for good, the royal governor would have his revenge for the borough's poor hospitality.

A little after 3:00 p.m. on Sunday, January 1, 1776, Dunmore ordered his ships to open fire on Norfolk, a bombardment that continued well into the night. After the British guns fell silent, the fires were continued by local Patriots who looted and put the torch to abandoned Tory homes. By the time the Continental Army arrived to stop the looters, more than two-thirds of Norfolk was in ashes. In early February 1776, the Continental Congress ordered the destruction of Norfolk's remaining buildings, declaring the borough of

no strategic value to the Patriots and noting that it could be defended only at the expense of personnel and supplies needed elsewhere. "A commission appointed in 1777 to review the damage in Norfolk found that 1,331 structures had been destroyed in and near Norfolk: 32 of them burned by Dunmore on November 30, 1775; 19 by Dunmore on January 1, 1776; 863 by local Patriots and Virginia troops between January 1 and January 15, 1776; and 416 by the order of the convention in early February 1776."[2]

Norfolk was the only American town completely destroyed and rebuilt—a British cannonball embedded in the wall of the Borough Church (today's St. Paul's Episcopal) serves as a reminder. But the Borough Council continued to meet in the ruins of the courthouse in order to preserve the charter, and Norfolk citizens returned before war's end to begin the process of rebuilding. By the end of the eighteenth century, several substantial residences had been erected, among them the Moses Myers and Willoughby-Baylor Houses, both of which are open to the public today. By 1790, Norfolk's population numbered about three thousand, half of its pre-Revolution population in little more than a decade. By the turn of the nineteenth century, the borough numbered nearly seven thousand, and Norfolk was the eighth-largest municipality in the United States.

THE NINETEENTH CENTURY

The British were defeated at Yorktown in 1781, and the 1783 Treaty of Paris that officially ended the war ensured freedom from English rule. But there would be an ongoing struggle for America to gain freedom of the seas. Trade restrictions imposed by Great Britain after the Revolution, Britain's practice of impressing alleged deserters off American vessels and the retaliatory Embargo Acts of President Thomas Jefferson in the early nineteenth century all but crippled Norfolk's economy, so dependent was the borough on foreign trade. The attack off Norfolk on the Norfolk-based USS *Chesapeake* by HMS *Leopard* in June 1807 was one of several factors that would lead the U.S. Congress under President James Madison to declare war against Great Britain in June 1812. The War of 1812 was fought under the banner "Free Trade and Sailors' Rights." To protect the harbor, Fort Norfolk was constructed on the Elizabeth River, on a site formerly occupied by a fortification from the American Revolution. The fort still stands and is open to visitors. No shots were fired on or from the fort—the closest battle took place on nearby Craney Island, where American troops won a decided

victory over British forces in June 1813. The Treaty of Ghent, signed in Europe on December 24, 1814, ended the war. Tradition says that Norfolk merchant Jasper Moran renamed his property "Ghent" in honor of the important treaty. The Ghent residential neighborhood, now a National Historic District, was developed on Moran's property in the 1890s.

With the end of the War of 1812, foreign trade with Europe and the West Indies resumed, and there was a gradual return to a robust local economy. Norfolk was incorporated as a city in 1845. Befitting the new status, a handsome domed building was constructed to serve as the city hall and courthouse (today's MacArthur Memorial Museum and Archives); a new school, patterned after the Temple of Theseus in Athens, was built to house the Norfolk Academy (now home to the Hurrah Players); and the Gothic Revival–style Freemason Street Baptist Church, its spire seeming to pierce the sky, opened to serve a congregation recently split from another Baptist congregation. Prosperity, it seemed, had returned. But a reversal of fortune was in the wind. In June 1855, the steamer *Ben Franklin*, traveling from the Virgin Islands, put into a local shipyard for repairs. In addition to cargo bound for New York, there were stowaways on board: mosquito larvae carrying the virulent yellow fever pathogen. The first cases of the fever appeared onboard the ship within days and then quickly spread to shore, finding victims on both sides of the Elizabeth River. Citizens evacuated by the thousands. Of those who remained, almost everyone became ill, and some two thousand in Norfolk died, as many as eighty per day at the height of the rampage. Every family was affected; businesses closed; schoolrooms and social activities, even church services, were suspended; and the sound of the undertaker's wagon echoed in the streets day and night. The epidemic ended with the first hard frost, but the economic and emotional repercussions lingered as Norfolk citizens tried to put their lives back in order.

In February 1861, radical differences between North and South led seven Southern states to announce their secession from the United States and the formation of the Confederate States of America. Four more states, Virginia among them, would join the Confederacy later that year. In March 1862, one of the most famous naval battles in history took place in Hampton Roads, as the USS *Monitor* and CSS *Virginia* (formerly USS *Merrimack*) engaged in the first battle between ironclad warships. Although both ironclads were ungainly and difficult to maneuver and there was no clear victor, the battle marked a turning point in the course of naval warfare. It was the beginning of the end for the wooden navy and the genesis of the modern steel navy. Two months after the battle, Norfolk

mayor William Lamb surrendered the city to Federal troops, and Norfolk was under martial law for the duration of the war.

After the Civil War, Norfolk County's rich waterways and farmland helped support a return to economic stability. Princess Anne and Norfolk Counties became leaders in truck farming, supplying more than half of all greens and potatoes consumed on the East Coast. Lynnhaven oysters were another major export. Packing warehouses lined the waterfront as cotton began to flow into the port. Cotton replaced tobacco as Norfolk's primary export until railroads opened the way for the transportation of coal. Soon after the first carload arrived from West Virginia in 1883, coal became Norfolk's primary export and remains an important commodity today.

THE TWENTIETH CENTURY

The world came to Norfolk in 1907, when the Jamestown Exposition was held on 340 acres at Sewells Point (now the site of Naval Station Norfolk), on the shore of the Chesapeake Bay some twenty miles north of downtown, to commemorate the 300th anniversary of the first permanent English settlement in America.

A miniature city was created on the grounds, with boulevards, lights and telephone service and beautiful, permanent buildings representing governments, manufacturing and institutions from around the world. Each state was invited to participate, and twenty-one of them erected elaborate buildings on the Exposition property. Today, seventeen of the original Exposition buildings survive. Of these, many serve as housing for senior naval officers and are known collectively as "Admirals' Row."

The Exposition was not a financial success, but its impact on the city of Norfolk was huge. In anticipation of the crowds of visitors, several hotels and apartment hotels were constructed downtown. Many stand today, including the Fairfax Hotel (now Fairfax Apartments), the Lorraine Hotel (later the Thomas Nelson, now the Tazewell Hotel and Suites) and the Lynnhaven Hotel (later the Commodore Maury, now the James Apartments). These substantial buildings helped to anchor a Granby Street that was transitioning into Norfolk's primary shopping district. By 1910, Granby was Norfolk's busiest street. The value of its real estate had risen more than tenfold from $250 per front foot in the 1880s to $2,975 per front foot in 1910. The Granby Street Historic District was listed in the National Register of Historic Places in 1987 and expanded in 2001.

A little farther north of downtown, the Pelham Place and Holland Apartments, also still standing, were built in Ghent. The Sterling Place neighborhood, then under development, was renamed Colonial Place in keeping with the theme of the Exposition. The names of the original colonies, captains of the Jamestown ships (Captains Christopher Newport and Bartholomew Gosnold) and even the New England–bound *Mayflower* are represented there.

A streetcar line was extended the length of what is now Hampton Boulevard to transport visitors from downtown to the Exposition grounds. Developers were quick to buy up acres of land along the streetcar route to lay out west side neighborhoods such as Larchmont, Lochhaven, Algonquin Park and others, as the family breadwinner was now able to travel by streetcar to and from his place of business downtown, while his family enjoyed fresh air, greenspace and modern housing amenities in the suburbs. The area was annexed into the city of Norfolk in 1923. The annexation—more than twenty-five square miles of Norfolk County land—brought in twenty-five thousand new citizens, making Norfolk the second-largest city in Virginia.

The Exposition closed in November 1907. During the Exposition, senior naval officers observed that the site would be ideal for a naval station. A bill passed in 1908 proposed that Congress allocate $1 million for the purchase of the property, but the initiative died when the Assistant Secretary of the Navy was given a choice between purchasing the property and funding a new coal ship. The Secretary insisted that a new ship was an absolute necessity, and the land sat vacant for nearly a decade. When the United States entered World War I, the Secretary of the Navy was persuaded to buy the property. In June 1917, President Woodrow Wilson signed a bill establishing a naval installation on 474 acres at Sewells Point that included the old Exposition site. It would be called Naval Operating Base, Hampton Roads (NOB). Known today as Naval Station Norfolk, it is the largest naval installation in the world.

The U.S. stock market crash of October 1929 ushered in a decade that would become known as the Great Depression. In the 1930s, President Franklin Roosevelt introduced his New Deal Program in an effort to create jobs to put people back to work and fund local infrastructure enhancements. Locally, the Civilian Conservation Corps (CCC) was responsible for the creation of Seashore State Park (now First Landing State Park) in Princess Anne County. Projects in Norfolk included a Works Progress Administration (WPA) project that employed two hundred African American women and twenty African American men for a beautification

initiative in what was then Norfolk County. The workers battled inclement weather, insects, snakes and poison ivy to clear acres of dense undergrowth and then planted hundreds of azaleas, camellias, rhododendrons and bulbs to create the Azalea Gardens, later called Norfolk Municipal Gardens. The garden project took four years to complete. It has expanded into today's Norfolk Botanical Garden. Open year-round, NBG is famous worldwide for its annual holiday Garden of Lights display and Million Bulb Walk. The garden features thousands of varieties of plants on 175 acres with twelve miles of paved and mulched trails.

The December 1941 Japanese attack on the American naval base at Pearl Harbor and America's entry into World War II effectively ended the Great Depression. Many Americans sought and found employment in the military and in war-related industries such as shipbuilding and the manufacture of armaments. On the homefront, women were hired for jobs vacated by men who had gone off to war. Citizens planted victory gardens, participated in scrap and paper drives, purchased war bonds and observed curfews, blackouts and rationing guidelines. The Port of Hampton Roads was a major point of embarkation for troops heading overseas. Norfolk's population exploded. An influx of military and civilian personnel from across the country brought the city's population from 144,332 in 1940 to more than 168,000 naval personnel and nearly 200,000 civilians by the end of 1943. Everything from a seat on the trolley to a place to lay one's head was in short supply. Many who were brought to Norfolk by the war chose to remain in Norfolk after war's end. In 1950, the city's population numbered 213,513. Annexations of the Tanners Creek District of Norfolk County in 1955 and a portion of the Kempsville District of Princess Anne County in 1959 brought an additional 24.66 square miles into the city.

In 1954, in *Brown v. Board of Education of Topeka, Kansas*, the U.S. Supreme Court ruled that segregation of public schools based on race was unconstitutional. Citing the ruling as an attack on states' rights, Virginia senator Harry F. Byrd tried to rally southern states to stand together, saying in February 1956, "If we can organize the Southern States for massive resistance to this order, I think that in time the rest of the country will realize that racial integration is not going to be accepted in the South."[3] Thus began the strategy of "Massive Resistance" that would characterize the South's response to mandatory school desegregation.

Leola Pearl Beckett et al. v. The School Board of the City of Norfolk was filed in U.S. District Court for the Eastern District of Virginia in May 1956, challenging the constitutionality of a state law that allowed local school

boards to refuse to assign Black students to white schools. On January 11, 1957, U.S. District Court judge Walter E. Hoffman ruled in favor of Beckett and ordered Norfolk's public schools to desegregate. A two-year stalemate followed, as Norfolk and other Virginia cities tried to walk the line between compliance with a federal law mandating desegregation and a state government that promised to close any public school that desegregated. In Norfolk, school district lines were redrawn, some schools were closed or repurposed and the applications of Black students to white schools were denied—all in an effort to avoid desegregation for as long as possible. When 151 local African American students and their parents applied again for transfer to white schools in August 1958, Judge Hoffman ruled that 17 of the applicants qualified for admission to the city's six all-white junior and senior high schools and must be assigned to them immediately. Minutes after Norfolk School Board announced that the students would report to their new schools on Monday, September 29, Virginia governor J. Lindsay Almond Jr. seized and closed the affected schools, leaving the 17 Black students and another 10,000 white students with no school at all. Norfolk's Vivian Mason organized a tutoring program at First Baptist Church, Bute Street, for the 17 Black students. Options for the white students included tutoring programs, existing and newly formed private schools and attending county schools not affected by the desegregation mandate. It is not known how many never finished high school at all.

The fight to reopen the six schools continued until Monday, February 2, 1959, when they were reopened, and seventeen African American teenagers made history as the first students to desegregate Norfolk Public Schools.

URBAN RENEWAL IN NORFOLK

By the 1930s, large pockets of residential areas in and near downtown had deteriorated so badly that living conditions were intolerable. In 1935, Norfolk city manager Thomas P. Thompson appointed a citizens committee to study the city's substandard housing in preparation for a massive urban renewal program. This would lead to the formation, in July 1940, of the Norfolk Housing Authority to prepare the city to participate in federally funded low-cost housing projects.

World War II, with its population boom of military and civilian war workers and their families, redirected the early mission of the Housing Authority from clearing slums to building housing for defense workers. After

the war, the vision of the Housing Authority broadened beyond merely replacing substandard housing for the poor to creating a remodeled city for all. The name of the agency was changed to Norfolk Redevelopment & Housing Authority (NRHA) to reflect its new dual purpose. In December 1948, Norfolk City Council tasked the Authority with planning a slum clearance program and devising a minimum housing and zoning code to prevent future slums. In 1949, NRHA became the nation's first agency to receive funds under the new Federal Housing Act. Funding was received in September 1950, and Project One, the first phase of redevelopment, began in December 1951. Because Norfolk was the first city in America to undertake redevelopment on such a broad scale, the national news media broadcast the pioneer event across the country.

By the time Project One was phased out in 1965, a total of 190 acres downtown had been cleared, providing land for affordable housing for hundreds of families once living in deplorable conditions. Amenities included new schools, playgrounds, police and fire stations, widened streets and private businesses. At the same time, the Authority turned over the former site of Broad Creek Village (built as demountable housing during World War II) to the city for development as Norfolk Industrial Park, to encourage industry and manufacturing enterprises to establish locations in Norfolk.

NRHA's Project Two also focused on slum clearance, targeting 135 acres in the Atlantic City neighborhood. Plans included a "waterfront expressway" (the extension of Brambleton Avenue), the expansion of Norfolk General Hospital (today's Sentara Norfolk General) and the construction of a Medical Arts Center for physicians' and dentists' offices. Other improvements included the Public Health Center and King's Daughters Hospital, an investment of approximately $10 million, with the majority of the funds coming from federal grants and private contributions, according to the *Norfolk* publication of September 1959.[4]

Project Three, approved by the council in June 1958, was the most ambitious piece of the NRHA vision, committing the city to a $26 million program to modernize 147 acres downtown, including the razing of East Main Street's famed honky-tonks and tattoo parlors; the demolition of run-down buildings on the crowded, narrow streets between Main Street and Brambleton Avenue; the widening of downtown streets; the construction of new sky-scraping office buildings to anchor the financial center; and the addition of improved entry routes into and out of downtown.

Commercial improvements that followed on the newly available land downtown included the Golden Triangle Hotel (1960), the 1959 Rennert

Building and parking garage (now the site of MacArthur Center Mall) and the Norfolk Cultural and Convention Center (Scope and Chrysler Hall) in 1972.

Norfolk became a model for urban renewal nationwide and, in 1960, received the prestigious All-America City award, granted jointly by the National Municipal League and *Look* magazine. Presenting the award, *Look*'s publisher said, "Out of a city whose problems had multiplied almost to the point of disaster…Norfolk citizens are creating a city with a bright new character."

Nine annexations between 1887 and 1959 and a 1988 land swap with the city of Virginia Beach brought Norfolk's land area to its present size. In January 1963, Princess Anne County and the town of Virginia Beach consolidated, creating the independent city of Virginia Beach, and Norfolk County merged with the town of South Norfolk to form the independent city of Chesapeake.

Norfolk was landlocked. With no more land available for expansion, the city had to look to the development of existing assets for its economic future. City leaders began a long push to revive Norfolk's urban core, beginning at the place where Norfolk began: the downtown waterfront on the Elizabeth River. Once a bustling working harbor, with commercial shipping and boats carrying passengers to Baltimore and to railroad connections with points farther north, Norfolk's waterfront had, by the 1960s, become a wasteland of decaying piers, dirt-paved parking lots and vacant warehouses. The shipping industry had moved northward to Norfolk International Terminals; travelers no longer made their way by steamer, and prime waterfront property along the river sat vacant, begging to be repurposed.

In the summer of 1976, America celebrated the 200th anniversary of the signing of the Declaration of Independence with Operation Sail, an East Coast festival established by President John F. Kennedy in 1961 to provide training in sailing, to highlight America's maritime history and to promote good will among nations. OpSail is best known for its handsome, tall, square-rigged ships from many nations, but there are always plenty of smaller vessels that take part along the way as the tall ships sail up the East Coast to arrive in New York Harbor in time for the Fourth of July, stopping off at ports along the way. In 1976, festival coordinators invited Norfolk to serve as a host port. That year, Norway's *Christian Radich* tied up at the dock at NOAA, drawing more than two thousand visitors.

Norfolk's annual Harborfest was initiated the following year, and the repurposing of the downtown waterfront began. Revelers attending the first

Harborfest braved dust and mud and uneven footing to enjoy four days of music, food vendors, plenty of tall ships to board, sailors from many nations mingling with crowds of locals and a spectacular fireworks finale over the Elizabeth River. Within six years, city planners had created a new boulevard, Waterside Drive, connecting downtown Norfolk to the Virginia Beach–Norfolk Expressway. Obsolete shipping and warehousing facilities along the downtown waterfront were demolished, and in June 1983, the City of Norfolk and the Maryland-based Rouse Company opened Waterside Festival Marketplace, a dining and entertainment venue that brought people back to the waterfront and served as a catalyst for the revitalization of downtown. Today, Harborfest is the largest and longest-running free maritime festival in the nation and a tangible reminder of Norfolk's historic ties to the water.

Waterside shares the skyline with a booming financial district, convention hotels, the Decker Half Moone Cruise & Celebration Center and Nauticus Maritime Museum, which features the Hampton Roads Naval Museum and USS *Wisconsin*. A little to the east, Harbor Park baseball stadium opened in April 1993, home to the Norfolk Tides AAA minor-league baseball team. Norfolk's efforts to revitalize its downtown have attracted acclaim from economic development and urban planning circles throughout the country.

Once separated by waterways, the entire Hampton Roads region is now connected by a loop of interstate highways and bridge-tunnels. In 1952, the Downtown Norfolk–Portsmouth Bridge-Tunnel replaced the ferry system begun by Adam Thoroughgood in 1636. It was followed by the Hampton Roads Bridge-Tunnel (1957); the Midtown Norfolk–Portsmouth Tunnel (1961); Chesapeake Bay Bridge-Tunnel (1964); the Virginia Beach–Norfolk Expressway (1967, renumbered to I-264 in 1999); a second, parallel tube for the Hampton Roads Bridge-Tunnel (1976); and a second, parallel tube for the Downtown Tunnel (1986). The chain of tunnels was completed when the Monitor-Merrimac Memorial Bridge-Tunnel opened in 1992. Passenger ferries returned to the Elizabeth River in 1983.

Today, institutions for higher learning in Norfolk include Norfolk State, Old Dominion and Virginia Wesleyan Universities, Eastern Virginia Medical School and the downtown Norfolk campus of Tidewater Community College. Among the menu of cultural offerings are the Virginia Symphony, Virginia Opera, Chrysler Museum of Art, Virginia Stage Company, Virginia Arts Festival and the restored 1919 Attucks Theatre, as well as many community groups. The Port of Virginia, with a facility at Norfolk International Terminals, is one of the busiest ports by container volume in the nation, reporting record-breaking volume annually.

Norfolk is a multimodal city. The Tide light rail line opened in 2011. An Amtrak passenger station provides rail service to Washington, D.C., and points north. Passenger ferry service once again connects Norfolk to Portsmouth across the Elizabeth River. Cruise ships dock at Norfolk's Decker Half Moone Cruise and Conference Center in downtown. Norfolk International Airport connects Virginia to the world. Closer to home, a series of bike trails ensures safety for cyclists around the city, and the beautifully landscaped Elizabeth River Trail is a favorite path for walkers and runners as well as cyclists.

Norfolk has emerged as an international leader in resilience efforts, finding ways to solve problems related to sea level rise and flooding, along with economic resilience and neighborhood strength. From fifty acres and a population of 1, Norfolk has grown to a city of ninety-six square miles and more than 240,000 people living, working and enjoying life. And it all began with a river.

Chapter 1

HUSTLE AND BUSTLE

DOWNTOWN IN THE PORT CITY

Amanda Williams

INTRODUCTION

Downtown Norfolk as a neighborhood is the area defined as sites in the Boush Street, Brambleton Avenue, St. Paul's Boulevard and City Hall Avenue box. Unsurprisingly, this area features a number of civic buildings and churches of historical note. Other sites reflect the commercial prosperity of the city and its identity as an entertainment and tourist destination.

The downtown area has been the commercial and political center of the city of Norfolk for several centuries. Each century has seen Norfolk's citizens face the challenge of war, storms and economic hardship. The downtown landscape reflects these challenges and provides a window into how these events have both shaped the city's character and spurred its development. Aside from the challenges, the buildings downtown also tell the story of the interests and aspirations of Norfolk's citizens.

Most cities conform to a simple brand. Norfolk's identity is difficult to pinpoint, and so it goes through frequent re-brandings. Is it a southern city? Is it a Navy town? Does it have a local or international outlook? These are common questions.

Since its founding, Norfolk has been a pragmatic place. This pragmatism was necessary to weather the variable challenges it faced. And so, Norfolk is a southern town with a deep cosmopolitan streak. It is a Navy town that is home to one of the nation's largest museums dedicated to an Army

general. It is a city that has been devastated by war but also built by war. It is a place with as many historic secular entertainment venues as houses of worship. Downtown reflects this eclectic, complex identity.

SITE GUIDE

MacArthur Memorial
198 Bank Street
https://www.macarthurmemorial.org

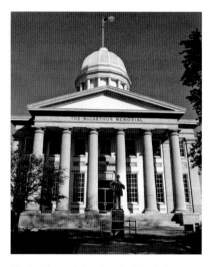

Used with permission from the MacArthur Memorial Archives.

Norfolk became an independent city in 1845. With this new status, planning began immediately for a new city hall and courthouse building. William Singleton served as chief architect on the project, and Thomas U. Walter, the architect who designed the dome of the Capitol in Washington, D.C., designed the building's fifty-foot-high dome. Construction was completed in 1850, and the building was used as both a courthouse and city hall until 1918. During the American Civil War, the city's surrender to Federal forces was announced from the steps of the building. In 1960, the courthouse relocated and the building became vacant. The building was then offered to General Douglas MacArthur, the son of a Norfolk woman, as the site for a potential museum. General MacArthur accepted the offer and, prior to the passing of the Civil Rights Act, insisted that the facility be free and open to all equally. Following extensive renovations, the building was opened to the public in 1964 as the MacArthur Memorial. General MacArthur and his wife are buried within the museum rotunda, and the museum complex now includes a research library and a visitors' center. A bronze statue by one of the World War II "Monuments Men," Walker Hancock, stands at the entrance to the building. The museum and archives have continued to grow, and today the MacArthur Memorial is an internationally recognized museum

and research center dedicated to preserving and presenting the story of General Douglas MacArthur and that of the millions of men and women who served with General MacArthur in World War I, World War II and the Korean War.

City Market/Municipal Building
214 Monticello Avenue

Designed by George C. Moser and constructed in 1890–91, the City Market was a multistory towered building. For more than thirty years, the market provided residents with access to a variety of foods. A sign above the entrance proclaimed the market's purpose: "That pure food may be kept in the best manner and sold at a fair price."[5] In 1923, a new market venue was built, and the old City Market building was converted into an armory and a public auditorium. It was then commonly referred to as the Municipal Building. In 1959, the building was demolished and replaced by the Rennert Building, which was subsequently demolished in 1996 to make way for MacArthur Center Mall.[6] The Dillard's section of MacArthur Center Mall sits on the site of the City Market/Municipal Building.

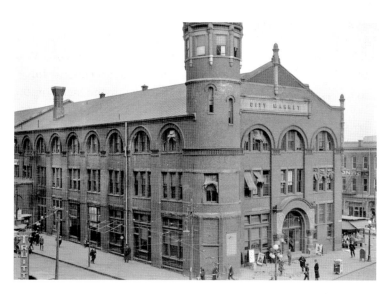

Old City Market, circa 1920. *Courtesy of the Sargeant Memorial Collection, Norfolk Public Library.*

Monticello Arcade

208 East City Hall Avenue

https://www.monticelloarcade.com

The Monticello Arcade was built in 1907 by Percy S. Stephenson on land leased from the Selden-Grandy estate. This three-story covered pedestrian passageway between City Hall Avenue and Plume Street was designed in the Beaux Arts style and features a mix of Neoclassical, Gothic and Renaissance architectural elements. The building was likened to an ancient stoa and to the earlier multi-story wooden arcades that were centers of commercial life in the nineteenth century. It opened to the public in 1908, following the successful Jamestown Exposition, which had drawn considerable national attention and investment to the region. From the start, the Monticello Arcade represented a cross-section of Norfolk's booming economic life in the early twentieth century. The bottom floors housed a variety of small businesses—including milliners, tailors, shoemakers and cafés. The upper floors were occupied by insurance agencies, builders and real estate offices. With its sophisticated design and well-appointed public spaces, it was a coveted business address for decades. The Monticello Arcade survived the Great Depression and another period of economic downturn in the 1960s and 1970s before being placed in the National Register of Historic Places in 1975. Today, it is only one of two surviving "shopping arcades" in Virginia, and it remains at the heart of Norfolk's business district.[7]

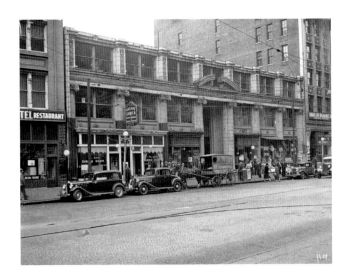

Monticello Arcade, 1934. *Courtesy of the Sargeant Memorial Collection, Norfolk Public Library.*

Royster Building
201 Granby Street
http://glasslighthotel.com

Norfolk's skyline remained relatively low until the early twentieth century. The twelve- or fifteen-story[8] Neoclassical Royster Building was one of the first high-rise structures constructed in the city. It was built on part of what was once Town Back Creek, and its foundation consists of more than 1,700 piles. Constructed at a cost of $350,000 in 1912, the building served as the headquarters of the F.S. Royster Guano Company until 1975. Norfolk Housing and Redevelopment Authority then occupied the building until 2016. Today, the building has been converted into the boutique Glass Light Hotel.

Navy YMCA
130 Brooke Avenue
https://www.rockefellernorfolk.com

Norfolk has a long history as a military town. As such, there has always been an effort to provide service members with opportunities for relaxation and entertainment. The balance between entertainment and propriety could often be difficult to achieve. Since 1844, YMCA facilities in Great Britain and the United States had successfully been providing young men with this balance and the stability of a "home away from home." Norfolk was the perfect place for a YMCA, and in 1902, a small Navy YMCA was established in the city.[9] Several years later, John D. Rockefeller donated $325,000 for the construction and furnishing of a new Navy YMCA for the city. The new building opened on March 17, 1909,

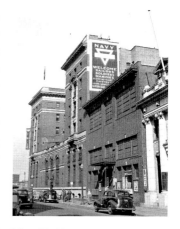

Navy YMCA, 1939. *Courtesy of the Sargeant Memorial Collection, Norfolk Public Library.*

and later welcomed tens of thousands of service members during the world wars. Amenities included temporary housing, a gym, a swimming pool, a dining room, a barbershop, laundry and spaces for USO shows and dances. There was also a chapel on site, and the Navy YMCA set a record for 368 weddings in 1944.[10] In 1972, Norfolk's civilian and military YMCA branches

were consolidated, leaving the Navy YMCA building vacant. It was then purchased by the Union Mission and served as a homeless shelter until the Union Mission relocated in 2009. In 2016, the building was renovated into apartments and renamed the Rockefeller.

Monticello Hotel
108 East City Hall Avenue

When construction began on the Monticello Hotel in 1896, hotels were becoming a major feature of downtown Norfolk. When the hotel opened in 1898, it was celebrated as Norfolk's best hotel and one of the finest hotels in the American South. On January 1, 1918, the hotel caught fire. Local firefighters were unable to control the blaze, and the weather was so cold that water froze on the building as the crews tried to douse the blaze. Firefighters from nearby cities, as well as Marines and aviators stationed at the naval station, arrived to assist, but in the end, the fire gutted the hotel. Despite nationwide steel rationing due to World War I, the hotel was soon rebuilt with two additional floors and a ballroom named the Starlight Room that would be the focus of many social events. During the 1933 Hurricane, the hotel suffered major flood damage. Again, the Monticello recovered and remained a hotel until 1970. It was demolished in 1975 to make way for the Norfolk Federal Building, which now stands on the site.

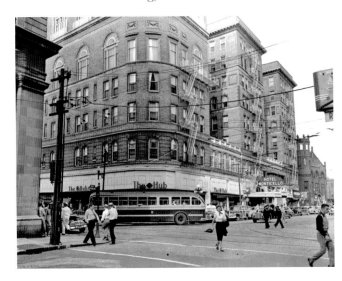

Monticello Hotel, circa 1950. *Courtesy of the Sargeant Memorial Collection, Norfolk Public Library.*

Wells Theatre

108 East Tazewell Street
https://www.vastage.org/wells-theatre

With its decorative murals and terra-cotta ornaments, the Wells Theatre is an excellent example of early twentieth-century Beaux Arts theater design. Designed by the New York firm E.C. Horn and Sons, it was opened to the public on August 26, 1913, with a production of the musical *The Merry Countess*. At the time, Norfolk was the leading entertainment center for the south Atlantic Seaboard and was home to a total of seventeen theaters. As the flagship for Wells Amusement Enterprises, the Wells was the most dazzling and most modern. A movie screen and projector were later installed in response to the growing popularity of film, but the Wells remained predominately a venue for theater and vaudeville. Between 1913 and 1935, acts including Will Rogers, John Philip Sousa, Douglas Fairbanks Sr., Billie Burke and Fred Astaire appeared at the Wells. During World War II, the theater offered burlesque shows, attracting thousands of servicemen who passed through the city. From 1961 to 1979, the theater became an X-rated movie house. Following a major restoration program in 1980, the Wells was added to the National Register of Historic Places and became home to the Virginia Stage Company.[11] Today, as it was originally intended to be, the Wells is a premier venue for theater.

The NorVa

320 Granby Street
https://www.thenorva.com

The NorVa theater opened in 1922 as a two-thousand-seat film and vaudeville theater. Considered one of Norfolk's best "movie palaces," the theater increasingly focused on film. It continued to operate until the 1970s. From 1980 to 1998, the building was home to the Downtown Athletic Club. It was then renovated and reopened in 2000 as a performance venue. Today, the venue attracts a diverse range of performers and was considered one of America's best music venues by *Rolling Stone* magazine.

Smith & Welton Department Store
300–306 Granby Street

Now part of Tidewater Community College's Norfolk Campus, the seven-story Smith & Welton Department Store building was built in 1922. For decades, Granby Street was the focus of Norfolk's shopping and entertainment life. Beginning in the 1960s, though, many major department stores began relocating to other areas. Smith & Welton was the last major department store to remain on Granby Street before it closed in 1988. The exterior of the old Smith & Welton building is notable for its terra-cotta ornaments and its two-story frontispiece doorway.

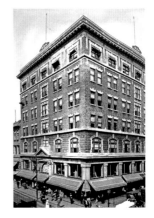

Smith & Welton Department Store, circa 1924. *Courtesy of the Sargeant Memorial Collection, Norfolk Public Library.*

Hotel Commodore Maury
339–349 Granby Street
https://www.thejamesapartments.com

In anticipation of the Jamestown Exposition of 1907, several hotels were built in Norfolk to accommodate increased tourism. These hotels largely featured elaborate entrances and decorative terra-cotta elements. Originally opened as the Lynnhaven Hotel, this structure was completed in 1906. It was soon renamed the Southland Hotel. For many years, it played host to travelers and tourists in the region. In 1954, it was brought under new management and underwent a $1 million renovation. It was then reopened as the Hotel Commodore Maury, in honor of Commodore Matthew Fontaine Maury, the U.S. naval officer celebrated as the "father of modern oceanography." After another period of decline in the 1970s, in 1982 the hotel was again renovated, reopening as the Hotel James Madison. The building has since been converted into apartments and is known as the James.

Epworth United Methodist Church

124 West Freemason
http://epworthva.org

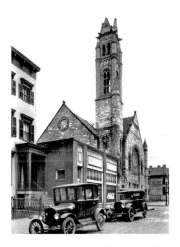

Norfolk has been home to Methodist congregations for more than three hundred years. The destruction of most of the city during the Revolution briefly scattered the city's Methodists, but by 1802, the Cumberland Street Methodist Church had been established. In 1850, some members of the congregation left this church to form the Granby Street Methodist Church. Decades later, to better meet the needs of a growing congregation and increasing community outreach, the Granby Street church bought

Epworth Methodist Church, 1924. *Courtesy of the Sargeant Memorial Collection, Norfolk Public Library.*

land on Freemason Street to build a new church. This church would be named "Epworth" in honor of the boyhood home of Methodism's founder John Wesley. Designed in a Byzantine and Richardsonian Romanesque style, it is constructed of granite and sandstone and features a cruciform floor plan and a multi-level gallery sanctuary. When it opened in 1896, the church was considered one of the handsomest church buildings in the American South. In 1997, it was added to the National Register of Historic Places.[12]

Scope Arena

201 East Brambleton Avenue
https://www.sevenvenues.com/venues/detail/scope-arena

Italian architect Pier Luigi Nervi designed Scope Arena. Completed in 1971, the building is based on Italy's Palazzetto dello Sport, which was built for the 1960 Summer Olympics in Rome. The venue's concrete dome and twenty-four flying buttresses make it an iconic landmark in downtown Norfolk. When it opened in 1971, it was the largest facility in Virginia, with the exception of the Pentagon. The name of the building derives from the word *kaleidoscope* and reflects the venue's ability to adapt to host a wide variety of events. Currently, the venue plays host to the Norfolk Admirals hockey team, the MEAC Basketball Tournament, conventions, concerts and more.

Old Norfolk Academy Building

485 St. Paul's Boulevard
https://hurrahplayers.com

In the 1840s and 1850s, Thomas U. Walter, a prominent architect who designed the dome of the U.S. Capitol in Washington, D.C., designed several structures in Norfolk. One of those commissions was a new building for Norfolk Academy, the oldest private school in Virginia. From 1840 until 1915, the building Walter designed housed the then all-boys school. The Old Norfolk Academy building is an excellent example of Greek Revival architecture, and its proportions are modeled after those of the Temple of Theseus in Athens. Named to the National Register in 1969, the Old Norfolk Academy building has been a major part of Norfolk's history. Edgar Allan Poe is said to have given his last public lecture in the building in 1849. During the 1855 yellow fever epidemic, the building was used as a temporary post office. During the American Civil War, it was used as a hospital for Federal troops. After Norfolk Academy moved to a new location in 1915, the building was then briefly used by the Red Cross during World War I. From 1920 until 1971, it served as Norfolk's Juvenile Court. It then housed the Norfolk Chamber of Commerce before becoming the home of the Norfolk Hurrah Players, a nonprofit family theater company.[13]

Willoughby-Baylor House

601 East Freemason Street
https://chrysler.org/historic-houses/the-willoughby-baylor-house

The Willoughby-Baylor House sits on land that was included in the original Norfolk Township in 1680. During the American Revolution, the local Masonic Hall stood on the site. This building was destroyed in Dunmore's attack on the city in 1776, and in 1794, Captain William Willoughby built his home on the lot. The nearby Moses Myers House serves as an example of upper-class taste in Norfolk's post-Revolutionary period, while the Willoughby-Baylor House reflects middle-class taste of the same period. The home is an example of the Federal style, but additional work on the home in the 1830s added Greek Revival elements. The home was eventually sold to Dr. Baynham Baylor. The property passed hands numerous times after 1890, and in 1964, the home was purchased by the

Norfolk Historical Foundation and renovated. Since then, it has served as a historic house museum and a museum of Norfolk history. Today, it is listed in the National Register of Historic Places and is operated by the Chrysler Museum of Art.

Freemason Baptist Church
400 East Freemason Street
https://www.freemasonstreet.org

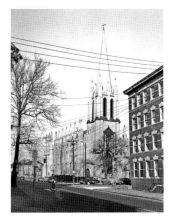

Freemason Baptist Church, 1953. *Courtesy of the Sargeant Memorial Collection, Norfolk Public Library.*

The Freemason Baptist Church congregation formed in May 1848, when about eighty members of Norfolk's Cumberland Baptist Church split from that congregation after a scandal in which the Cumberland minister became affianced to two women. Around this time, the famous architect Thomas U. Walter was in Norfolk to consult on the new city hall building, which is now the MacArthur Memorial. Walter was asked to design a church for the new congregation. His plan called for a Gothic Revival building and, like many revival styles of the period, placed an emphasis on Gothic decoration rather than actual structural form. The cornerstone was laid in August 1848, and the new church was dedicated on May 30, 1850. With its steeple and Gabriel's trumpet weathervane, the church was the tallest structure in Norfolk for nearly twenty years, until the steeple was blown off in a great storm in August 1879. The replacement steeple was slightly smaller, but the Gabriel's trumpet weathervane was replaced. Freemason Baptist Church is currently the oldest Baptist house of worship in Norfolk and was added to the National Register of Historic Places in 1971.[14]

Moses Myers House
327 East Freemason Street
https://chrysler.org/historic-houses/the-moses-myers-house

The Moses Myers house was one of the first brick buildings constructed in Norfolk after the American Revolution. The end of that war brought an influx of merchants and trade to the city. One of these merchants was Moses Myers. Myers was also the first Jew to settle in Norfolk. A prominent citizen, he served as the local French Consul and later as the customs collector for the Port of Norfolk. Between 1791 and 1792, he built this two-story Federal-style house. In 1796, he constructed an addition that included an octagonal dining room often attributed to the architect Benjamin Latrobe.

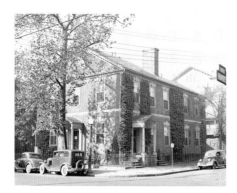

Moses Myers House, 1938. *Courtesy of the Sargeant Memorial Collection, Norfolk Public Library.*

The home is notable for its rich decoration and the quality of its craftsmanship and original furniture. Over the years, notables such as the Marquis de Lafayette, James Monroe, Stephen Decatur and Theodore Roosevelt visited the home. The house remained in the family for five generations before eventually becoming a historic house museum. Today, the house is listed in the National Register of Historic Places and is operated by the Chrysler Museum of Art.[15]

St. Paul's Episcopal Church
201 St. Paul's Boulevard
http://www.stpaulsnorfolk.org

Built in 1739 on the site of an earlier 1641 chapel, the "Borough Church," as it was first known, is the only colonial-era building to survive the American Revolution that is still standing in Norfolk. In 1776, as Lord Dunmore's fleet bombarded Norfolk, a cannonball struck the church. Seventy-five years later, the cannonball was relocated and cemented back into the church wall as a historical marker of the bombardment. As the oldest structure in downtown Norfolk, the building has borne witness to considerable change.

St. Paul's Episcopal Church, 1943. *Courtesy of the Sargeant Memorial Collection, Norfolk Public Library.*

Starting off as an Anglican church, after the American Revolution, it broke with the Church of England and became an Episcopal church. In 1803, it was taken over by a Baptist congregation before being reclaimed by an Episcopalian congregation in 1827, when it was re-consecrated as St. Paul's Episcopal Church. During the American Civil War, St. Paul's served as a chapel for Federal troops. The interior of the building underwent extensive renovations in 1913. Throughout its long history, the building has played host to dignitaries, a memorial service on the death of George Washington and the funeral of General Douglas MacArthur. In 1971, it was added to the National Register of Historic Places.[16]

Walter E. Hoffman United States Courthouse
600 Granby Street
http://www.vaed.uscourts.gov/locations/nor.htm

Built between 1932 and 1934, the Walter E. Hoffman United States Courthouse is home to the U.S. District Court for the Eastern District of Virginia. Standing four stories tall and occupying two city blocks, the building is a significant part of Norfolk's civic landscape. Construction occurred during the Great Depression and provided many local workers with jobs as part of the Works Progress Administration. When first opened, the building served as a courthouse and a post office. In 1983, the post office was relocated. In 1984, the building was placed in the National Register of Historic Places. It is considered one of the finest examples of Art Deco style in Norfolk.

Norfolk College for Young Ladies
College Place

In the late 1870s, it was estimated that about fifty young ladies left the region each year to be educated elsewhere. According to local businessmen, each departure cost the region an annual loss of about $300. Determined to stop this exodus, John Roper and other business leaders opened the Norfolk College for Young Ladies at the corner of Granby and Washington Streets, today called College Place, in 1880. At first, 125 young women attended the school and took classes in French, German, math, elocution, art, domestic arts and more. Mary Washington College took over the school in 1899, but the school lasted only a few more years. In 1905, the building was converted into the Algonquin Hotel. It was renamed the Hotel Edwards in 1918 and then the Hotel Lee in 1936. Small businesses occupied the first floor of the building for decades. The building was demolished in 1983. Today, part of the Tidewater Community College campus in Norfolk sits on the site.

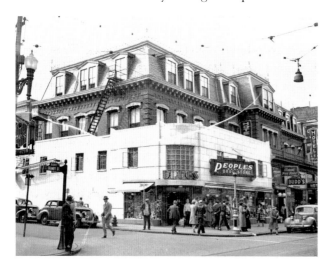

Norfolk College for Young Ladies, which later became this People's Drug Store at Granby Street and College Place, 1940. *Courtesy of the Sargeant Memorial Collection, Norfolk Public Library.*

Chapter 2

COBBLESTONES AND CURVED ARCHES
HISTORIC FREEMASON DISTRICT

Jaclyn Spainhour

INTRODUCTION

Walking down the cobblestone-lined streets of the historic Freemason District, the history buff cannot help but feel surrounded by the past. Homes of Norfolk's most prominent businessmen, doctors and lawyers of yesteryear greet you with their towering turrets and wrought-iron fences. Everything about the neighborhood screams wealth and prosperity, and many of the descendants of these founding families remain in the area today as philanthropists and business men and women carrying on the family legacy. The neighborhood association has taken great care to ensure that the area remains a place true to its historic roots and welcomes visitors as they walk down the Cannonball Trail, which cuts through its streets.

The Freemason Historic District is located on the Elizabeth River just past downtown. In 1977, the Freemason area received its historic designation. Prior to that time, buildings were demolished to make way for parking lots or new office buildings. Through the joint efforts of the city, the Norfolk Redevelopment and Housing Authority and residents, the Freemason Historic District has become a welcoming place to homeowners and business owners alike.

In January 1776, the city was totally destroyed and was subsequently rebuilt. It suffered major damage once again during the War of 1812. This area houses the oldest house in the city, the Allmand-Archer House, which was built in 1790.

The area was a direct result of a subdivision of Norfolkian Samuel Smith's property in 1710. The street names that visitors see today are not necessarily those of the original plans. The original streets were called Bute, Dunmore, Duke (which became Princess north of Bute), York, Botetourt, Yarmouth (formerly Suffolk) and Freemason (formerly Knight and Grafton).

This neighborhood became quite popular in the mid- to late nineteenth century as a place to build homes for "new money" families among the established older homes. Many of the homes in this area belonged to prominent families in rows. It was not uncommon for a father to purchase homes next door to and on the same corner as the main family home for his children to inhabit upon marriage. This practice helped establish social dominance in the neighborhood.

The area is most noted by locals today for its cobblestone-lined streets, which originally came from Belgian blocks used as ballast for ships. When brick and slate sidewalks were put down throughout the area, much of the stone sidewalk was removed. Cobblestones are visible today all down Freemason Street to the Elizabeth River, where it meets Botetourt Street, and make for the perfect backdrop for engagement and family photographs. You will likely run into a photographer or two out and about on a day with nice weather in Freemason. The neighborhood is one of the most popular spots in Norfolk for such activities.

Unfortunately, over time, many of the historic homes in this area were demolished. In the 1960s, there was talk of creating a major thoroughfare through the neighborhood, which contributed to a lack of investment in preservation of the historic homes. By 1975, it began to be restored to what visitors see today, including work on the streets and sidewalks. Those structures remaining give a hint of the fascination the people of Norfolk had with architecture. The keen observer will notice architectural and decorative details indicative of the eighteenth through the twentieth centuries. Many of the homes that have intact period exteriors no longer have period interiors and have been adapted to modern life. One exception is the John Cary Weston House, which up until recently had interiors reflective of the Victorian period thanks to its longtime owner. Anyone wishing to build in the neighborhood is subjected to intense review by the city's Architectural Review Board, as well as the Freemason Street Area Association. New construction is still happening today, although at a slower pace.

When you reach Botetourt Street, take a moment to consider supporting the local businesses there, such as Cure Coffeehouse and Voila. As you walk through the neighborhood, imagine the sounds of hooves beating

against the cobblestones. Picture the elegant dresses of the Victorian women swaying in the breeze. The Freemason District is truly the best place to lose oneself in the preserved beauty of days gone by.[17]

SITE GUIDE

Freemason Abbey Restaurant

209 West Freemason Street
http://freemasonabbey.com
$$

This former church is typical of Romanesque Revival architecture, using granite ashlar with brownstone trim. The church was dedicated in 1873 by the congregation of the Second Presbyterian Church. In 1902, the congregation voted to sell the building in order to build another church in Ghent. The building was purchased by the First Church of Christ, Scientist at that time and remained under this ownership through the 1950s. In 1960, it became the meeting hall for the Independent Order of Odd Fellows. Contrary to the name, the church was never affiliated with the Freemasons, but rather was named after the street on which is sits. It now operates as the Freemason Abbey Restaurant, a well-loved eatery in the area best known for its award-winning she crab soup.

Hunter House Victorian Museum

240 West Freemason Street
www.hunterhousemuseum.org
$-$$

The Hunter House was designed by Bostonian architect William Pitt Wentworth in 1894 for James Wilson Hunter, a prominent businessman turned banker who owned a dry goods and notions Store downtown. It is believed that Mr. Hunter met Mr. Wentworth at Christ and St. Luke's Church on one of the many trips Mr. Wentworth took to Norfolk. This serendipitous meeting would have occurred before the two churches merged following a fire at Christ Church in the early 1800s. Mr. Hunter had the home built for his family of five, which included himself; his wife, Lizzie Ayer Barnes; and their children, James Wilson Jr., Harriet Cornelia and Eloise

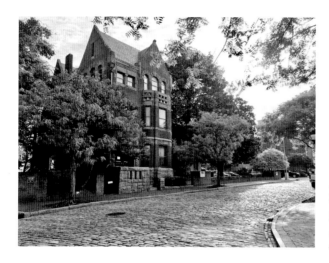

Exterior of the James Wilson Hunter family home. *Courtesy of the Hunter House Victorian Museum.*

Dexter. They were a "new money" family, and building their family home in this neighborhood was a sign of wealth at the turn of the century. James Wilson Hunter Jr. became one of Norfolk's most prominent cardiologists and radiologists at the turn of twentieth century. His sisters were heavily involved in heritage-based organizations, such as the Daughters of the Revolution, and none of the three children married or had children. They lived together in the home until they passed away, the last of whom was Eloise in 1965. The whole family is buried at Norfolk's Elmwood Cemetery.

The house was crafted in the Richardsonian Romanesque style and features prominent archways, brick, brownstone and granite. Its most distinguishing features are the stained-glass windows, which are best viewed from the interior. The museum was opened to the public in 1988 and continues to operate under the umbrella of the nonprofit organization organized by the family, the Hunter Foundation. Its collections include the personal items of the family, including period furniture, clothing, decorative art objects, medical equipment and ephemera. The museum offers exhibits throughout the year, including a standing mourning exhibit and holiday traditions. You can view its hours and programs on its website.

246 West Freemason Street

Architects now occupy this late nineteenth-century home built in the Romanesque Revival style. The structure was home to many Norfolkians, including the superintendent of schools in the late '90s, and as a rental

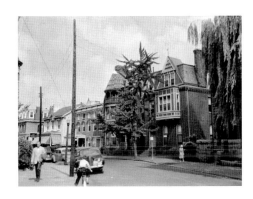

The 200 block of West Freemason Street, 1947. *Courtesy of the Sargeant Memorial Collection, Norfolk Public Library.*

property for the neighboring Hunter family. Notice the recessed entrance behind twin arches, supported by polished granite columns. Also of interest is the curved bay façade topped on the third floor with open porch and a conical roof.

Ellis House
256 West Freemason Street

William H.C. Ellis, an attorney with Ellis and Thomas in Norfolk, had this Italianate home built in 1869 and resided here until 1889. Ellis was an attorney at law with the firm Ellis and Thom and later with Ellis and Kerr. It was later the home of Judge Thomas Willcox. A heavy bracketed cornice runs along the roof. Notice the elliptical windows with keystone hoods on either end of the home. The turret was removed, and the building was restored for office use in 1982.

Petty-Dickson House
300 West Freemason Street

This house was built in 1852 as a Greek Revival townhome. Sometime after 1870, the third-floor mansard roof was added. Owned by William H. Addington, a shoe merchant, the home was sold for $8,250 in 1856 to Mrs. Hannah M. Petty, whose daughter married William C. Dickson. The house was later used as a shoe store, a clothing boutique, a beauty salon and offices. Notice the iron fencing, which runs along the entire block and has different patterns along the way.

301 West Freemason Street

This Italianate home is now offices. Notice the paneled cornice topped with a pyramid, the triangular window and the dormer window. The structure also has brick quoins on the corner.

Camp-Hubbard House
308 West Freemason Street

Norfolk banker William S. Camp built this Greek Revival home in 1852. In 1851, Camp helped organize the Merchants' and Mechanics' Savings Bank, the only local bank to survive the Civil War. In 1897, the residence was sold to Sallie T. Hubbard. The Camp and Hubbard families were the only occupants until the house was converted to offices in the 1970s. At other times in its life, the home served as a fraternity house and headquarters for an architectural firm. The house features a portico with paired Ionic columns. The front windows are topped with decorative stylized acanthus leaf flat lintels.

Camp-Hubbard House, 1953. *Courtesy of the Sargeant Memorial Collection, Norfolk Public Library.*

Roper House
320 West Freemason Street

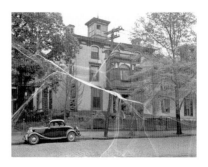

George W. Roper, founder of the Norfolk Shipping and Drydock Corporation, has this Colonial Revival home built in 1901. It was later used as a boardinghouse but has been since converted back to a single-family residence. A prominent feature of the home is the set of colossal columns with composite capitals, using Corinthian and Ionic elements. Looking up, notice the large curved bay window on the

John L. Roper House, 1937. *Courtesy of the Sargeant Memorial Collection, Norfolk Public Library.*

roof. It is surrounded by a balustrade. Above the front door is a fanlight. The gates to the home use the old numbering system for houses.

Roper's Daughter's Houses
324–332 West Freemason Street

This shared house was two separate homes built in the early 1900s for two of George Roper's daughters. Of architectural interest on the no. 322 house is the carved doorway, as well as the heavy iron fencing with grapeleaf motif. At the corner of Dunmore and Freemason, look around at the hooded dormer windows on the roof of the no. 324 house.

McCullough Row
338–346 West Freemason Street

These row house apartments were constructed in 1889 by A.A. McCullough, a prominent Norfolk coal and lumber dealer. Mr. McCullough was also a member of the board of the Norfolk College for Young Ladies. This row contains alternating curved and angled bays that are unified with a string course or belt course between the second and third floors. This Italianate structure is built in gray brick with flat lintels atop the windows.

Old Norfolk Public Library
345 West Freemason Street

Bostonian architect Herbert D. Hale designed the library in the Beaux Arts style. It was begun in 1901 on land loaned by Norfolk's Grandy family and with a grant of $50,000 donated by Andrew Carnegie. It served as the main branch of the library until 1964. It was used as the Norfolk Theatre Center from 1967 to 1976 and has since been converted to office space and residential use.

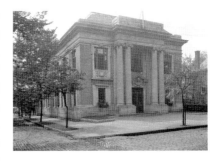

Norfolk Public Library at Freemason Street, 1921. *Courtesy of the Sargeant Memorial Collection, Norfolk Public Library.*

As is typical of Beaux Arts building, many classical elements appear: symmetry, paired Ionic columns and carved swags. Above the door is a bust of Athena, the goddess of war. The frieze carries the names of classical authors.

Weston Houses
348–350 West Freemason Street

This shared structure was built in the last decade of the nineteenth century. Notice the heavy hooded entrance with rather delicate leaded fan lights.

Weston House
352 West Freemason Street

This is another house built in the late nineteenth century for a member of the Weston family. Notice the ball on the upper corner of the house. It also has a curved front stairway.

John Cary Weston House
358 West Freemason Street

This home was designed in the High Victorian Italianate style of architecture in 1870 for John Cary Weston of the Great Bridge Lumber and Canal Company. For a time, this building was used as offices. One resident even wrote and offered a guided ghost tour of the neighborhood out of the residence.

Notice the elaborate detailed brick carvings over the two-story bay windows, incised carved frieze under the eaves and the cornice. An ornamental cast-iron veranda begins at the Freemason entrance and wraps around the Botetourt side of the home. Iron cresting appears above. Also notice the two gabled dormer windows on the Botetourt side.

Grandy House
355 West Freemason Street

An excellent example of Georgian Revival, the Grandy House was built about 1900 by Charles Rollins Grandy for his bride. In 2017, the home was

burned and subsequently demolished. Had it remained standing, visitors would notice the Flemish bond brick pattern of stretchers and headers in each row. The entry was composed of a pediment supported by Roman Ionic columns. On the east side of the home, there was a gambrel roof and an oriel window with diamond panes.

Selden Point
351 Botetourt Street

This home was built on 1807 for Dr. William Boswell Selden as his country house before the area began its major development. Dr. William Selden, the son of William B. Selden, served as surgeon general of the Confederate army. During the Civil War, the house was occupied by Federal forces and used as their headquarters. Robert E. Lee visited in 1870, shortly before his death.

The house was originally a Federal-style structure. Additions were made throughout the years that add a Victorian flair. The gabled roof has three dormers—two are polygonal. The house had several outbuildings and stables. On the grounds to the south of Selden Point is the kitchen. The structure, topped with a mansard roof, is a reproduction of the summer kitchen from an earlier home across the street that is no longer standing.

The Norfolk Boat Club
432 West Freemason Street

The Norfolk Boat Club was established in 1893 by a group of Norfolk men who were enthusiastic about boating sports, rowing in particular. This is the third

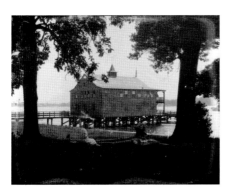

structure to stand on this site; two previous buildings were consumed by fires. It is still in operation today, and you can often find local couples having photographs taken at this picturesque end of the street.

Norfolk Boat Club, circa 1929. *Courtesy of the Sargeant Memorial Collection, Norfolk Public Library.*

Ruffin House
403 West Freemason Street

This vernacular Queen Anne–style house was built in the early 1920s. Notice the half-timbered gable and the paned windows.

400–402 West Freemason

This is another example of a shared house, which was popular in this neighborhood and others like it during this period. It is a four-bay, two-unit row house with gabled dormers and round arched windows, built in the late nineteenth century. As you turn the corner, notice the tracery windows above the basement entrance.

409 Botetourt Street

Another early twentieth-century structure, this was designed in a vernacular Tudor style. The house is built of brick and stucco. Notice the half timbering on the front.

S.Q. Collins House
403 West Bute Street

The Italianate home was built in 1885 and designed by John A. Tucker for S.Q. Collins, partner with John LeKies of a sawmill in the Berkley section of Norfolk. He was also an officer of the Norfolk Cutlery Company.

The symmetrical façade has a central portico entrance with composite Corinthian columns. Segmented arched hoods top the windows. Notice the iron-crested widow's walk atop the low hipped roof, as well as the iron fencing surrounding the house. At 419 Duke Street, an architecturally identical building can be found, originally built for sisters in the neighborhood.

424 West Bute Street

This structure was designed in the Queen Anne cottage style in the late nineteenth century. Notice the terra-cotta panels on the bay.

Kenmure—William Lamb House
420 West Bute Street

This historic home is one noted in local legend as part of the lore of the city's disappearing, and then reappearing, mace. Built in 1845 for William Wilson Lamb, Kenmure was constructed in the Greek Revival style. Lamb, a Norfolk banker and six-time mayor, chose this name for the home after his family estate in Scotland. Lamb is most notable for his service as mayor during the Union occupation of Norfolk, which began in 1862. He led the committee that offered the city's surrender to the Federal forces and was even imprisoned for a time, along with his family, at Fort Monroe in Hampton, Virginia.

Legend has it that Lamb had the city's mace in his possession upon the surrender of the city and chose to hide it from the Federal forces beneath one of the hearths in his home. This makes sense, as it was very popular at the time for Soldiers to loot the homes they took over during a period of occupation. Thanks to Lamb, the mace was kept out of the hands of the Soldiers and was eventually forgotten. It was unearthed once again in 1894 and continues to be part of Norfolk's local lore today.

When Lamb passed away, and the house was given to his son William Lamb, who was considered a local hero. The younger Lamb played an integral role in the Confederate stand at Fort Fisher, North Carolina, and helped Norfolk's financial revival following the war. He promoted the port city to overseas markets and helped it rise to be part of the cotton trade with Great Britain.

Architecturally, the home offers an English basement, Greek Ionic columns and a cupola, among other details. It is one of the many fine examples of nineteenth-century architecture in the neighborhood.

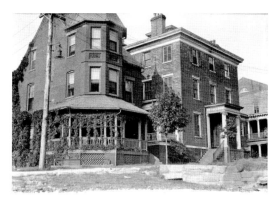

Kenmure, 1926. *Courtesy of the Sargeant Memorial Collection, Norfolk Public Library.*

Chamberlaine House
414 West Bute Street

This home was built in 1889 for William W. Chamberlaine, treasurer of Seaboard and Roanoke Railroad and president of the Electric Company of Virginia. Captain Stephen Decatur, one of Norfolk's most famous citizens, lived across the street. The house has also served as the headquarters of the Red Cross and as law offices.

There are numerous architectural details of note on this structure: the large "goose neck" broken pediment, the elaborate sting course between the second and third floors, brackets featuring stylized leaves, egg and dart molding and curved windows in the front bay.

Richard Taylor House
408 West Bute Street

This Greek Revival home was built after the Civil War in 1867 for Richard Taylor, former paymaster of the CSS *Florida* in 1863. Following the war, he became involved in Norfolk's banking community, helping to organize Citizens Bank of Norfolk, serving as its president and later becoming the president of the Marine Bank.

Paired Ionic columns support the portico, which is topped by a wooden balustrade. Notice the decorative window crowns, similar to those of the Camp-Hubbard House on Freemason Street. Notice also the door's sidelights and transom.

Botetourt Apartments
500 Botetourt Street

Recently renovated, this turn-of-the-century apartment building may have been built for the crowds expected for the Jamestown Exposition in 1907. The author of this chapter lived there for a time and can attest that the common interiors are indeed quite Art Deco in style.

Dunmore Apartments
317–323 West Bute Street

This row of English Queen Anne townhouses, originally four in all, was built about 1891 for members of Norfolk's Pickett family. John S. Pickett was the owner of a local oyster packing company, Pickett and Company, where other members of the family were also employed. Charles Pickett was secretary/ treasurer of the Norfolk Businessman's Association from 1890 until 1899. After 1900, the buildings were occupied by various tenants. Notice the terra-cotta ornamentation, the elaborate brick cornice and string course and the fish scales on the dormer windows.

Omar's Carriage House Restaurant
313 West Bute Street
$$

Renovated into a restaurant, this structure was the carriage house to the John Roper House on Freemason Street, which is no longer standing. Notice the cupola on top. The front windows are in place of the original doors. The restaurant is popular with locals and serves delicious Moroccan and American fare.

Originally built in the early 1840s, the carriage house operated as a place for saddling up horse-drawn carriages. In the nineteenth century, Captain John L. Roper, a timber merchant, bought the property for his family's array of carriages, horses, riding equipment and even a sleigh.

In the mid-1940s, Virginia Bruce Roper converted the facility into a tearoom in the ideal location. Well-known individuals frequented the restaurant, including Mrs. Douglas MacArthur.

By 1974, the quaint tearoom found itself under new ownership, which decided to turn the building into a nightspot known as Round the Corner. The building was then repurchased in 1978 and again became known as the Carriage House. In 1998, Omar Boukhriss purchased it and made it into the success it is today.

309 West Bute Street

Currently housing a business, this former residence is stucco and brick Tudor Revival style. Notice the heavily hooded door, the brick string course to the right and the leaded casement window.

409 Yarmouth Street

This building was the carriage house to the Petty-Dickson House on Freemason Street and has Flemish bond brickwork with flat lintels. The main building dates to before the Civil War, with the wings added later in the nineteenth century.

Joseph W. Perry House
273 West Bute Street

This Second Empire home was built around 1880 for Joseph W. Perry, owner of J.W. Perry and Company, a local cotton factory and dry goods merchant. By 1910, Perry was affiliated with several banking enterprises and businesses, including the Atlantic Trust and Security Company (a building and loan association) and the Citizens Bank of Norfolk and the Bush-Hume Piano Company. The home is one of the few frame houses remaining downtown. Looking up, notice the mansard roof, the applied detail on the dormer windows, the bracketed paneled cornice and the cast-iron fencing on its porch. It is one of four remaining wood structures in the Freemason Historic District.

267 West Bute Street

Designed in the English Queen Anne style like the Dunmore apartments, there are numerous architectural highlights to view in this building, including the arched entrance that sits on corbelled bases, the terra-cotta cherubs above the window and the bottle glass fan light with the house's original street number.

Looking up, notice the patterned slate roof, the third-floor balcony with hooded roof and the fish scales. Look also at the paneled chimneys.

William S. Wilkinson House
259 West Bute Street

This Italianate townhouse was built in 1885 for William S. Wilkinson, a local banker and manager of the Norfolk Clearinghouse Association. You may notice that the window crowns are different on each story, with the most decorative being on the first story. There are two reeded string courses on the front of the building.

257 West Bute Street

This two-story brick structure has a hipped roof and dates from the last decade of the nineteenth century. The house still maintains its original iron fence, which matches that of the Collins House.

LeKies House
419 Duke Street

This brick Italianate structure, built in 1885 for John B. LeKies, is an identical counterpart to the S.Q. Collins House at 403 West Bute Street. The two gentlemen were business partners in the firm LeKies and Collins. LeKies is known for his burial monument at the local Victorian burial ground, Elmwood Cemetery. Notice the widow's walk atop the house.

Glisson House
405 Duke Street

This Greek Revival home was built in 1840 for Commodore Oliver S. Glisson. Glisson served in the Federal forces during the Civil War and, following the war in 1865, left the city when faced with negative public sentiment toward him. The house is now owned by the Hunter Foundation and serves as a retirement home for men. The structure appears, head on, to contain the usual architectural elements found in Italianate homes. The portico has been removed—it was originally a gabled pediment portico. Notice the transom and the window crowns.

Taylor-Whittle House
227 West Freemason Street

This 1791 Federal-style home is reflective of the homes crafted after the Revolution in major port cities. This family residence remained in use as such for nearly two hundred years. It remains one of the finest examples of preserved Federal homes in Virginia and was purchased originally in 1802 from George Purdie of Nansemond County by Richard Taylor, an importer from England. Upon his death, Taylor left the home to his daughter Sarah Taylor Page, the wife of Captain Richard Page, who is known today for his familial affiliation as nephew of the infamous Henry "Light-Horse Harry" Lee. Page also was a distinguished military man, having sailed with Commodore Perry to Japan and taken part in both the Mexican-American and Civil Wars.

Among many of his esteemed visitors was Admiral David Farragut, whose family resided in the area, including a sister-in-law known as Camilla Francis Loyall. Descendants of the Whittle and Page families resided in the home through the 1960s, when the city underwent urban renewal and many established older families left the neighborhood and city. The home was left to the Historic Norfolk Foundation in 1972. For a time, it operated as offices for both the Norfolk Historical Society and the Junior League of Norfolk–Virginia Beach. Today, it stands vacant due to an expensive foundation issue that prevents anyone from inhabiting the building.

The house is architecturally interesting as well as historically important. Passersby can note the Doric columns, portico and the half-arched window in the gable, as well as the delicate molding. It is an enviable example of fine post-Revolution Federal architecture.

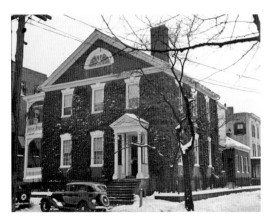

Taylor-Whittle House, 1935.
Courtesy of the Sargeant Memorial Collection, Norfolk Public Library.

Allmand-Archer House
327 Duke Street

Like the Taylor-Whittle House, this home offers a rare example of a surviving Federal-style building. The townhome is thought to have been built in 1790 by Matthew Harvey, a Norfolk merchant who then sold the property to Harrison Allmand, a fellow merchant known as "Old Gold Dust," in 1802. During the War of 1812, the home was residence to American officers. The house later passed to Albert Allmand, a man who is known for his role as a member of the welcoming committee for Lafayette on his American Tour, and subsequently to the Archer family through marriage. Descendants of the Allmand and Archer families lived on the property until the 1970s.

The house was acquired by the Historic Norfolk Foundation, and in 1993, the property was purchased for use as the Emma V. Kelly Memorial Library by the Grand Temple Daughters of Improved Benevolent Protective Order of Elks of the World. It currently serves as a law office.

The Pagoda
265 West Tazewell Street
https://www.pagodagarden.org

Once known as the Marine Observation Tower, the Taiwanese Pagoda and its Gardens are another popular local destination for photographs, engagements and weddings in the neighborhood. The structure was completed in 1989 as a gift to the Commonwealth of Virginia and the City of Norfolk from the Taiwan Provincial Government, meant to honor the historic trading relationship between the two ports. The gift was first proposed in 1983 by Dr. Lee Teng-Hui, the then governor of Taiwan. The Pagoda boasts intricate Chinese-style architectural details and is a two-story structure sitting on the foundation of, interestingly enough, an old 500,000-gallon molasses tank. The completed structure was made entirely of items manufactured in Taiwan and assembled by Taiwanese artisans in Norfolk.

Today, the Pagoda is supported by a nonprofit 501(c)(3) organization known as the Friends of the Pagoda and Oriental Garden Foundation. Formed in 1998 between the neighborhood association and the United Chinese-American Association, this group works under a mission to assist the city in preserving the structure and surrounding garden, creating educational experiences and promoting positive cultural exchange.

Chapter 3

THE NAVY'S CITY

NORFOLK'S MILITARY HISTORY, 1667-1945

Anthony J. Orlikoff

*A powerful Navy we have always regarded as our proper and natural means
of defense; and it has always been of defense that we have thought, never of
aggression or of conquest....Our ships are our natural bulwarks.*
—*President Woodrow Wilson*

INTRODUCTION

On a clear day, observant commuters driving across either the Hampton
Roads Bridge-Tunnel or the Monitor-Merrimac Memorial Bridge-Tunnel
will notice a variety of ships in the waters of Hampton Roads. And the
most eye-catching among these ships are the towering forms of U.S. Navy
aircraft carriers, perhaps as many as five to six if the observer is lucky.
Upon closer inspection, an observer might notice the smaller forms of
dozens of Navy destroyers or the striking white hull of the hospital ship
USNS *Comfort* (T-AH 20).While these arresting silhouettes are impressive,
what is even more remarkable is that these commuters are driving by, only
a mile and half away, from the greatest concentration of naval power in the
world, Naval Station Norfolk. And as viewers contemplate this, they might
also realize that the very waters they are driving over were host to one of
the most consequential and notable battles in naval history, the Battle of
Hampton Roads, the first engagement of ironclad ships in world history.
As Norfolk Naval Shipyard historian Marcus Robbins noted, the bridge-

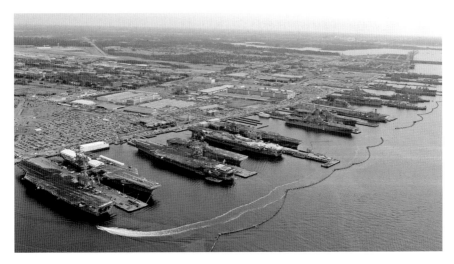

This aerial image of naval might was captured at Naval Station Norfolk on December 20, 2012. Five aircraft carriers (*left to right*)—USS *Dwight D. Eisenhower* (CVN 69), USS *George W. Bush* (CVN 77), USS *Enterprise* (CVN 65), USS *Abraham Lincoln* (CVN 72) and USS *Harry S. Truman* (CVN 75)—along with dozens of other ships, compose an unrivaled concentration of naval power and force projection. *Official U.S. Navy photo, photographed by Mass Communication Specialist Second Class Ernest R. Scott.*

tunnels of Hampton Roads "act as a natural picture frame showcasing where naval history was made."[18] Such are the daily realities of living in, working in and traveling through "the Navy's City."

The military history of Norfolk is rich and varied. Though dominated by the city's historical and contemporary connection to the Navy, Norfolk's status as one of the oldest coastal cities in North America placed it at the forefront of American military history. From the American Revolution through the American Civil War to World War II, as well as through to the present day, Norfolk's role as a significant location in American military history is undeniable. Home to the world's largest Navy base, Naval Station Norfolk, the base's 75 ships, 134 aircraft, 11 aircraft hangars and more than 200,000 people leave an indelible mark on the city of Norfolk. Along with integral facilities at the Norfolk Naval Shipyard and Naval Medical Center Portsmouth, Norfolk's connection to the Navy is both historical and contemporary. Indeed, it's hard to imagine Norfolk without the Navy and the Navy without Norfolk.

Visitors and locals alike interested in understanding Norfolk's military history should, above all, consider both the mercurial and consistent nature of the city's relationship with the Navy. Norfolk has always and

likely will always have a powerful connection to maritime affairs, given its geographic proximity to the Chesapeake Bay and Atlantic Ocean. As such, the people of Norfolk have always been in proximity to the day-to-day realities of what living in a nautical city is like—party to the presence of navies, shipbuilding and international commerce. The course of history has often placed Norfolk at the front lines of significant and turbulent events, heightening the sense of Norfolk's importance in naval history.

THE HARD HAND OF WAR: NORFOLK IN THE REVOLUTION

Hampton Roads was a center of maritime and naval activity from the very inception of the English settlement of North America through the establishment and support of the Virginia Colony. Indeed, as the English settlement of the Hampton Roads region grew throughout the seventeenth and early eighteenth centuries, so too did the area's naval presence. In 1667, the Royal Navy stationed its first warship, the frigate *Elizabeth*, in the Chesapeake Bay to guard it from hostile foreign adversaries. On June 4, 1667, a small Dutch flotilla attacked and destroyed *Elizabeth*, leaving the vulnerable tobacco trade ships in Hampton Roads ripe for plunder. The ignominious fate of *Elizabeth* was a harbinger of things to come for the region. The geography of the Chesapeake Bay, shaped by glaciers and a meteorite impact, facilitated both maritime trade and naval warfare. If the Royal Navy, the Virginia settlers and, later, the fledgling American people wanted to establish Hampton Roads as a lucrative and prosperous trade hub, they would have to protect it.

By 1752, after decades of erecting coastal fortifications and battling foreign raiders, the city of Norfolk and town of Portsmouth were established along the Elizabeth River as profitable and stable coastal communities. And with this prosperity came additional investment. On November 1, 1767, Andrew Sprole, a wealthy Scottish merchant, established the Gosport Navy Yard in Portsmouth. Believing in the region's economic potential, Sprole's investment proved to be a fruitful one, as the Gosport Navy Yard developed into a profitable shipyard by the time of the American Revolution. With the outbreak of the American Revolution in 1775, the Virginia Colony seized Sprole's properties, and the fledgling United States of America had a shipyard to call its own. At the onset of the American Revolution, the inhabitants of Hampton Roads and Norfolk were well acquainted with the realities of shipyards

and warships. Yet the people of Norfolk were ill-prepared for the hard hand of war, which soon reached the city.

On March 20, 1775, the Second Virginia Convention met and selected delegates for the Second Continental Congress, where the Declaration of Independence was signed. Alarmed by the conference and Patrick Henry's famous "Give Me Liberty or Give Me Death" speech, the royal governor of Virginia, John Murray, the 4th Earl of Dunmore, acted rapidly to suppress what he viewed as an inevitable rebellion. He seized Williamsburg's gunpowder stores, enraging local militia leaders, and Dunmore was forced to flee the capital. Dunmore further stoked the fires of rebellion with a proclamation guaranteeing freedom to slaves who fled their Patriot owners and served the British. Virginia militia forces, desiring control of the Tidewater region, resisted Dunmore's forces and were defeated in a skirmish at the Battle of Kemp's Landing on November 17, 1775. One month later, the militia decisively defeated Dunmore's forces at the Battle of Great Bridge, causing the evacuation of British forces from Norfolk

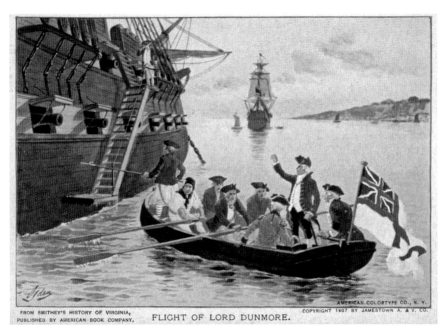

FROM SMITHEY'S HISTORY OF VIRGINIA, PUBLISHED BY AMERICAN BOOK COMPANY. FLIGHT OF LORD DUNMORE. AMERICAN COLORTYPE CO., N. Y. COPYRIGHT 1907 BY JAMESTOWN A. & V. CO.

If there ever was a villain in Norfolk's early history, it was Lord Dunmore. Impetuous and brash, Lord Dunmore was reviled by Virginians for the bombardment of Norfolk as well as his controversial policy of emancipating Patriot slaves. This postcard, first published in Norfolk by the Jamestown Amusement & Vending Company in 1907, depicts the ignominious departure of Lord Dunmore from Norfolk after the Royal Navy's bombardment in January 1776. *Courtesy of the Library of Congress.*

County. Loyalist citizens of Norfolk, who made up a sizeable portion of Norfolk's population, accepted an offer of evacuation from Dunmore, and Norfolk was subsequently occupied by Patriot forces.

On New Year's Day 1776, Patriot partisans in Norfolk fired on some of Dunmore's nearby ships in the Elizabeth River. In retaliation, the Royal Navy fired on Norfolk with more than one hundred cannons, and Dunmore's forces stormed ashore to burn waterfront buildings. Patriot and militia forces, in response, set fire to and looted many Loyalist properties. This procession of looting and destruction continued for three days, as fires raged across the city. Lord Dunmore left with the fleet, never to return. The destruction rendered to Norfolk, one of most prosperous maritime communities on the East Coast, was catastrophic: 863 buildings were destroyed, most of which were burned down in the flames of the Patriot retaliation.

Norfolk's remaining residents found some respite from the hardships of war until May 1779, when a British expeditionary force occupied Norfolk and burned many waterfront properties, including the ever important Gosport Navy Yard. The British periodically returned to the region, including a notable foray led by the traitor Benedict Arnold, who used Portsmouth as base of operations. After British General Charles Cornwallis's fateful defeat at Yorktown functionally ended the American Revolution, the residents of Norfolk were finally able to begin rebuilding what had once been a prosperous maritime community.

A NEW BEGINNING: NORFOLK AND THE NAVY

As Norfolk merchants rebuilt in the wake of the destruction of the Revolution, the seeds of the Navy and its involvement in Norfolk were planted. With the Continental Navy dissolved, Congress passed An Act to Provide a Naval Armament, authorizing the building of six frigates and officially founding the U.S. Navy. The federal government, under the supervision of naval officials and government contractors, leased shipyards to create these first six frigates. One of these shipyards was Gosport, which was contracted to build the USS *Chesapeake*, a thirty-six-gun frigate. Construction was plagued by setbacks and delays, but *Chesapeake* was finally launched from Gosport on December 2, 1799, and commissioned in May 1800. In response to the expensive leasing program, Secretary of the Navy Benjamin Stoddert realized that it would be far more cost-

effective in the long run for the Navy to own and operate shipyards directly. Thus, the federal government purchased Gosport Navy Yard from the Commonwealth of Virginia for $12,000 on June 15, 1801.

Throughout the Quasi-War with France and the Barbary Wars, Gosport and Norfolk served as a hub of naval activity, repairing and refitting all six frigates, including the storied USS *Constitution*. As Norfolk and the U.S. Navy moved into the nineteenth century, an infamous incident would forever cloud their shared history. Concerned about British sailors deserting Royal Navy ships while Britain was in the throes of its titanic clash with Napoleon I, Vice-Admiral George Berkeley of the Royal Navy ordered that all British ships were to stop American ships to search for deserters. On June 22, 1807, the British frigate *Leopard* hailed *Chesapeake* as it was departing Hampton Roads. Commodore James Barron, commanding officer of *Chesapeake*, refused to comply with Captain Salusbury Pryce Humphreys's demand to search the ship for deserters. Barron, realizing that *Chesapeake* was unprepared to fight, tried to stall for time, but it was too late, as *Leopard* opened up with warning shots and then a full broadside on the vulnerable *Chesapeake*. For fifteen painful minutes, the fifty-gun *Leopard* raked *Chesapeake* with full broadsides until *Chesapeake*'s crew was finally able to fire one impotent shot in retaliation. Barron humiliatingly surrendered, suffering three killed and eighteen wounded. Four deserters were taken from *Chesapeake*, and Barron limped *Chesapeake* back to Norfolk. The *Chesapeake-Leopard* Affair, as it became known, was one of the most humiliating events in Navy history and almost led to war with Great Britain.

Captain Stephen Decatur, regarded as one of the great heroes of the Barbary Wars, was the commandant of Gosport and in overall command of naval forces in Norfolk. He quickly readied Norfolk's defenses, yet tensions waned and diplomacy prevailed. The husband of Susan Wheeler, daughter of Norfolk's mayor Luke Wheeler, Decatur heavily criticized Barron for his conduct in handling the *Chesapeake* and immediately took command of the frigate. Disgraced and eventually court-martialed (during which Decatur was a member of the court), Barron never forgot Decatur's harsh criticisms. In 1820, Barron challenged Decatur to a duel, as the latter again criticized Barron's conduct as he was seeking reinstatement in the Navy. On March 22, 1820, Barron killed Decatur in a duel at Bladensburg outside Washington. And thus the Navy lost one of its greatest heroes at the hands of one of its own.

Although diplomacy prevailed in 1807, war with the British over the controversial practice of impressment broke out five years later when

Charles Bird King captured the dignified confidence of Commodore Stephen Decatur in this 1820 oil on canvas painting. Decatur's exemplary leadership qualities, tremendous bravery and personal integrity personified the ideal nineteenth-century naval officer. The citizens of Norfolk warmly welcomed the arrival of Decatur as both the husband of Susan Wheeler and the commandant of Gosport and wanted to name a street after the heroic naval commander. Decatur politely declined the offer, but the citizens of Norfolk named the street (now the bustling Monticello Avenue) Tripoli Street, after Decatur's famous victory over the Barbary pirates. *Courtesy of the National Portrait Gallery (CC0).*

President James Madison signed a declaration of war on June 18, 1812. Enraged by British impressment of American mariners and support for hostile Native Americans on the frontier, the fledging United States was attempting to seize an opportunity by engaging a British military preoccupied with fighting Napoleon. American frigates and privateers sortied out of the Chesapeake Bay and other ports to harass British commerce. To counter the credible threat of the American commerce raiders, a British strike force led by Captain George Cockburn arrived in the Chesapeake Bay with orders to blockade and disrupt American military and maritime operations. Promoted to rear admiral, the aggressive and experienced Cockburn raided across the Chesapeake, destroying private property as well as military supplies. But Cockburn had his sights on a larger target.

With 2,650 troops under the command of Colonel Thomas Sydney Beckwith, Cockburn aimed to capture Norfolk, seize the American frigate USS *Constellation* and occupy the Gosport Navy Yard. Brigadier General Robert Taylor of the Virginia militia commanded Norfolk's defenses, and he decided to garrison Craney Island, strategically situated at the mouth of the Elizabeth River, with a makeshift battery of cannons from *Constellation* and Fort Norfolk and 767 men. On June 21, 1813, British forces in barges advanced toward Portsmouth, landing troops north of the island, with other

barges advancing toward the island itself. The makeshift battery on Craney Island, manned in part by Marines and Sailors from *Constellation*, opened fire on the approaching barges and quickly destroyed three of them. Other barges became bogged down in mud and were unable to advance. The British retreated, and their attack on Norfolk was thwarted, suffering 100 casualties. The citizens of Norfolk, many of whom had watched the battle from the shore, cheered. Taylor was hailed as a hero.

Cockburn, in response to the unexpected difficulty of attacking Norfolk, quickly routed militia forces outside the small town of Hampton. After his forces sacked Hampton, Cockburn continued to raid up and down the Chesapeake Bay. Norfolk had proven to be too well defended to attack again, but after the arrival of reinforcements, Cockburn launched the infamous attack on Washington, D.C., that resulted in the embarrassment of American forces at Bladensburg and the burning of the White House and other federal buildings.

After the War of 1812, the U.S. Navy had established itself as a mature and effective fighting force, and in turn, Hampton Roads was appreciated as a strategically important trade and naval hub. Yet the British had proven the region's vulnerability to attack, as well as the Navy's impotence to resist a determined enemy sortie into the Chesapeake Bay. Thus, the Navy of the Antebellum era was characterized by growth, investment and consolidation.

The need for further defenses was addressed by the Fourteenth Congress of the United States in 1816–17, authorizing an increase in naval shipbuilding and appropriating $838,000 for the building of further coastline fortifications. The forty-two coastal forts produced by this appropriation constituted a more secure bulwark against naval invasions. In Hampton Roads, Fort Monroe was erected at Old Point Comfort as the cornerstone of the region's defenses. A smaller fort, Fort Calhoun, was constructed on an artificial island called the Rip Raps at the mouth of Hampton Roads. In conjunction with Fort Calhoun and other batteries, the region's defenses were quite formidable by the 1850s.

Congress also saw the need for increased naval spending in terms of both ships and infrastructure. Ships of the line, massive ships with seventy-four guns, were built at Gosport in the 1820s, including the USS *Delaware*, which was launched in front of a crowd of twenty thousand on October 21, 1820. Dozens of other ships were built during the Antebellum period at Gosport and across the country. In Hampton Roads, the center of this naval activity was Gosport. A report from the Secretary of War in 1821 identified Hampton Roads and Boston as areas of primary naval activity, arguing that

This contemporary lithograph, by J.G. Bruff, illustrates one of the crowning achievements in Norfolk's history: the first operational use of a dry dock in North America. USS *Delaware*, a seventy-four-gun ship of the line, docked at Gosport on June 17, 1833, to massive fanfare as thousands of Norfolk and Portsmouth citizens crowded the dock to celebrate the auspicious occasion. *Naval History and Heritage Command.*

they should receive priority funding. Congress acted on this advice, providing the Navy $500,000 for shore facility upgrades. On June 17, 1833, a dry dock in North America was flooded for the first time to receive USS *Delaware*. The dry dock at Gosport, the first in the Western Hemisphere, was just one of many infrastructure improvements. The shipyard expanded to meet the needs of a more active navy, with thirty-three lots of land acquired between June 1826 and April 1828 alone.

Given the importance of Norfolk and Gosport Navy Yard, naval officials deemed a dedicated Navy-run medical facility an important investment. Workers used 500,000 bricks from Fort Nelson to lay the foundation of the hospital, and by 1831, the hospital had begun operating and receiving patients. Through a combination of medical professionals, enslaved laborers, and institutional support from the Navy, the hospital became an integral component of Hampton Roads' naval infrastructure. The decision to establish a hospital proved to be a prudent one, as cholera and yellow fever outbreaks in 1832 and 1855, respectively, ravaged the region's population.

"GLADIATORS IN THE ARENA": NORFOLK IN THE CIVIL WAR

By 1860, Hampton Roads was one of the largest, most prosperous and most important centers of naval activity in North America. The Navy had eighty-nine ships in commission or in ordinary, Gosport had never been larger or more active, and the people of Hampton Roads had all but forgotten about the harsh realities of war at their doorsteps.

On April 17, 1861, Virginia, joined by ten other Southern states, seceded from the Union over questions regarding states' rights and the preservation of slavery. The fledging Confederate States of America would have to defend its perceived sovereignty, and Virginia, given its geographic proximity the Northern states, was the primary theater of the war on the East Coast. The Navy, with some personnel pledging allegiance to the new Confederacy, was in a precarious predicament in Hampton Roads, and nowhere was this truer than in Gosport Navy Yard. The prosperity and naval might of Gosport became a liability as naval personnel were forced to flee with as many ships as they could man for the safety of Fort Monroe. Before they left, Union forces burned, sabotaged and destroyed anything of military value, including several ships, gunpowder stores, cannons and supplies. Although this destruction was prodigious, it was far from enough to completely stymie the value the Rebels got from holding the yard. In Gosport, the Confederacy held in April 1861 the largest dry dock in the United States, thousands of cannons of various types and large caches of supplies. Union forces at Fort Monroe quickly blockaded Hampton Roads, and once again the people of Norfolk found themselves on the front lines of war.

Confederate Secretary of the Navy Stephen Mallory had an unenviable task in the spring of 1861 of not only creating a navy practically from scratch but also having that navy contend with a blockade from the U.S. Navy. In accordance with Lieutenant General Winfield Scott's "Anaconda Plan," the Navy blockaded the Confederate coastline to strangle the flow of supplies and trade goods to and from the Confederacy. Mallory knew that this blockade had to be broken for the Confederacy to survive a protracted war. Confederate leadership was also determined to hold Norfolk, Portsmouth, and the critically important Gosport Navy Yard, as the Union presence was an ever-present threat at the unassailable Fort Monroe. With hardly any ships and few facilities in which to build new ones, Mallory and the Confederate leadership decided on a new strategy of concentrating their resources to design and build experimental ironclad ships. John Luke Porter,

a gifted naval constructor, and John Mercer Brooke, head of the Confederate ordnance branch, along with William P. Williamson, the chief engineer at Gosport, collaborated on designing and building the first Confederate ironclad. They decided to raise the wreck of one of the ships the Union had sunk at Gosport, the USS *Merrimack*, and convert it into an ironclad, the CSS *Virginia*. With their design finalized by the end of June 1861, construction began at Dry Dock No. 1 at Gosport in July. With iron plating produced at Tredegar Ironworks in Richmond, the ship was covered in layers of armor, approximately two to four inches thick. Critically, the principal armor of the *Virginia* was placed at a thirty-five-degree angle, sloping to deflect enemy shots. With the addition of fourteen cannons and a bow ram, *Virginia* was a formidable, though very slow, warship.

Union spies uncovered *Merrimack*'s conversion, and it was eventually decided that the Union should also build ironclads to counter the threat posed by such vessels. Secretary of the Navy Gideon Welles eventually authorized the production of a few proposed ironclad designs, one of which was Swedish inventor John Errisson's USS *Monitor*. Unlike *Virginia*, *Monitor* was entirely made of iron and was built from the keel up as a new warship. By far the most radical design feature of *Monitor* was an armored, revolving turret that contained two eleven-inch Dahlgren guns. The steam-powered turret, the first in world history, allowed *Monitor* to fire no matter which way the ship was oriented. These features combined to create an innovative and effective ironclad vessel, and *Monitor* was made ready for battle.

Though still incomplete, *Virginia* was deemed ready for combat operations in March 1862. Commanded by U.S. Navy veteran Franklin Buchanan, *Virginia* deployed from Gosport to Hampton Roads on March 8, 1862. Joined by the small vessels of the James River Squadron, *Virginia* targeted the blockading ships of the Navy anchored in Hampton Roads. *Virginia* first attacked USS *Cumberland* and USS *Congress*, anchored at the mouth of the James River. Armed with eleven-inch Dahlgren guns, the sloop of war *Cumberland* had the firepower that was most likely to pierce *Virginia*'s armor. *Cumberland* and *Congress* opened fire on *Virginia*, yet the lumbering Confederate vessel shrugged off these shots as the vessel's sloped armor worked as designed. *Virginia* murderously returned fire, raking both Union vessels. *Virginia* rammed into the side of *Cumberland*, piercing the wooden hull of the ship and causing it to rapidly sink. Valiantly, many in the crew of *Cumberland* refused to flee the sinking ship, with 121 Sailors going down with the ship as they defiantly returned fire until the vessel sank beneath the waves.

Virginia next turned its sights on *Congress*, and before long, the Union vessel was forced to surrender as the Confederate vessel endured the cannon fire from *Congress*. Although *Virginia* tried to take *Congress* as a prize, fire from shore batteries forced the Confederates to set fire to *Congress*, burning until late into the next morning. USS *Minnesota*, anchored beneath Fort Monroe, was too far away to help the doomed *Cumberland* and *Congress*. In their haste to join the battle, the crew of *Minnesota* grounded their ship in the mud of a shoal, leaving them a helpless target for *Virginia*. Forced to retire to Sewell's Point due to the setting sun, the commanding officer, Lieutenant Catesby ap Roger Jones (Buchanan was wounded by a sharpshooter during the battle), was determined to return the next day to finish off *Minnesota*. Although it had suffered some damage, *Virginia* won a crushing victory for the Confederacy. For one day at least, the Confederacy ruled the waves in Hampton Roads.

Fortunately for the Union, USS *Monitor*, commanded by Lieutenant John Worden, arrived at 10:00 p.m. that night and was quickly ordered to aid *Minnesota*. On March 9, *Virginia* raised anchor and steamed toward *Minnesota*. *Monitor*, hidden behind *Minnesota*, darted out from behind the larger wooden ship, and the two opened fire on the approaching iron juggernaut. *Virginia* returned fire, setting *Minnesota* on fire. With *Minnesota* vulnerable, *Monitor* advanced out into open water, and the first duel between ironclad ships in world history began. Jones, having the advantage in firepower, sought to unleash full broadsides on the smaller vessel, yet almost all of these shots were ineffective. Worden, in turn, decided to use *Monitor*'s superior mobility to outmaneuver and circle *Virginia*, probing for weak points in its armor. For four hours, the ships battled in Hampton Roads, with Confederate General R.E. Colston, who witnessed the battle from Ragged Island, remarking that "like gladiators in the arena, the antagonists would repeatedly rush at each other, retreat, double, and close in again."[19] Around 12:00 p.m., concentrated fire on *Monitor*'s pilothouse temporarily blinded Worden as shrapnel and dust burst through a viewing slit as *Monitor*'s commanding officer looked through. The two ships disengaged, with *Monitor*, under strict orders to protect *Minnesota*, refusing to pursue *Virginia* across Hampton Roads. Both sides claimed victory, although the Navy was able to maintain its blockade and once again controlled the waves.

The Battle of Hampton Roads was one of the most important battles ever fought in world history. Though relatively indecisive, the battle's symbolic importance was not lost on the observers there, with Deputy Secretary of the Navy Gustavus Fox, who had watched the battle from Fort Monroe,

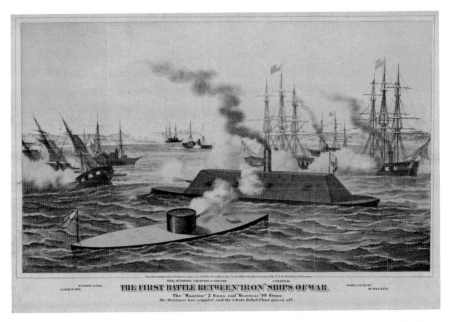

THE FIRST BATTLE BETWEEN IRON SHIPS OF WAR.
The "Monitor" 2 Guns and "Merrimac" 10 Guns.
The Merrimac was crippled and the whole Rebel Fleet driven off.

Depictions of the Battle of Hampton Roads were widely distributed in the press, including this Kurz and Allison print. Portraying the perspective of Union Soldiers on the shores of Hampton and Newport News, the print is an amalgamation of different components of the battle, including the sinking of USS *Cumberland* and the engagement between ironclads that occurred the next day. *Courtesy of the Library of Congress.*

reportedly calling it "the greatest Naval battle on record."[20] In one battle, the wooden ships of the navies of the world were proven obsolete, and naval warfare would never be the same. For the residents of Norfolk, the battle was a triumphant strike against the hostile Union forces in the area, and many believed that Norfolk's safety was assured in the form of the mighty CSS *Virginia*. It was not until a man of bold action arrived in Hampton Roads that this was proven to be a false sense of security.

President Abraham Lincoln arrived at Fort Monroe on May 7, 1861, to confer with Major General George B. McClellan, whose forces were bogged down in the Peninsula outside Yorktown. With McClellan refusing to meet with the president while in the field, Lincoln was determined to make use of his time in Hampton Roads. He immediately ordered the lethargic commanders of the Navy and Army in the area, Rear Admiral Louis Goldsbourgh and Brigadier General John Wool, to probe Norfolk's defenses and plan an invasion. The first major attack on Norfolk's defenses came on May 8, with *Monitor* spearheading a flotilla of ships to bombard Sewell's Point. *Virginia* did slowly advance up the Elizabeth River to try

to contest the attack yet decided not to engage the larger Union force. With the Confederates forced to abandon the Sewell's Point defenses and *Virginia* appearing cowed, Lincoln was convinced that Norfolk could be taken if a suitable landing site was found.

Secretary of the Treasury Salmon P. Chase, who had accompanied Lincoln to Hampton Roads, reported that he and Wool had discovered a suitable landing point that was sheltered from a potential intervention by *Virginia*. The president, wanting to see the landing site for himself, boarded a small tug accompanied by a party of Soldiers from Fort Wool to conduct an evening reconnaissance of the site. Ocean View, then a rural area of Norfolk County and occupied by nothing more than farmers and small village, was deemed a suitable option for landing forces for a march on the city itself. Lincoln and Wool agreed to launch the amphibious invasion on May 10.

In the early morning hours of May 10, nearly five thousand Soldiers from Hampton and Newport News boarded ships at Fort Monroe to embark for the invasion of Norfolk. Lincoln accompanied the invading forces. Navy Lieutenant Thomas Selfridge accompanied Lincoln on a tug and recalled, "He was very much preoccupied. He sat out on deck, aloof from everyone else, and appeared extremely tired, careworn, and weighted down with responsibility."[21] The invasion was initially disorganized, but Chase, who had gone ashore with the troops while Lincoln stayed offshore, sprang into action and ordered Brigadier General Egbert Ludovicus Viele, who had accompanied Lincoln to Hampton Roads as a guest of the cabinet, to take

President Lincoln's daring nighttime reconnaissance of Ocean View on the night of May 9, 1862, was an unprecedented feat of direct military action by a sitting president. After ordering that a group of Confederate cavalry visible on the shore must not be fired upon, Lincoln boarded a rowboat with others and landed on the beach of Ocean View. Thus, for the first and likely only time in American history, the commander-in-chief personally led a reconnaissance mission of a hostile shore. After walking up and down the beach, the president departed without incident, and none in the Confederacy was aware that the most powerful man in the United States had stepped foot on their territory. *Courtesy of the Library of Congress.*

command of the landing force. With Viele in command, the Army quickly organized and made rapid progress toward Norfolk. With Confederate forces abandoning their positions before them, they surged forward until they were met a few miles outside the city by the mayor of Norfolk, who, after some delay, surrendered the city.

Although Jefferson Davis, president of the Confederacy, and the Confederate leadership had long considered abandoning Norfolk, the loss of Norfolk was nothing less than a grievous body blow to the Confederate cause. Not only had they lost one of their most populous and prosperous coastal cities, but they had also lost the irreplaceable Gosport Navy Yard and their mightiest naval asset: the CSS *Virginia*. Forced to abandon the ship with the loss of Gosport, the crew of the CSS *Virginia* scuttled their own ship in a violent explosion. In turn, for the second time in thirteen months, Gosport Navy Yard was burned and sabotaged, this time at the hands of the Confederates. The hard hand of war once again become known to the people of Norfolk, as the jubilation of *Virginia*'s victory over the Union had soured in just a few weeks to destruction and military occupation.

The war raged on for four more years, and all the while, Hampton Roads was still very much a theater of war, as the James River Squadron made several harassing attempts at attacking blockading ships. Norfolk itself was occupied by Army forces, and the city became an important logistical hub for the Union for the remainder of the war. The road networks that converged in the city proved a vital cog in the Union's vast supply chain network as fighting raged across Virginia. The citizens of Norfolk were party to a lengthy occupation, with Union patrols and vast columns of Soldiers merging into the daily rhythms of life in Norfolk. Gosport became an important base and resupply station for ships of the vast Union armada, which was slowly choking the life out of the Confederacy through an extensive blockade of the Southern coast.

As the war mercifully ended in April 1865, the people of Norfolk once again faced the need to rebuild their shattered economy and way of life. But from the ashes of Gosport would spring forth a new beginning for Norfolk and the Navy, one that would propel Norfolk to economic prosperity and naval significance unlike any could have imagined. This new era was epitomized in a simple nominal change: Gosport was renamed and designated as U.S. Navy Yard, Norfolk, Virginia.

GROWTH AND INNOVATION: NORFOLK IN THE NEW CENTURY

Throughout the Reconstruction era, the Navy went through a period of stagnation and regression. No longer needing the naval might needed to quell the rebellion, naval spending decreased and more than four hundred vessels were scrapped or decommissioned within a year of the end of the Civil War. Although the people of Norfolk rebuilt—and so, too, did the Navy Yard—the funding and desire for ships and shipbuilding was nearly nonexistent. It was not until the 1880s that the fortunes of the Navy changed. New technological innovations such as steel hulls, steam engines and advanced guns necessitated a reinvigoration of the Navy. In this "New Steel Navy" era, naval shipbuilding once again became an everyday facet of life in Hampton Roads. The Congressional approval of the construction of four steel warships in 1883 (the ABCD ships: *Atlanta*, *Boston*, *Chicago* and *Dolphin*) marked the beginning of this new era, and soon the reinvigorated naval zeal reached Norfolk. In 1887, Congress awarded the contract for the first American battleship, the USS *Texas*, to the U.S. Navy Yard, Portsmouth, and soon other contracts followed. A second dry dock was built to help support these efforts, and the Navy Yard was again a center of Navy activity.

Across the water in Newport News, a new shipyard was founded by millionaire businessman Collis Peter Huntington on January 28, 1886, and Newport News Shipbuilding and Dry Dock Company rapidly grew to rival even the Norfolk Navy Yard, receiving its first Navy contracts in 1892 and first battleship contracts in 1896. Coal was the fuel of the modern U.S. Navy, and Virginia's plentiful and reliable supply of coal via the railroad network ensured that Hampton Roads was a premier area for naval investment.

This shipbuilding activity was punctuated by the outbreak of war. The Norfolk-based battleship USS *Maine* mysteriously exploded in Havana Harbor on February 15, 1898, and soon the United States declared war on the Spanish, blaming them for the ship's demise. The Flying Squadron, a powerful force of armored cruisers and battleships, sortied out of Hampton Roads bound for a blockade of Cuba. These ships participated in the Battle of Santiago, where a naval force crushed an inferior Spanish fleet, sinking six ships while suffering only two casualties. With the Spanish-American War soon over, it was clear that the age of the "New Steel Navy" had pushed Hampton Roads and Norfolk back to the center of naval affairs.

One of the harbingers of Norfolk's naval destiny came from an unlikely source. On April 26, 1907, three hundred years to the day after the first Jamestown settlers first landed at Cape Henry, the Jamestown Exposition

opened to immense fanfare at Sewell's Point in Norfolk. Once the site of Confederate earthworks, Sewell's Point was chosen for much the same reason Hampton Roads was chosen for English settlement: the proximity of Norfolk to major waterways made it easily accessible to both residents of the region and out of state travelers. The Exposition, organized in the same fashion as a world's fair, was composed of a menagerie of scientific, naval, historical and technological displays and exhibits. Designed as both a showcase and celebration, the Jamestown Exposition included unique buildings provided by each state, a 120-foot model of the Panama Canal, electric trains, a building highlighting African American achievements and even a re-creation of the devastating San Francisco earthquake. And, of course, in classic Norfolk fashion, there was a naval review and a reenactment of the Battle of Hampton Roads. Notable attendees included President Theodore Roosevelt, Booker T. Washington, Mark Twain and, importantly, various admirals and senior Congressional leaders. Roosevelt even presided over the departure of the Great White Fleet, the audacious deployment of American battleships on a worldwide cruise from Sewell's Point, shortly after the conclusion of the Exposition.

For all its undeniably spectacular displays, the Jamestown Exposition was a financial failure and might have just ended up a footnote in history if not for a quite unintended side effect. Located at the mouth of the vast Hampton Roadstead and surrounded by naval shipyards, Sewell's Point was an obvious location for a naval base to any astute observer. And the infrastructure that was established to support the Jamestown Exposition— such as rail lines, roads and support structures—provided a nucleus around which to build.

Around the same time, important events were occurring in the region and around the world. When the Wright brothers conducted their first auspicious test flights, military innovators were immediately intrigued about the military potential of the airplane. After some tentative planning, Captain Washington Chambers contracted pilot and entrepreneur Eugene Ely for one of the most ambitious test flights of all time. On November 14, 1910, Ely took off in his Curtis Pusher from the modified deck of the cruiser USS *Birmingham* (CL 2), anchored in Hampton Roads. After a short flight, Ely landed his plane safely at Willoughby Spit. It was the first time that an airplane successfully took off from a ship. And from this small test flight sprang the entirety of the Navy's aviation program.

Across the world, the nations of Europe were preparing for war, and the Navy, a fledgling yet powerful force after the Spanish-American War,

refused to be left behind. The shipyards of the United States—including the U.S. Navy Yard, Portsmouth and Newport News Shipbuilding—responded in kind, producing dozens of warships. As the United States prepared for the possibility of entering World War I, which broke out in Europe in August 1914, Navy leadership began to grasp the realities of supporting a modern fleet. They deemed the existing infrastructure in Hampton Roads inadequate to support the large fleets of dreadnoughts, heavy cruisers and destroyers composing the Navy. A plan was proposed—championed especially by Norfolk lawyer Theodore J. Wool, who had purchased through a holding company the Sewell's Point land—to establish a new naval base in Hampton Roads. When the United States entered World War I on April 6, 1917, plans were already in motion for the Navy to acquire Sewell's Point as the location for a new naval base. With the backing of Secretary of the Navy Josephus Daniels and President Woodrow Wilson, Congress quickly approved a bill to establish "Naval Operating Base, Hampton Roads, Virginia." On June 15, 1917, President Wilson signed the bill into law and Norfolk was never the same.

Under the direction of Rear Admiral Albert C. Dillingham, the newly christened Naval Operation Base (NOB) rapidly expanded. Building around the remaining infrastructure from the Jamestown Exposition, 17,132 Sailors were quickly received, outfitted and trained in the new NOB within the first six months. Young Sailors bound for service during World War I came to the Norfolk base to attend fully operational radio, signal, medical and other schools. A fledgling naval air station was established, and vast supply warehouses were erected; 125 buildings were in operation at the training station by April 1918, with many more well on their way. This sudden burst of naval activity stressed and almost buckled Norfolk's infrastructure, as additional labor, transportation and utility requirements taxed Norfolk's residents.

The naval development occurring at what would become Naval Station Norfolk was mirrored across Tidewater as war proved to be the catalyst for a rapid intensification of industry. The U.S. Navy Yard escalated its output to meet America's wartime needs, with seventy-five structures, dozens of ships and three dry docks constructed between 1916 and 1920 alone. The Portsmouth Naval Hospital similarly expanded, with dozens of new wooden structures built to support the treatment of the wounded and instruct new corpsmen. This expansion proved to be invaluable, as the 1918 influenza pandemic ravaged Norfolk and the rest of the world. Disease-stricken Sailors and naval personnel overwhelmed the hospital.

Foremost among the expanded dry docks during this period was the massive Dry Dock No. 4. At 1,011 feet long, 144 feet wide and 40 feet deep, it was the largest dry dock in the world when it was completed on April 1, 1919. Photographed here under construction in 1918, Dry Dock No. 4 allowed the U.S. Navy Yard to build or service ships of any size, proportion or capability. *Courtesy of the Naval History and Heritage Command.*

Although Navy doctors and nurses worked hard to save as many as they could, there was little they could do to stem the tide of the pandemic. By November 1918, more than 40 percent of the Navy's personnel had been infected; 244 died at the hospital, while another 175 died at the NOB.

The rapid expansion of Hampton Roads' naval infrastructure proved invaluable in supporting the Navy's main mission in World War I: to support and protect the transatlantic supply ship convoys from the predations of German U-boats. The people of Hampton Roads, historically accustomed to regional military conflict, now supported America's efforts in a global conflict raging at their very doorstep, as the German U-boats, during both world wars, prowled the Atlantic coastline for prey. Anti-submarine nets were laid at the mouth of Hampton Roads, and destroyers patrolled the local waters for U-boats. Many Hampton Roads–based destroyers either deployed to Europe, like Commander Joseph Taussig's Destroyer Division Eight, or escorted vital convoys of supply ships en route to Europe to support the vast American Expeditionary Forces. Battleship Division Nine also deployed to Scapa Flow to join the massive dreadnought armada of the Royal Navy, although they arrived too late to provide any meaningful aide.

NORFOLK ASCENDANT:
NORFOLK AND THE NAVY IN WORLD WAR II

By the end of the World War I, the destiny of Norfolk had been irrevocably changed. The undeniable weight of naval infrastructure in the form of local shipyards coalesced with the burgeoning Sewell's Point NOB to cement Norfolk's status as the foremost location on the Atlantic coastline for further naval spending and development. The end of World War I marked the beginning of a new era for Norfolk, one that area residents still inhabit; Norfolk became the "Navy's City."

Norfolk's rapid ascent in the realm of naval infrastructure and shipbuilding during World War I was undercut by an initial round of budget cuts to naval spending after the end of the war. As a result, the bustling activity at the Sewell's Point NOB sputtered and stalled to a crawl. However, technological innovations and infrastructure improvements continued, notably in the realm of naval aviation. The Naval Air Station at the NOB hosted a number of important interwar developments, namely the further development of the Navy's aviation branch.

One of the catalysts for the development of naval aviation came from the Army when Brigadier General Billy Mitchell demonstrated, to a number of skeptical and incredulous officials, the portents of the Navy's future in aviation. Concerned with the Navy's obsession with building expensive dreadnought battleships, Mitchell conducted a series of bombing tests on captured German ships from World War I. In dramatic fashion, Army, Navy and Marine bombers sunk the German dreadnought *Ostfriesland* in a series of tests conducted on July 20–21, 1921, as stunned naval officers looked on. Although many in the Navy decried the legitimacy of the tests, the potential offensive power of the airplane was too strong to ignore. In 1920, the Navy approved the conversion of a collier, USS *Jupiter* (AC 3), into the Navy's first aircraft carrier, the USS *Langley* (CV 1). Although ungainly, *Langley* proved a valuable prototype, and soon hundreds of pilots were training in Hampton Roads for naval aviation operations.

Although the *Ostfriesland* test proved a thunderbolt for naval aviation, the overall climate for naval development was significantly curtailed by the Washington Naval Treaty. Signed in 1922 by the United States and other naval powers, the treaty limited the number of ships each nation could include in its battle fleets. This veritable anchor weighed down any shipbuilding efforts and led to the stagnation of the Hampton Roads naval economy, particularly for the Norfolk Navy Yard (the new name was adopted in 1929) and Newport News Shipyard. By 1924, Norfolk Navy Yard's workforce had declined to below 1899 levels, and despite some additional development of the Naval Air Station and the building of a weapons and ammunition depot in Yorktown, naval activity waned in the region.

However, this period of stagnation did not last long, as Norfolk's preeminent status as a Navy hub led the service branch to prioritize the area shipyards for the few contracts that were available. In 1925, Norfolk Navy Yard was awarded a battleship modernization contract, providing a valuable stimulant to the area's economy, while Newport News Shipbuilding was awarded contracts for two cruisers. These contracts kept the area shipyards afloat during the 1920s and into the early days of the Great Depression. In 1933, naval activity in the region received a sudden spike as the importance of aircraft carriers to the future of naval warfare became clear. Hampton Roads was chosen as the location for the Navy's buildup of carriers and the training of air crews. Newport News Shipyard was awarded the contract for USS *Ranger* (CV 4), the Navy's first purpose-built aircraft carrier. After *Ranger* was launched in 1933, contracts quickly followed for USS *Yorktown* (CV 5), USS *Enterprise* (CV 6), USS *Hornet* (CV 8) and the landmark USS *Essex* (CV

This photo, taken during the test by one of the Army planes, captures a near miss as the *Ostfriesland* is helplessly pummeled from the air. Although many naval officers present for the test were still skeptical, the tide shifted in favor of naval aviation, and it was clear that the navy needed to develop naval aviation as an integral component of battle fleets. *Courtesy of the Naval History and Heritage Command.*

9). Newport News Shipyard established itself as the nation's leading builder of aircraft carriers, a legacy that continues to this day.

The Naval Air Station, centered on the small Chambers Field, became one of the global centers of naval aviation training. Norfolk Navy Yard benefited from New Deal programs designed to increase employment, allowing the further modernization of the Navy's destroyers, cruisers and battleships. As the storm clouds of World War II began to darken the global skies, President Franklin Roosevelt petitioned Congress for $1 billion in naval spending. The effect was immediate in Norfolk, as employment doubled at Norfolk Navy Yard in 1938 alone. Contracts for new battleships USS *Alabama* (BB 60) and USS *Indiana* (BB 58) were awarded for Norfolk Navy Yard and Newport News Shipbuilding, respectively, and by 1941 naval economic activity was almost at a wartime level. Hampton Roads became the headquarters for the 125-ship-strong Atlantic Squadron, as the outbreak of World War II in Europe necessitated that the Navy be

prepared for war at a moment's notice. On December 7, 1941, the war readiness of Norfolk and the Navy was put to the test.

World War II was one of the most influential and transformative events in world history, and for Norfolk this was no exception. While every area of the United States transformed to reflect the wartime needs of mass military and industrial mobilization, Norfolk's transformation was among the most keenly felt and among the most logical. In terms of geography, existing naval infrastructure and a vast, preexisting industrial capacity for shipbuilding, Norfolk was an obvious choice for extensive wartime activity and was the culmination of centuries of naval history.

On December 7, 1941, carrier planes from a Japanese strike force launched a surprise attack on the U.S. Navy base at Pearl Harbor, and on December 11, Germany declared war on the United States. In Norfolk, the reaction was immediate. USS *Yorktown* was deployed to the Pacific, Norfolk's defense was made ready, blackout regulations went into effect and suspicious persons were investigated as potential German saboteurs. With Japanese forces far away in the Pacific, the omnipresent threat to Norfolk and Hampton Roads would come from the *Kriegsmarine* and the infamous U-boat menace. Hampton Roads would have to act simultaneously as the center for naval logistics, industry and deployment on the East Coast while also serving as a bulwark against the threat of German U-boats. The people of Hampton Roads found themselves again at the front lines of war, with the Navy playing one of the deadliest games of cat and mouse the world had ever seen in the Battle of the Atlantic.

Admiral Karl Donitz, the commander of Germany's U-boat force, was prepared for this moment. The German navy was already fighting an undeclared war against the U.S. Navy in the months preceding Pearl Harbor, and Donitz was prepared to deploy dozens of U-boats to prowl the East Coast of the United States. Three days prior to Germany's declaration of war, Donitz had received orders to initiate Operation *Paukenschlag* (Drumbeat), the unrestricted targeting of Allied shipping in the Atlantic. The German goal was to stymie, as much as possible, the inevitable flow of supplies, troops and war materiel from the United States to the beleaguered British and Soviet forces fighting the *Wehrmacht* in Europe. If this flow of supplies could be slowed down or even stopped, the German high command reasoned, then Germany could tighten its stranglehold on Europe before American aid could arrive to achieve a meaningful difference. For the Navy, faced with the difficult prospect of deploying millions of Soldiers and shipping tens of thousands of tons of supplies across the Atlantic Ocean, the

U-boat threat had to be neutralized. For the fight in Europe to be won, the Allies had to win the Battle of the Atlantic first.

The U-boats immediately made their presence felt, as U.S. high command made several critical errors. Chief among these mistakes was not organizing ships into convoys, as isolated ships were picked off one by one. On January 12, 1942, the British steamer *Cyclops* was sunk by a U-boat. The oil tanker *Allan Jackson* was next, sunk on January 18, and then the freighters *Ciltavarian* and *City of Atlanta* followed on January 19. German U-boats reaped a grisly toll, as they sunk almost one Allied ship per day. The period between January and April 1942 was referred to as the "Happy Time" by U-boat commanders, and for good reason, as German U-boats sunk eighty-two Allied ships in about four months. The effect on morale was devastating in Norfolk and Hampton Roads as the burning hulls of sinking ships visible from the shoreline became a regular facet of life. Allied high command was equally alarmed, as it was obvious to everyone that their rate of loss was unsustainable.

To counter the effectiveness of the U-boats, the Navy instituted a number of changes. First of all, the convoy system was adopted and instituted in May 1942. With supply ships grouped together and protected by U.S. Navy and Royal Navy escorts, the U-boats found their prey much harder to isolate and bring down. Second of all, a more comprehensive patrol system was instituted, as patrol craft blanketed the East Coast in search of U-boats. Third of all, special hunter-killer groups were formed to combat U-boats, as escort carriers with patrol craft were paired with destroyers armed with depth charges. Hunter-killer groups formed the backbone of the Navy's offensive response to the U-boats, as they were vulnerable to destruction when found. USS *Roper* (DD 147) demonstrated this when it sank *U-85* off the Outer Banks on April 14, 1942. While German U-boats were still effective, Donitz made the decision to end Operation *Paukenschlag* in September 1942 and shift his forces to the North Atlantic, where land-based craft could not patrol. The Battle of the Atlantic raged on until 1944, but the U-boat threat to local waters was functionally over.

While the Navy was learning harsh lessons combating the U-boat threat, the industrial output, infrastructure expansion and training activity in the region began to shift into overdrive. Norfolk and Hampton Roads had always hosted such activity, yet during World War II this increased to an unprecedented level. Both the Norfolk Navy Yard and Newport News Shipyard rapidly expanded to meet wartime industrial needs, with the former doubling in size during the war; 101 ships were built at the Norfolk Naval

Shipyard during the war—including the battleship USS *Alabama* (BB 60), and the carriers *Shangri-La* (CV 38), *Lake Champlain* (CV 39) and *Tarawa* (CV 40)—all while the shipyard repaired and serviced an additional 6,850 ships. Accordingly, the yard's workforce expanded to meet the incredible demands of the wartime economy, going from about 7,600 workers in 1939 to more than 42,000 by February 1943. Newport News Shipbuilding mirrored this stunning productivity, delivering a mind-boggling eight carriers in twenty-seven months during the war, including the USS *Essex* (CV 9).

Naval infrastructure in the region similarly expanded to meet the immense needs of the Navy. The NOB alone expanded from a prewar size of 945 acres and 472 buildings to more than 3,500 acres with 2,300 buildings. In particular, the NOB served as one of the chief supply depots on the entire East Coast, adding more than five million square feet of storage space to the Naval Supply Depot during the war. The Naval Air Station, one of the few robust interwar investments, rapidly expanded to become one of the largest air bases in the entire world, serving as the Navy's primary aviation headquarters, supply depot, patrol station and training center. Naval Air Force, Atlantic Fleet, was formed and headquartered at the NAS, with its primary mission to train and deploy pilots for all theaters of war. Naval aviation activity expanded to outlying auxiliary sites in Virginia and North Carolina, chief among them the facilities built at Oceana. Other facilities were built to support various Navy ratings, with the most notable among the facilities at Little Creek in Virginia Beach. Camp Bradford at Little Creek became a location for amphibious warfare training, with more than 100,000 Soldiers and Sailors trained at the base during the war. Other schools at Little Creek were created, and by the middle of the war, Little Creek was among the busiest locations in Hampton Roads. More than 360,000 Soldiers, Sailors and Marines trained at Little Creek bases during the war, and they were later combined to form what is today the Naval Amphibious Base.

Norfolk also served as a keystone port of embarkation for American forces, ranking only behind New York and San Francisco in tonnage shipped overseas. The most important day for Norfolk and Hampton Roads as an embarkation point occurred on October 24, 1942, when the largest transoceanic invasion in world history occurred, Operation Torch. In accordance with Allied grand strategy, Operation Torch was the invasion of Axis-occupied North Africa, with the goal of penetrating what Winston Churchill allegedly deemed the "soft underbelly" of Axis territory. To do this, hundreds of ships and tens of thousands of Soldiers were massed in Norfolk. Preparing for the invasion was a massive undertaking, as one of the

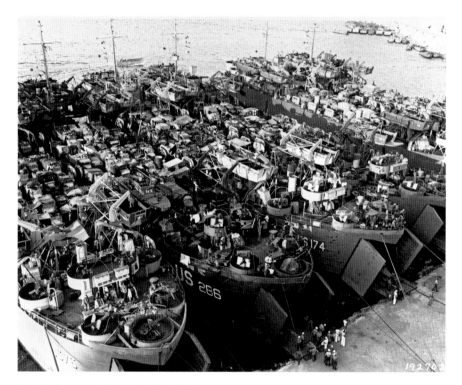

In this photo, tank landing ships (LSTs) are prepared for Operation Dragoon, the invasion of southern France, in Bagnoli, Italy, on August 8, 1944. LSTs were one of the many types of ships built in Hampton Roads during World War II. *Courtesy of the National Archives and Records Administration.*

largest concentrations of military might in American history was prepared for the daring transatlantic invasion. These forces, in conjunction with their British allies, successfully invaded Vichy French–occupied Morocco and Algeria in November 1942, marking the gradual rolling back and defeat of Axis forces in Europe.

As the people of Norfolk and the world celebrated the end of World War II on August 15, 1945, the profound changes to Norfolk during the war were revealed in stark relief. Never before had naval activity been conducted so rapidly on such a massive scale as it had in Hampton Roads during World War II. And contrary to what had occurred in prior conflicts, the effects of these activities were cemented and lasting, as the United States assumed the role as the global bastion of capitalism and democracy in the postwar world. And Norfolk's role in this postwar world was obvious to everyone.

Norfolk, from the very beginning, was inextricably linked to the tides of maritime commerce, activity and warfare that invariably flowed

throughout history. And in this complex arrangement, so too ebbed and flowed Norfolk's fortunes as a maritime community. The very waters that enabled prosperous commerce facilitated the arrival of the destructive chaos of warfare, from the American Revolution all the way to predations of German U-boats. This discordant relationship between prosperity and war established the partnership between the Navy and Norfolk that continues to this day. The people of Norfolk and the United States learned the harsh lessons that only history can teach: economic prosperity and maritime communities had to be protected, and to do this, power had to be projected. Operation Torch was the sea change moment in Norfolk's history, the ultimate validation of Norfolk's metamorphosis. Once the vulnerable target of Dutch raiders in the 1600s, Norfolk, in less than four hundred years, transformed into the port of embarkation for the largest projection of transoceanic power in world history. Norfolk, from that moment on, was never again a soft target. Norfolk was the Navy's City, and it remains that way to this day.[22]

SITE GUIDE

The Battleship *Wisconsin*
One Waterside Drive, Norfolk, VA 23510
Admission Fee/Guided Tours

Situated in the heart of downtown Norfolk's historic waterfront, the USS *Wisconsin* (BB-64) is an iconic component of Norfolk's historical landscape. Earning five battle stars through service in World War II, the Korean War and the Persian Gulf War, the Iowa-class battleship is a storied warship ideal for visitation by any lover of naval or military history. *Wisconsin*, placed in the naval reserve fleet, arrived behind the Nauticus building on December 7, 2000, and was opened to the public on April 16, 2001.

Originally operated by Hampton Roads Naval Museum, USS *Wisconsin* was struck from the Naval Reserve Fleet and officially made into a museum ship. On December 14, 2009, the Navy officially transferred *Wisconsin*'s stewardship to the City of Norfolk, and Nauticus took over operations.

Wisconsin is surrounded by Wisconsin Square, a free area around the ship that is a perfect spot to take photos or read more about the iconic ship. *Wisconsin* is open for tours of both the exterior decks and interior spaces of the ship and is accessed through the Nauticus building.

Wardrooms, berthing areas, the inside of Turret 1 and the bridge are just some of the areas available to tour through either standard admission or a premium guided tour. Note that some areas of the ship are only accessible by guided tour.

Nauticus

One Waterside Drive, Norfolk, VA 23510
(757) 664-1000 / https://nauticus.org
Admission Fee

Alongside the battleship *Wisconsin* is Nauticus, a museum and science center focused on military, maritime and natural history. Suitable for audiences of all ages, the family-friendly museum was opened to the public in June 1994. Ever since then, Nauticus has delighted visitors with a variety of exhibits and experiences.

Adding the *Wisconsin* in 2001 and the Half Moone Cruise and Celebration Center in 2007, as well as hosting Hampton Roads Naval Museum since opening in 1994, Nauticus offers something for everyone to do. Nauticus comprises three floors, with Hampton Roads Naval Museum and entrance to the *Wisconsin* located on the second floor and a theater and exhibit gallery on the third floor. Guests can engage with a variety of history- and science-based exhibits, such as a horseshoe crab touch tank, a shark lab, science on a sphere, a weather station, USS *Wisconsin* artifacts and an interactive ship bridge.

Hampton Roads Naval Museum

One Waterside Drive, Norfolk, VA 23510
(757) 322-2987 / https://www.history.navy.mil/content/history/museums/hrnm.html
Free Admission

Located on the second floor of Nauticus, Hampton Roads Naval Museum (HRNM) is a free Navy-operated museum that focuses on the Navy's many activities and contributions to local history. Originally located at Naval Station Norfolk in the historic Pennsylvania House, HRNM relocated to the Nauticus building in 1994, operating the *Wisconsin* until 2009. The second-floor gallery offers an overview of U.S. Navy History in Hampton Roads and

beyond. Accredited by the American Alliance of Museums in 2008, HRNM is the perfect place for military history buffs and the casually interested alike.

The HRNM gallery hosts many rotating exhibits, including a special exhibit on the Navy in the Vietnam War and the Confederate commerce raider CSS *Florida*. Other items on exhibit include artifacts from the USS *Cumberland* and USS *Monitor* from the Civil War era and an eighteen-pounder naval cannon. HRNM also provides free military ceremonies, educational programs and docent-led tours.

Portsmouth Naval Shipyard Museum and the Lightship Portsmouth Museum

2 High Street, Portsmouth, VA 23704
(757) 393-8591 / https://portsmouthnavalshipyardmuseum.com
Admission Fee

Across the Elizabeth River and located in Portsmouth, the Portsmouth Naval Shipyard Museum covers more than 250 years of Portsmouth's military and maritime history. In particular, the museum focuses on the history of the Norfolk Naval Shipyard, America's oldest and most storied shipyard. Visitors can look forward to experiencing the venerable history of the Norfolk Naval Shipyard through ships models, uniforms, artifacts and various exhibits.

The museum also operates the Lightship Portsmouth Museum. Lightship LV-101 (renamed *Portsmouth*) served for forty-eight years off the coasts of Virginia, Delaware and Massachusetts, essentially acting as a mobile lighthouse, protecting incoming ships from dangerous shoals and safely guiding them into harbors. Lightship LV-101 retired from service in 1964 and is now open as a museum ship for interested visitors.

Fort Norfolk

801 Front Street, Norfolk, VA 23510
(757) 754-2004 / https://www.virginia.org/Listings/HistoricSites/FortNorfolk
Free Admission / Free and Guided Tours

Fort Norfolk, one of the oldest fortifications in the United States, is free and open to the public for tours. Located in historic Ghent, Fort Norfolk stands as a surviving example of Norfolk's historic defenses. Operated by the Army Corps of Engineers, Fort Norfolk was built in 1795 as a part of George

Washington's first system of coastal defenses. Serving in this capacity during the War of 1812 and held by both Union and Confederate troops during the Civil War, Fort Norfolk includes earthen embankments, a dungeon, officers' quarters and a barracks. Fort Norfolk is open to the public for self-guided tours, with free guided tours offered every Sunday from noon to 4:00 p.m. from June 23 to September 29.

Victory Rover Naval Base Cruise
One Waterside Drive, Norfolk, VA 23510
(757) 627-7406 / https://www.navalbasecruises.com
Tour Fee

One of the best ways to experience the world's largest naval base, Naval Station Norfolk, is to book a cruise with the *Victory Rover*. The two-hour narrated naval base cruise is a comfortable and accessible way to see the destroyers, cruisers and carriers of the American fleet from the water. The climate-controlled vessel can accommodate 149 guests and includes an open-air top deck, restrooms, snacks, ship store and bar.

Naval Station Norfolk Bus Tour
9079 Hampton Boulevard, Norfolk, VA 23505
(757) 444-7955 / https://www.cnic.navy.mil/regions/cnrma/installations/ns_norfolk/about/installation_guide/visitor_information.html
Tour Fee

The Navy, in association with Tidewater Tours, offers guided bus tours of Naval Station Norfolk. Conducted by naval personnel, the bus tours are the only way for members of the general public to see inside the world's largest naval base. Interested visitors may book their tickets ahead of time or purchase them at the Naval Station Norfolk Tour & Information Center. These forty-five-minute bus tours are offered year-round and depart directly from the Information Center. Although photography is prohibited, guests can look forward to seeing a variety of historic sites and ships on base, such as aircraft carriers, destroyers and historic homes from the Jamestown Exposition.

The Armed Forces Memorial
Towne Point Park, Norfolk, VA 23510

The Armed Forces Memorial is a 160-foot monument plaza with twenty bronze letters placed around the base of a flagpole. Erected and dedicated in 1998, the goal of the memorial is to highlight the voices of veterans who never returned from war, as the bronze letters bear the actual words of veterans from letters they sent home. Designed by James Cutler and Maggie Smith, the memorial is a must visit for any visitor looking for a quiet place to reflect.

The Lone Sailor
Wisconsin Square, Norfolk, VA 23510

The Lone Sailor is a life-size cast-bronze statue of a Sailor and his duffel bag. Standing vigil over USS *Wisconsin*, *The Lone Sailor* represents all of the men and women who have served, are serving and will serve in the U.S. Navy. Sculpted by Stanley Bleifeld, Norfolk's *Lone Sailor* is a copy of the original, which stands at the Navy Memorial in Washington, D.C. *The Lone Sailor* is surrounded by a small memorial plaza with eight commemorative plaques, highlighting the stories of eight Norfolk ships beset by tragedy. The bell from the USS *Norfolk* (DL-1) is also located in the plaza.

USS *Intrepid* (CV-11) Propeller
Across from Sarah Constant Beach Park, 300 West Ocean View Avenue, Norfolk, VA 23510

Located in historic Ocean View, the USS *Intrepid* propeller stands as a tangible connection to the region's naval past. One of twenty-four Essex-class carriers built during and after World War II, USS *Intrepid* is one of the most storied warships in American history. Known as "The Fighting I," *Intrepid* admirably served for more than thirty years before becoming a museum ship located in New York City.

Landing of Wool Marker
Next to Sarah Constant Beach Park, 300 West Ocean View Avenue, Norfolk, VA 23510

This historic marker commemorates the landing of Union forces, by the order of President Lincoln and under the command of General John Wool, at Ocean View Beach on May 10, 1862. Norfolk was taken by Union forces later that afternoon.

Birthplace of Naval Aviation Marker
West Ocean View Avenue at Rallston Street, Norfolk, VA 23503

This sign marks the landing location of Eugene Ely's historic November 14, 1910 flight from the deck of USS *Birmingham*. Piloting a Curtis biplane, Ely flew two miles before landing on the beach of Willoughby Spit, becoming the first person ever to pilot and land a plane after taking off from a ship.

Operation Torch Marker
Sarah Constant Beach Park, 300 West Ocean View Avenue, Norfolk, VA 23510

During the winter and spring of 1942, Operation Torch, the Allied invasion of Axis-occupied North Africa, was planned at the Nansemond Hotel in Ocean View. This historic marker commemorates the planning of the transatlantic invasion and the eventual success of the operation after the invasion departed Hampton Roads.

Camp Talbot Marker
Granby Street at Oak Grove Road, Norfolk, VA 23505

Talbot Park, now a residential neighborhood, was the site of a Confederate camp during the American Civil War.

Fort Tar Marker
Monticello Avenue at Ninth Street, Norfolk, VA 23510

This sign marks the location of Fort Tar, part of Norfolk's early defenses. During the War of 1812, it was manned by members of the Virginia militia.

Light Artillery Blues Marker
Highland Park, Norfolk, VA 23508

One of Norfolk's storied military units is the Light Artillery Blues, serving in Civil War on the side of the Confederates as well as in World War I and II. The location of its armory from 1916 to 1961 is marked by this sign near the campus of Old Dominion University.

Craney Island Marker
Fairfax Avenue, Norfolk, VA 23507

The Battle of Craney Island was an important victory over British forces at the hands of the U.S. Navy and Virginia militia during the War of 1812. This marker, placed near Fort Norfolk, commemorates the repulse of this British attack.

Tripoli Street Marker
Monticello Avenue, Norfolk, VA 23510

This marker commemorates the original name of Monticello Avenue; Tripoli Street was named in honor of Commodore Stephen Decatur's famous action in the Barbary Wars.

Confederate Defense Line Marker
Princess Anne Road, Norfolk, VA 23502

A line of Confederate breastworks guarded one of the roads into Norfolk during the Civil War. This sign marks the location of this defensive line, which was abandoned when Union forces marched on the city.

Half-Moon Fort Marker
Town Point Park, Norfolk, VA 23510

This sign marks the construction of a fort in the 1670s to defend the early English colony in Virginia from hostile raiders. Shaped like a half-moon, the fort predated the establishment of the town of Norfolk.

DEPARTMENT OF DEFENSE (DOD) COMMON ACCESS CARD REQUIRED

The following locations are accessible only with a Common Access Card (CAC), as they are behind the gates of DoD installations. All are free to visit.

USS *Iowa* Memorial

Massey Hughes Drive, Naval Station Norfolk, Norfolk, VA 23503

On April 19, 1989, an explosion in the no. 2 sixteen-inch turret of USS *Iowa* (BB 61) claimed the lives of forty-seven Sailors. A small memorial looking out to Hampton Roads commemorates this loss of life.

USS *Cole* Memorial

Massey Hughes Drive, Naval Station Norfolk, Norfolk, VA 23503

On October 12, 2000, USS *Cole* (DDG-67) was attacked in Aden, Yemen, by suicide bombers from the extremist group Al-Qaeda. The bombing ripped a forty-by-sixty-foot hole in the port side of the ship, killing seventeen Sailors and wounding thirty-nine. Dedicated one year later on October 12, 2001, the USS *Cole* Memorial consists of three plaques and a memorial plaza.

Virginia and the *Monitor* Marker

Massey Hughes Drive, Naval Station Norfolk, Norfolk, VA 23503

This sign commemorates the Battle of Hampton Roads, the first battle between ironclad ships in world history. Fought on March 8–9, 1862, the famous duel of the ironclads during the American Civil War signified a radical change in naval technology, heralding a new age of iron for the fleets of the world.

Jamestown Exposition Homes

Dillingham Boulevard and Powhatan Street, Naval Station Norfolk, Norfolk, VA 23511

These historic homes were originally erected in 1906–7 for the Jamestown Exposition, which commemorated the 300th anniversary of the founding of the Jamestown settlement. Though a financial failure, Sewell's Point, the site of the Jamestown Exposition, was chosen as the location for what would become Naval Station Norfolk. The homes bear the names of individual states, such as the Pennsylvania House, and stand as beautiful examples of turn-of-the-century architecture.

McClure Field

Naval Station Norfolk, 440–444 Pocahontas Street, Norfolk, VA 23511

Where did baseball greats such as Bob Feller, Pee Wee Reese, Dom DiMaggio and Phil Rizzuto play ball while they were in the Navy? Why McClure Field, of course. America's second-oldest baseball stadium was erected in 1918 and was the site of a series of games in September 1943 between mixed teams of professional and regular Sailors. Unfortunately for members of the general public, only active-duty Sailors witnessed the epic seven-game series.

Ely Memorial Park

Naval Station Norfolk, 298 West Bay Avenue, Norfolk, VA 23503

This small memorial park commemorates all those who have lost their lives in aviation operations in the area. Eugene Ely, the first person to take off and land a shipboard plane, lost his life on October 19, 1911, in a flying accident in Macon, Georgia. The various aircraft located in the park stand in quiet vigilance for Ely and all of the other aviators who died while serving their country.

U.S. Submarine Veterans World War II Memorial

Naval Station Norfolk, C Street, Norfolk, VA 23511

Dedicated to the Navy submariners who died while serving in World War II, the Submarine Veterans Memorial includes a memorial plaque, an anchor and the bell from USS *Sea Cat* (SS-399).

Portsmouth Naval Hospital

Navy Medical Center Portsmouth, Building 1, 620 John Paul Jones Circle, Portsmouth, VA 23708

Built in 1827, the original building, known as the Portsmouth Naval Hospital, is still active today as an administrative support building for the larger hospital complex. Designed by John Haviland, the building stands as a striking example of historic architecture. (The interior of the building is *not* accessible unless on official business.)

Trophy Park

Norfolk Naval Shipyard, Barron Street, Portsmouth, VA 23704

Trophy Park is home to dozens of large historical artifacts on display in the park. Anchors, cannons, missile launchers and even iron plates from the CSS *Virginia* stand as representatives of Norfolk Naval Shipyard's storied place in Navy history.

Chapter 4

NEW ENERGY OF NORFOLK
ARTS AND THE NEON DISTRICT

Rachel McCall

INTRODUCTION

Although only christened the NEON District relatively recently, the area at the intersection of Ghent and downtown Norfolk has been a pivotal area of growth, development and renewal since the city's founding. As downtown has expanded and contracted through urban trends seen across the United States, so too has NEON borne witness to ever-changing times for city-dwellers. Its current rebirth is the result of careful planning, a new era of downtown expansion, grass-roots demand for an arts district and a renewal of creative energy in the city. In fact, the NEON name itself is an homage to that spark, an acronym for the "New Energy of Norfolk," dreamed up by a group of local artists.

Hundreds of years before the neighborhood became known as an art center, it was farmland sitting just outside the original township on the edge of Smith Creek, a body of water now known as "the Hague." The area had been used as protection for the young town, with Fort Tar built as a bastion against British armies during the War of 1812. Today, all that remains of the fort is a historic marker on Monticello Avenue and a short lane bearing its name. As Norfolk's population steadily rose through the early to mid-nineteenth century, the northern farmlands saw construction of a cotton factory (near current-day Olney Road) and the beginnings of working-class housing. In 1845, Norfolk annexed this region and established a city property, encompassing roughly 1.3 square miles and ten thousand people. The future NEON District was now a part of Norfolk, dense with housing for the poor

and middle classes, a main thoroughfare in the extension of Granby Street northward and ultimately poised for reconstruction after the Civil War.

The neighborhood's first era of significance transpired early in the twentieth century, arriving with that quintessential invention of the modern age: the automobile. The production, sale and maintenance of automobiles became the driving factor in real estate development of the NEON District. Downtown had outgrown itself. New high-rise buildings dotted Norfolk's skyline, and larger lots and affordable prices beckoned across Queen Street (now Brambleton Avenue). Real estate speculators took notice and began buying up significant sections of the area around Granby Street, Queen and James (now Monticello Avenue), rumored to be the site of a new and very large public building constructed by the city.[23] Wealthy Norfolk business owners began snapping up investment properties. Showrooms and warehouses for newly minted automobiles started to replace residential dwellings. The commercial growth was in such abundance that by 1914, local newspapers were declaring that "Granby Street Has Grown in a Marvelous Manner."[24] Norfolk's central spine was expanding north, and side streets were extended, connecting downtown to popular neighborhoods like Ghent, Colonial Place, Park Place, Larchmont, Edgewater and Lochhaven. The city's investment in new infrastructure for Granby Street—concrete power poles, streetlights, sidewalks and granite curbs—quickly paid off, with the highest land values assessed on Granby's commercial corridor. From Queen Street to Fifteenth Street, the newly anointed "White Way" would prove to be a dense and thriving business district.

During this period of rapid growth, dozens of buildings were constructed, most related to the service or sales of automobiles. Norfolk's Auto Row was born and would be the home to all things vehicular for decades. By and large, the buildings were one- to two-story brick or concrete block, with large front windows and flat or sloped roofs. Primarily, two architectural firms were responsible: Wickham C. Taylor (1880–1963) and Neff & Thompson (1910–31). Gradually, the small storefront buildings evolved into larger structures that could house independent car manufacturing companies and local repair shops and vehicle retailers. The real estate and auto booms were such that even the Texas Company couldn't resist, purchasing $1,000 per linear foot of frontage for its new headquarters at the corner of Granby Street and Olney Road, cementing "the automobile invasion."[25] The new Texaco building would be a shining star of Auto Row, a handsome three-story brick office building with a regional sales department, accounting staff and a full-service station on the first floor.

The auto industry was so deeply tied to the neighborhood that at one time or another, every parcel in the 700 block of Granby Street contained a business related to automobiles.[26] Many of these pre–World War II buildings have survived along the 700 and 800 blocks, creating a walkable and captivating path up Granby Street. The vestiges of car life can still be seen throughout the neighborhood, in the large storefront windows that displayed the latest of each make and model, the long and wide commercial spaces that could accommodate repair shops and the roll-up garage doors that dot alleyways for easy access. It's not hard to picture bustling Norfolk streets filled with delivery trucks, shiny new automobiles, sharply dressed business owners, tire salesmen and uniformed service station attendants, all zooming along together.

Although the automobile was the all-important driving influence in the neighborhood's development, two factors contributed to establishing a connection to arts and culture. Auto Row's proximity to the prestigious and affluent Ghent neighborhood would provide the investment to create an arts institution, while the infill of Smith Creek would provide the necessary real estate. As the city grew, the omnipresent creeks, marshes and waterways of historic Norfolk were standing in the way of progress. What had long been an asset to the northern part of downtown, Smith (or Paradise) Creek was now hindering connections and expansions to outlying neighborhoods. By 1928, the marshlands had been reformed into a semicircular bulkhead for the stately homes on what was now christened "the Hague," while the eastern edges of the creek were filled in and paved to extend Olney Road. Nestled between the two sits Chrysler Museum of Art, constructed in 1933 as the Norfolk Museum of Arts and Sciences on what had been Lee Park, a scenic escape from the city looking out on the Hague bridge. The creation of an arts collection for the city's population to enjoy would ultimately inform the reinvention of the district decades ahead.

From the beginning of the new century until World War II, Norfolk experienced a booming city life—Sailors flooding the port, shopkeepers hawking the latest trends and pedestrians, streetcars and automobiles alike sharing Granby Street. But after the war, seeds of urban renewal began to change Norfolk's landscape. Auto dealers and repair shops began to move outward to Military Highway and Virginia Beach Boulevard for larger lots and easier access to new highways. Legislation cleared the way for low-cost, subsidized public housing to replace the slums surrounding downtown in neighborhoods like East Ghent, Brambleton and Atlantic City. Historic and architecturally significant buildings downtown were condemned. As a city, Norfolk led the way in a massive urban redevelopment program,

clearing hundreds of acres in the downtown commercial district and adjacent neighborhoods and displacing deeply rooted African American and working-class populations. Auto Row was no exception, with more than five acres cleared to make way for the Golden Triangle Motor Hotel, constructed as the ultimate in lodging for automobile travel in 1961.[27] Across Brambleton Avenue, the city invested heavily in two massive concrete palaces of entertainment, Scope Arena and Chrysler Hall, designed to anchor the northern edge of downtown. The shift away from historic, human-scaled architecture was palpable and would inform downtown and NEON's development for decades.

For the most part, Auto Row's redevelopment skirted the edges of the district through and after urban renewal efforts. Granby Street's historic corridor between Brambleton Avenue and Virginia Beach Boulevard remains relatively intact, with many buildings still dating to the early and mid-twentieth century. Postwar construction in the International and Commercial styles tends to be found on the perimeters, closer to the boulevards leading into downtown. Into the 1970s and 1980s, some of the large showrooms and warehouses from Auto Row's heyday found useful life again as furniture stores, a pawn shop and a florist, but many fell into disrepair, vacated and disconnected from the rest of downtown's commercial center by fast-moving Brambleton Avenue. It would take a rising tide of creativity, reinvestment and legislation to transform the area into Norfolk's first officially designated arts district.

Across the country, urban centers were making a comeback, and the arts were seen as an essential revitalization tool. Cultural facilities, public art and creative programming have proven a boon to urban areas, attracting tourists and residents, beautifying blighted areas, enhancing property values, drawing a well-educated workforce and overall contributing to a vibrant and innovative environment.[28] Throughout the 1990s and early 2000s, community leaders reinvested heavily into downtown Norfolk, bringing back residents, creating destinations for visitors, improving and beautifying the streetscape and introducing a number of legislative and economic efforts that would pave the way for a new downtown. Already seen as the cultural center of the region, early efforts focused on creating an arts or theater district in the core of downtown due to its existing historic theaters and several new arts facilities. Gradually, that was superseded by overall placemaking efforts, and attention shifted north of Brambleton Avenue, with the remaining section of downtown still in dire need of attention and reinvestment.

In 2009, the Virginia General Assembly enabled all Virginia localities to create arts and cultural districts, aligning locally with Norfolk's arts and

economic development strategies.[29] With that change, cities could now incentivize and provide the flexible support needed for arts businesses and organizations. Meanwhile, grass-roots efforts were percolating, as the younger demographic of Norfolk sought a local creative community. North of Brambleton Avenue, some artists and makers had already moved into the neighborhood. One of the first was Old Dominion University's alumni and faculty art gallery, which operated an exhibition space at 765 Granby Street from 1973 to 1998.[30] The Jaffe Arts Center also ran art exhibitions and poetry nights at 737 Granby Street. On the next block, at 810 Granby, young designers and fabricators set up a collaborative studio and workspace, the raw warehouse perfect for metal and woodworking. The proximity to downtown, affordable lease rates and historic shops and warehouses would prove the right fit for a creative class needing a home.

At the same time, two inspired young writers found themselves combating brain drain, needing a creative outlet and looking for ways to engage in the city. Hannah Serrano and Jesse Scaccia would lead the charge to create a place for arts, giving it a voice through their work at the digital alternative news publication *AltDaily*. They submitted The N.E.A.D. Project (Norfolk Emerging Arts District) to city leaders in 2012, sparking the vision of an arts district driven from the ground up. Combined with top-down zoning changes that allowed for new arts uses in the neighborhood, the efforts met in the middle. City leadership hired Texas urban planners Team Better Block to oversee a rapid-fire revitalization effort over a weekend in April 2013 to put real-world place- and arts-making efforts into practice, "spurring a broader conversation about what an arts district should be."[31] Dozens of volunteers built temporary stages, filled vacant storefronts with pop-up shops and cafés, striped temporary bike lanes and painted murals in a few short days. Hundreds of visitors turned out in what would become a seminal moment in the NEON District's history, showcasing the dream of a vibrant, bustling, creative neighborhood, with many of the original Better Block participants, volunteers and artists still tied to the present-day NEON community.

Once the vision was realized, it did not take long for development to follow. As with the real estate boom generated by the automobile industry a century before, investors quickly realized the potential of the neighborhood once again. Historic properties that had lain vacant for years finally found buyers. Arts patrons began to see opportunities in co-locating creative businesses near Chrysler Museum and Harrison Opera House. New arts collective Alchemy NFK put its stake in the ground. Renowned children's theater troupe Hurrah Players found a new location for its scene shop and a

black box theater. A café dubbed The Parlor made plans to showcase local artists and musicians.[32] The city followed suit, holding public meetings to guide next steps and advancing the nomination of the neighborhood for historic status. In 2014, Norfolk Auto Row Historic District was listed in the National Register of Historic Places for its significance in Norfolk's automobile industry, creating tax incentives that would prove essential for the neighborhood's redevelopment of historic buildings. Perhaps most notably, this enabled renovation of the former Texaco headquarters at Granby and Olney into a radiant example of arts, entertainment, dining and residential uses combined in one historic building.

As efforts coalesced into a place and a feeling, the district needed a name to fit this new mood. Over months of debate in 2014 with local artists, a downtown design agency, neighborhood businesses and city leaders, the charge of electricity behind the arts district morphed into the moniker the "New Energy of Norfolk," or NEON. The name harkened back to Granby's golden age under neon lights and marquees while speaking to the bright future propelled by Norfolk's youth. The collective vision was handed to downtown's place managers, the Downtown Norfolk Council, to execute and move forward. In less than eighteen months, the NEON District had been fully realized, with a managing body and a passionate cadre of performing and visual artists moving in, raising funds and physically transforming the neighborhood. That behind-the-scenes assistance paved the way to bring in the first muralists to the district, Nick Kuszyk and Hamilton Glass, painting like mad to finish two large walls before hordes of visitors arrived for the reopening of the Chrysler Museum of Art and Glass Studio in May 2014.[33]

Those murals would be the beginning of a large and varied public art collection, from street art to large-scale sculpture to a resurgence of neon signage. Grass-roots efforts now focused on identifying walls and connecting property owners with young artists ready to work. Taking cues from Hampton Roads, The Canvas—a project aiming to cover the region's abandoned buildings with art—the NEON's art committee inventoried every possible location in the district and went door to door, asking for permission to paint. After the success of the Bob's Gun Shop mural by Nick Kuszyk, local organizers understood how much a large and colorful mural could change the perception of a place. An open call for large-scale 2D and 3D projects to be revealed in the fall at the first-ever neighborhood arts festival galvanized the local artist community and led to a rush of projects in 2015. That summer and fall, more than twenty-eight art pieces were created in advance of the first NEON Festival. Three major murals were added:

We Can Create What We Can Imagine, *New Energy of Norfolk* and *Bloom*. They were the first murals to combine painted exterior walls with glass, light or projection elements, pairing together teams of artists specialized in each medium, and subsequently set a high bar of creativity for years to come.

The neighborhood was also changing from the inside out. Beyond paint on the walls, new business growth simmered and mixed with legacy retailers like Virginia Furniture, Bress Pawn and Norfolk Printing Company. As with neon art, the old influenced the new, shaping the neighborhood's community. Art patrons Brother and Meredith Rutter changed the scene with the creation of Work|Release, a gallery like none other that intermingled club kids, serious artists and art collectors on a nightly basis. From its inaugural neon show that opened the gallery in April 2015 to the last exhibition in 2017, Work|Release embodied what the NEON District's planners and dreamers had hoped the area would be. It was a magnet for other businesses hoping to draw a similar crowd: the first coffeeshop, a comedy theater, a skate shop, a glass art gallery and more. All felt the lure of NEON's creative drive and gritty, urban atmosphere.

As the neighborhood settled into the regular ups and downs of urban development, the NEON District found itself in good company throughout coastal Virginia. Arts districts were founded in Virginia Beach, Williamsburg, Portsmouth, Suffolk and the Eastern Shore. Murals have proliferated. Art and entertainment happenings pop up weekly, monthly and seasonally. Artists and entrepreneurs lease new spaces. The economic benefits of creative placemaking are now without question and so bring about a return to residential growth. The first new dwellings built in more than a century now commit to bring hundreds of people to walk among the historic streets of Auto Row. The storied newspaper headquarters of the *Virginian-Pilot*, which changed the course of the neighborhood's development in 1937, now beckons to residents wishing to live among the art and history in NEON.[34] Early promises of development are ensured with plans to improve Granby Street once again. What cemented Norfolk's northward growth in the early part of the twentieth century is still the same: lights, sidewalks, safe and interesting places to congregate and beauty in the infrastructure of a neighborhood. Each year adds another artwork, perhaps a business folds and a new one takes its place, new artists make their mark and a festival sparks a few new ideas. An industry no longer drives the place forward; instead, people do—living, creating, collaborating and discovering one another and their passion for a place.

SITE GUIDE

Chrysler Museum and Glass Studio

One Memorial Place, Norfolk, VA 23510
(757) 664-6200 / www.chrysler.org
Free Admission

Perched on the shores of the Hague in Ghent and flanked by the NEON District, the Chrysler Museum of Art was founded in 1933 as the Norfolk Museum of Arts and Sciences. The collection has its roots in a passion for the arts shared by two educators who arrived in Norfolk in 1871, Irene Leache and Anna Wood. The women hosted poetry readings, founded a seminary and began to piece together an arts foundation for their adopted city. The library dedicated to Irene Leache's memory would lead in 1917 to the creation of the Norfolk Society of Arts, whose primarily female membership successfully campaigned for the city to donate land for the first art museum in Norfolk. The new museum would be constructed on the grounds of Lee Park in the Italian Renaissance style and designed by both the architectural firms of Peebles and Ferguson and Calrow, Browne and FitzGibbon.[35]

The arts, sciences and history collection steadily grew from local contributions until a monumental gift in 1971 from Walter P. Chrysler

Chrysler Museum and Glass Studio. *Courtesy of the Sargeant Memorial Collection, Norfolk Public Library.*

Jr. ultimately changed the museum's course. The heir of the Chrysler automobile fortune and a devoted art collector, Chrysler during World War II was stationed in Norfolk, where he met and married his second wife, a local teacher named Jean Outland. The couple amassed a significant art collection, focusing largely on twentieth-century art, American and old master paintings, sculpture and glass, with particular attention paid to pieces produced by Louis Comfort Tiffany.[36] When searching for a permanent home for the collection after outgrowing the first location in Provincetown, Massachusetts, Jean steered Chrysler to her hometown of Norfolk. The city happily accepted their generous gift, constructing a new wing and renaming the museum in their honor.

Now encompassing fifty galleries, more than thirty thousand art objects, gardens, a café, a historic home and the Jean Outland Chrysler Library, the Chrysler Museum of Art is one of the finest art institutions on the Eastern Seaboard. It is complemented by the Perry Glass Studio, a cornerstone of the NEON District that opened to the public in 2011. Within a former bank building across the street from the central museum, the studio brings to life glass art with daily glass blowing demonstrations, live performances, classes for all levels, visiting artist series and a studio assistantship program. The last museum renovation added significant space for the glass collection, which combined with the Glass Studio's reputation for innovation and performance have elevated the Chrysler and Norfolk into one of the glass centers of the world. After a two-year closure, the museum celebrated the 2014 reopening in grand style, bringing Florentijn Hofman's massive inflatable *Rubber Duck* to float placidly on the Hague, smiling at the thousands of new and returning museum visitors.[37] The staff, visiting artists and creative community the Chrysler draws make it an essential part of Norfolk culture, just as Irene Leache and Anna Wood so desired—always free and always changing.

Harrison Opera House

160 West Virginia Beach Boulevard, Norfolk, VA 23510
(757) 664-6464 / www.sevenvenues.com/venues/detail/harrison-opera-house,
www.vaopera.org
Admission Fee

The Norfolk home of Virginia Opera, and a municipal performing arts venue, the Harrison Opera House, through various incarnations, has been

entertaining Norfolkians since World War II. The postmodern façade looks out to the west and the Chrysler Museum of Art, while the original, rear façade faces Granby Street. The building on the northern edge of the NEON District was constructed in 1944 as the Center Theater to serve as an Army and Navy USO for the vast military population now residing in Norfolk. With funding allocated by the city and the Federal War Fund, well-known local architects Clarence Neff and David Fitz-Gibbon designed the Moderne/International-style building to house a 3,000-seat auditorium and sports arena and a 1,800-person theater.[38] Over the next three decades, Norfolk's main theater space would host anything and everything from wrestling matches to high school graduations, William & Mary basketball games and, even once, Elvis Presley.

As the multifunctioning space fell into gradual disuse due to the construction of nearby Norfolk Scope and Chrysler Hall in the 1970s, bulldozers threatened. One woman carried the torch for music in Norfolk. Edythe C. Harrison, a lifelong opera fan, rallied fellow aficionados and performers to bring opera to the Center Theater in 1974 as the founding home of Virginia Opera.[39] Her work continued throughout an extensive renovation that created a lavish setting for arias: a grand three-story lobby, crystal chandeliers, sweeping staircases and a new façade facing Llewellyn Avenue. The old gymnasium and auditorium were converted for back-of-the-house operations and Virginia Opera offices. Unveiled to the public in 1993 and formally titled the Edythe C. and Stanley L. Harrison Opera House, the theater now seats 1,632 guests.

Museum Apartments

888 Magazine Lane, Norfolk, VA 23510
(757) 334-5204 / www.museumapts.com

Currently the site of the stylish postmodern Museum Apartments, the parcel sitting across from Harrison Opera House has had many lives over the years. The apartments sit on art-filled Magazine Lane, ideal for a leisurely walk through the neighborhood. The building itself was constructed between 1907 and 1908 for Edward M. Jordan as the Southern Storage Warehouse, which added a second floor in 1911. The warehouse gradually fell into disrepair and was revived when the land was purchased and the building razed by a local architect and developer Tom Morrisette as interest surged in the nascent NEON District.

There had been no new residential construction in the neighborhood for almost a century when the Museum Apartments broke ground in 2017. With its chalky white exterior populated by blocks of primary color, the large multi-family dwelling is the architect's ode to modern master Le Corbusier. The front façade's "portholes" speak directly to Harrison Opera House's round lobby windows across the way. As a commitment to NEON District's public art program, the Museum Apartments offer a gallery space for residents, as well as a tongue-in-cheek mural near the front entrance by Hampton Roads artist Mallory Jarrell. Her piece, entitled *#ILYNFKVA*, is a playful portrait of the Mona Lisa signing the street hand gesture for Virginia love.

Urban Discovery Ministries

121 East Virginia Beach Boulevard, Norfolk, VA 23510
(757) 622-1665 / www.urbandiscovery.org

Norfolk Fire Station No. 6 was built between 1952 and 1953 for the total cost of $180,000. It was dedicated on October 28, 1953, to serve the downtown and Ghent neighborhoods. The exterior, particularly the front façade where fire trucks entered, has been significantly altered. Now the home to Urban Discovery Ministries, a small storage building on the rear of the property is painted with peaceful imagery of a dove encircling Earth. Conceived by local artist Christopher Kozak, the mural was completed in just a few days by young people attending summer camp at UDM.

Fort Tar Lofts

1001 Monticello Avenue, Norfolk, VA 23510
(757) 416-5862 / www.forttarlofts.com

On the northeastern edge of the NEON District, an unassuming short street and triangular lot provide clues to the neighborhood's far-reaching history. Fort Tar Lane receives its name from Fort Tar, one of three colonial-era forts built to protect the young city from the British during the War of 1812. Only Fort Norfolk remains of the three, and there is no indication of what happened to Fort Tar, as it disappeared from maps in 1850. However, the area near Monticello Avenue again came to prominence during the heyday of Norfolk's automobile industry. One of the first buildings to be constructed

explicitly for the buying and selling of cars, the flatiron-shaped dealership was built between 1915 and 1916 for Frederick A. Roethke and designed by Herbert Woodley Simpson.[40]

As Virginia's oldest auto dealership, the Roethke business sold primarily DeSoto and Plymouth vehicles. Roethke (1871–1957) was a pioneer in the field who, along with his brother and business partner, began selling Detroit-made Hupmobiles in 1911. Sales boomed, and the brothers expanded to their newly constructed ten-thousand-square-foot dealership and garage, which featured an automobile elevator to transport vehicles between floors.[41] In 1938, the Roethke company added a rear addition for showroom space and completed a new façade on the original building. When Chrysler Corporation discontinued the DeSoto, the dealership closed in 1960, although the building continued to serve the auto industry as Mid-Town Motors and later as a body shop for Kline Chevrolet.

A Norfolk developer discovered the concrete blast from the past in 2012, just as interest peaked in establishing the Auto Row Historic District. He saw potential in the high ceilings, open spaces and warehouse-style windows of the former dealership and service station, giving it a second life as the Fort Tar Lofts.[42] Nearby, other large warehouses and former motor company headquarters dot Monticello Avenue, remodeled and adapted for modern times.

Wyndham Garden Norfolk Downtown

700 Monticello Avenue, Norfolk, VA 23510
(757) 627-5555 / www.wyndhamhotels.com

Upon opening in 1961, the Golden Triangle Motor Hotel was immediately hailed as the only hotel choice for a new age of automobile travel. Surrounded by new roads whizzing into and out of downtown Norfolk, the hotel towered above Norfolk's emerging skyline. Made possible by Norfolk's Redevelopment Project No. 1, which cleared 127 acres of downtown land in the late 1950s, the hotel was one of thirty new commercial buildings built by private developers with the city's wholesale endorsement.[43]

It was a luxurious, first-class hotel and the first to be built in Norfolk since the early twentieth century. Architect Anthony F. Musolino designed for owners Herbert Glassman and Robert Futterman a $7 million palace that would herald the modern age, with the first in-ground swimming pool in downtown and parking for every guest's car.[44] Elizabeth Taylor

Wyndham Garden Norfolk Downtown in an aerial view around 1960. *Courtesy of the Sargeant Memorial Collection, Norfolk Public Library.*

is even noted as a guest who stayed overnight. There was a popular private club and a gourmet dining room that changed menus seven nights a week. The 361 rooms stayed booked with convention-goers and mid-Atlantic travelers.

The hotel's flagship brand has changed many times, but it will always be remembered as the Golden Triangle to Norfolk. Even now, if a visitor drives up the famous car ramps up to the lobby or wanders through the marble lobby, they recognize emblems of a different age. The glorious past is not too far gone. Recent efforts to incorporate the hotel into the up-and-coming NEON District reveal the current hotel owner's passion for art and reinvention. In 2019, young Australian artist Karri McPherson created murals around the property that take inspiration from its midcentury design—and, of course, lots of triangles.

701 Monticello Avenue, Norfolk, VA 23510

Although vacant at the time of publication, the former bus station at the corner of Brambleton and Monticello Avenues has a busy history of Norfolkians coming and going. An original Art Deco bus terminal opened in 1942 to satisfy the ever-growing demand of World War II Soldiers and Sailors traveling to and from Norfolk's busy port. The depot boasted nine loading docks, twenty-two round-trip schedules per day and the modern amenity of air conditioning. A 1942 account reported such high usage by servicemen that the station implored civilian travelers to wait until after the weekend to travel.[45] With the depot razed to make way for the widening of Brambleton Avenue in 1960–61, a new bus station was designed by Clarence W. Meakin as a complement to the Golden Triangle Motor Hotel across Monticello Avenue. In a nod to Greyhound's years of faithful service to Norfolk, the beloved "thumbtack" sign pedestal still remains at the corner of Granby Street and Brambleton Avenue—only instead of the neon-lit Greyhound dog mascot rotating on top, a spinning LED cube with the brightly lit NEON logo welcomes visitors.

No. 701 Monticello Avenue around 1948. *Courtesy of the Sargeant Memorial Collection, Norfolk Public Library.*

The Norfolk Newspapers Building
150 West Brambleton Avenue, Norfolk, VA 23510

Proudly rising from the crowd of low-rise commercial buildings and parking lots in NEON, the former *Virginian-Pilot* newspaper headquarters is the rare four-story building north of Brambleton Avenue. Its stature was worthy of the locally owned newspaper that was Virginia's largest daily from its founding in 1865 until its sale in 2018.[46] The Norfolk Newspapers Building was constructed between 1936 and 1937 to the tune of $200,000, featuring the latest in comfort and building technology. The sixty-eight-thousand-square-foot behemoth was designed by Finlay F. Ferguson and Vernon A. Moore in the Stripped Classical style, with limestone cladding, symmetrical groupings of windows and a black granite entrance on the south façade.[47] Fitting for the newly booming Auto Row, the parcel had a large parking lot for employee vehicles and delivery trucks. Sadly, the day after construction broke ground, Ferguson dropped dead of a heart attack. His design would go on to be a wonder for the city of Norfolk, signaling a new age when publishing was consolidated into one state-of-the-art headquarters. When the newspaper moved into its grand new home in 1937, the *Virginian-Pilot* and its sister journal, the *Norfolk-Ledger Dispatch*, employed more than three hundred journalists and seven hundred carrier boys and printed more than 29 million newspapers per year.[48]

Over the decades, the newspaper evolved, adding and eventually disbanding an afternoon edition, creating new media companies and constructing extensions to the campus along Brambleton Avenue. A rear addition was built in between 1956 and 1957, and the *Pilot* eventually took over the building next door at 114–116 Brambleton, constructed in 1950 for a fertilizer manufacturer. In yet another expansion, the newspaper built a warehouse at 711 Magazine Lane, which had been the site of a row of tenement houses. Both of these sites ultimately became prime real estate for murals and were painted as the NEON District came to prominence and Magazine Lane morphed into an alleyway full of street art and graffiti.

The hallowed halls of Norfolk journalism are now in transition again. After eighty-three years of furious typing, late-night phone calls and inquiring e-mails, the warren of newspaper offices are empty and in the midst of conversion to new apartments. As so many papers across the world have folded into smaller and smaller leased spaces, the *Virginian-Pilot* likewise sold the grand headquarters in 2020. Reporters and editors said their final goodbyes in April 2020, remembering fondly the days of

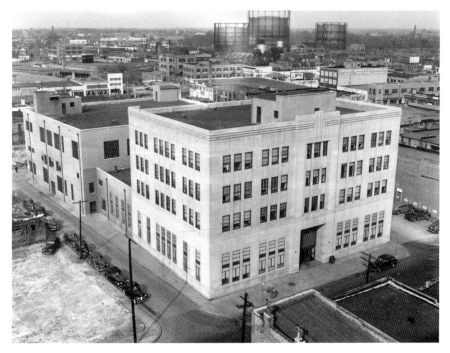

The Norfolk Newspapers Building in 1949. *Courtesy of the Sargeant Memorial Collection, Norfolk Public Library.*

hearing the printing press kick in with a loud rumble and the pneumatic tube system ferrying documents between floors.[49] A Richmond developer, the Monument Companies, has plans to create about 170 apartments, a rooftop deck, a swimming pool in the existing parking lot and a grand lobby that is in keeping with the building's iconic entryway.[50]

WTKR
720 Boush Street, Norfolk, VA 23510

The current WTKR station headquarters was built in between 1949 and 1950 for the WTAR Radio and Television Broadcasting Station and designed by the Norfolk firm of Rudolph, Cooke and Van Leeuwen. WTAR was the first radio station to go on the air in Virginia, debuting to listeners on September 21, 1923. The station added an FM counterpart in 1947, and then in 1950, its parent company, Norfolk Newspapers Inc., founded WTAR-TV, "a modest enterprise" that quickly grew from reaching six

hundred TV sets to more than sixty-five thousand.[51] As a sign of the times and America's new love of television, WTAR tacked on more space in 1952 and then again in 1954 with an adjoining television studio. By 1965, the studio needed still more room, so architect and developer Alex O. Ferebee remodeled the handsome two-story Colonial Revival store at 730 Boush for WTAR. To this day, daily news still broadcasts out from Boush Street, as well as lifestyle and morning shows filmed in the original studio.

Atlantic Permanent Building

d'Art Center
740 Boush Street, Norfolk, VA 23510
(757) 625-4211 / www.d-artcenter.org
Free Admission

Visit one of the few open-to-the-public artist studio spaces in the city at d'Art Center. The nonprofit arts organization has been connecting local artists to the greater Hampton Roads community since 1986 through a resident artist program, children's camps and creative workshops and classes. In its fourth home in downtown Norfolk, d'Art is a unique resource for the city that offers visitors the chance to wander into art studios and interact with and purchase a variety of artworks directly from their creators. The center first opened its doors in a location on College Place at a time when little art was downtown and then moved nearby to the historic Selden Arcade in 2005. The artists enjoyed a decade there, until an unfortunate electrical explosion in April 2015 forced yet another move, this time to the NEON District.[52] After the organization spent five years in the Duke-Grace Building, a private benefactor endowed it with its forever home just a block away, at 740 Boush Street.

Situated at the crossroads of NEON, the Atlantic Permanent Building and Loan Association Inc. constructed its headquarters on Boush Street in 1954. Although the architect remains unknown, the midcentury building is a striking example of jet-set architectural style with large plate glass windows and multiple levels of brickwork, creating interesting depths on the façade. A three-story section along Voss Street behind the main building was added in 1977. Recent redevelopment with local firm Work Program Architects overhauled the building into a modern mixed-use project, with galleries and studios for d'Art Center on the first floor and fourteen residential units above. The Atlantic Permanent Building's new

incarnation affords artists, visitors and residents an easy walk to the Chrysler Museum and Glass Studio or the shops and eateries along Granby Street.

Duke-Grace Building
740 Duke Street, Norfolk, VA 23510

Designed between 1967 and 1969 in the International style by Leavitt & Associates, the five-story Duke-Grace Building signifies expansion out of the core of downtown into northern sectors during a period of urban renewal. Newly cleared parcels of land in and around downtown paved the way for commercial space designed with ample parking in mind.[53] Today, it anchors the west side of the NEON District and is within quick walking distance of cultural attractions like d'Art Center (a former tenant) and the Chrysler Museum Glass Studio. After filling up on art, stop by for coffee or lunch at Café Milo, located next door at 217 Grace Street. The café occupies a small low-rise concrete block building occupied over the years by plumbers and now sports a colorful, Picasso-esque mural by Sage the Artist.

134–142 West Olney Road, Norfolk, VA 23510

As visitors to the NEON District travel from one side of the neighborhood to the other, they might notice a gap in the historic buildings at the corner of Wilson Avenue and Olney Road. A large public art piece, a rain garden and an ad-hoc skate park now reside on this land, which once belonged to automobile dealerships. The original two buildings were constructed in 1946, encompassing 134–136 Olney Road for Reo Truck & Bus Company Inc. and 138–140 Olney Road for Hurdle's Alignment Services. In the early 1980s, Tidewater Ballet Association took ownership of no. 134 and transformed the building into a regional center for dance, acquiring a stellar reputation and producing many young talents under the tutelage of founder Gene Hammett and his former student Glenn White.[54] Next door at no. 138, a local interior designer set up shop. The artistic businesses flourished, but over time, serious flood damage caused by several hurricanes permanently altered the buildings and forced both to relocate. Flood-prone and situated at one of the lowest points in the district, Olney Road seemingly wants to return to its past life as Smith Creek. The city demolished both buildings to create public open space

for a growing number of neighborhood residents in 2014. *Upper Blush*, designed and fabricated by New York sculptor Matthew Geller, meets the changing winds and waters of the neighborhood with shaded, swaying benches that divert rainwater into the adjacent garden.

TCC Perry Glass Wheel Arts Center
128 West Olney Road, Norfolk, VA 23510
(757) 822-1825 / www.tcc.edu
Free Admission

Tidewater Community College's Glass Wheel Arts Center, originally a store that sold tires and car radio parts, is a true testament to the Auto Row neighborhood that predates NEON. Built in 1919 for the Bell Motor Company, the structure has changed hands many times over the decades, once housing a wholesaler specializing in travel luggage and cameras. It was also the studio of Bevan Allen Norkin, a regionally known ceramic and porcelain artist. Just prior to the 2014 renovation that converted the building into an arts center, the Glass Wheel Studio was under restoration to be a residential home with retail space on the first floor. Local arts patrons stepped in with a vision to complement the NEON District: an integrated gallery space and studio artist program with a focus on contemporary glass art. When it opened in November 2015, the facility had an immediate effect on the developing art scene. Thirteen artists from both academic and non-academic traditions, working in mediums of all types, collaborated with one another, exhibited regularly, took part in critiques and volunteered in the district.[55]

Purchased by TCC in 2019 for an expansion to the college's visual arts program, the gallery hosts rotating exhibitions on the first and second floors that are open to the public daily. Student, alumni and faculty work are frequently on display and are available for purchase. Beyond the gallery shows, it is worth a visit to view permanent showpieces *Progression* by Chrysler Museum Glass Studio director Robin M. Rogers, a dichroic glass installation suspended from the atrium ceiling; a neon artwork titled *Labor of Love* by Hannah Kirkpatrick on the eastern façade; and a stunning free-form mural on the front of the building by Alex Brewer (known internationally as HENSE).

Hugh R. Copeland Center

112 West Wilson Avenue, Norfolk, VA 23510
(757) 627-5437 / www.hurrahplayers.com

A mainstay of the region's arts scene since 1984, family theater troupe Hurrah Players' second home in downtown Norfolk is the Hugh R. Copeland Center. Named for the effervescent and beloved founder and artistic director, Hugh Copeland, the center contains scene and prop storage, along with a flexible performance venue, classroom space and a box office. The Players often bring cabarets and smaller theater experiences to the NEON space, filling the venue with dozens of cheerful theater kids and their families. The company is well known as a tightknit family, never turning students away and producing alumni who have gone on to the bright lights of Hollywood and Broadway.

Hugh himself broke ground on the renovations in the fall of 2015, seated behind a bulldozer, knocking down bricks from a previous incarnation of the building. The main portion of the building was built as a stable in 1907 for the Miller, Rhoads & Swartz department store horses, used in delivery and transporting merchandise from Norfolk's docks to the store.[56] Arched windows on the rear of the building where horses peeked out can still be seen today. The building was later occupied by an automotive repair shop and Sutton Manufacturing, and a new façade with striking metalwork doors was added in 1949. In 1951, Sutton Manufacturing expanded next door, where Hurrah currently houses prop storage. After outgrowing several spaces over the years, Hurrah landed on the Sutton building for its expansion, just as the NEON District was making a name for itself in the art community. In May 2017, the company finally cut the ribbon on its new facility. Hurrah!

719-721-727 Granby Street, Norfolk, VA 23510

The 700 block of Granby Street was populated by many automobile dealerships beginning very early in the twentieth century. The shops between nos. 719 and 723 Granby Street were built as a three-dealership building, with C.L. Young Motor Cars selling Pierce Arrows, Haynes and Buick vehicles. Next door, the Pope-Republic Company and Overland Cars dealt in cars, tires, delivery trucks and other supplies.[57] Famed local photographer Harry C. Mann documented these dealerships along Granby in 1910, posing in his

Nos. 719-721-727 Granby Street in about 1916. *Courtesy of the Sargeant Memorial Collection, Norfolk Public Library.*

own photograph, which was considered unusual for him, alongside owner C.L. Young, both in dapper suits and bowler hats.

Although the buildings have been extensively altered over the decades, passersby can still peer through the large front windows under the classic neon sign still blinking "Bress Pawn Shop." When the shop closed its doors at 721 Granby for the final time in 2018, the Bress family had been buying and selling Norfolk's goods for more than seventy years. Bringing two family pawn businesses together through their marriage, Larry and Linda Bress relocated the retailer to Granby Street in 1982 after urban development pushed them out of the original Church Street shop. The couple installed an antique banker's cage with barred windows for dealings in jewelry, memorabilia, "a wooden leg, air conditioners, conga drums"—nothing was too unusual for the Bresses to unload.[58] Mainstays in the neighborhood for decades, the family also purchased nos. 725 to 729 Granby Street, first to expand the pawn shop and then to lease for up-and-coming businesses attracted to the energy of NEON.

Virginia Furniture
745 Granby Street, Norfolk, VA 23510
(757) 627-5075 / www.virginiafurniturecompany.com

In another tale of Norfolk legacies relocating to the NEON District, Virginia Furniture moved to the neighborhood in 2005; however, the business can trace its roots all the way to 1939. That was when brothers Leonard and Harry Laibstain witnessed the booming retail businesses up and down Church Street and jumped into the fray, spending twenty-five dollars per month on rent. The brothers, listening to radio reports of World War II shortages, understood that families were short on cash for big purchases like furniture and began offering their own financing for folks willing to pay a little bit at a time. The family still operates that way, helping customers afford their wares, making repairs and deliveries and giving little gifts along the way like "a pot or pan, a snack, a toaster" when payments are made on time.[59]

Prior to the Laibstains' purchase, the building at 743–753 Granby Street housed numerous automobile dealerships and vehicle part shops. Like many of the Auto Row buildings, it was designed and built by local architecture firm Neff & Thompson. Situated at the crossroads of NEON, on Granby Street and Olney Road, the building provides a broad canvas for artists and art watchers. The north façade features one of the most popular murals in the district, *Transparent Seas*, a forty-foot-long, high-tech vinyl creation that interacts with viewers through color and light. The product of a collaboration between renowned artist Jason Levesque and digital ad agency Grow, the mural comes alive at night. As onlookers near the wall, colored lights react to movement and reveal elements of the sea and earth hidden behind female heads.[60]

Bob's Gun Shop
746 Granby Street, Norfolk, VA 23510
(757) 627-8311 / www.bobsgunshop.com

Visitors to the NEON District can't miss Bob's Gun Shop at the corner of Granby Street and Olney Road. Its three-story mural, vintage neon marquee and painted "BOB'S" sign signal that you are in the heart of NEON. Prior to its current colorful style, the 1920s building featured a brick façade designed by Peebles & Ferguson for a Chevrolet dealership. One interesting footnote in the building's long history is the mysterious tale of Norfolk mayor Fred

Bob's Gun Shop. *Courtesy of the Downtown Norfolk Council.*

Duckworth. In 1953, he obtained the warehouse and office building at 746 Granby through a land swap for his auto dealership, the Cavalier Motor Company. Notorious for his staunch support of urban renewal, bulldozing entire neighborhoods and a "bruising style of leadership," Duckworth made many enemies throughout his twelve-year run as mayor and then as leader of the Tidewater Virginia Development Council, a shadowy economic development organization he relocated to 746 Granby. Were those enemies willing to eliminate Duckworth for good? He was gunned down late on a Friday evening in March 1972 off Little Creek Road, and the killers were never identified.[61]

Shortly after Duckworth's killing and the demise of TVDC, local family business Bob's Gun Shop reinvented the space as a sporting goods mecca and shooting range. Longtime owner Robert Marcus purchased Bob's from his uncle at his retirement, after having worked in the shop since high school.[62] Mr. Marcus has been a faithful patron of the arts and the neighborhood, lending a billboard and the very large south side of the building to mural projects. In fact, his generosity enabled the first large-scale work in the district: Nick Kusyzk's *Razzle Dazzle*. Kuszyk, who often goes by the street name of RRobots, won the commission in 2014 with a design inspired by "razzle dazzle" camouflage painted on World War I battleships, aimed at

confusing enemy warships at sea.[63] Since then, the mural has become the piece most affiliated with the district, inspiring many more colorful and geometric artworks in Norfolk.

The Texaco Building

759 Granby Street, Norfolk, VA 23510
Rutter Family Art Foundation, www.rutterfamilyartfoundation.org
Commune, (757) 962-2992 / www.communevb.com

The crown jewel of the NEON District, the Texaco Building, anchored automobile industry growth in the early twentieth century and then arts-related development nearly a century later. Built for the Texas Company (or Texaco) in 1917–18, the three-story brick masonry office building was one of the largest on Granby Street and featured decorative elements on the exterior. The Texas Company's signature star emblems overlaid with a "T" can still be seen on the façade. Several dozen employees worked in the regional headquarters: the sales team on the second floor, accountants on the third and filling station attendants servicing vehicles on the first. Cars would pull up on Granby Street, drive through first-floor garage doors, fill up and exit onto Olney Road.[64]

After falling into disrepair, a glimmer of hope arrived in the form of urban planning team Better Block, which ultimately saved the building. The arts fair and urban demonstration project implemented by the city and Better Block filled the first floor with artists and pop-up shops for a weekend in 2014. Although the building had been stripped bare, arts patrons and investors saw its potential. Local attorney Arthur "Brother" Rutter and his wife, Meredith, were looking for a downtown apartment and space to house their growing contemporary art collection. Although larger than what they had in mind, their vision grew with the building—it would house a multi-use arts and dining space on the first floor, apartments on the second floor and a private apartment and gallery on the third.[65] Establishing the Rutter Family Art Foundation and christening the first-floor venue Work|Release, the couple's investment immediately changed the face of the neighborhood. From the opening neon art exhibition in 2015 to the time of this publication, the Texaco has provided a true arts destination for NEON. Over the years, the foundation has hosted juried exhibitions, lectures, concerts, artist workshops and curatorial fellowships, but most importantly, it is a space where art makers and art lovers alike cross paths and share ideas.

Texaco Building. *Courtesy of the Downtown Norfolk Council.*

Today, the first floor is home to Commune Norfolk, a branch of the popular farm-to-table eatery established in Virginia Beach. The weekend brunch is a staple in NEON. Looking back on their investment in NEON, the Rutters have this to say: "The Texaco building has always been a centerpiece of the district, highly visible and centrally located. We knew that revitalization of the neighborhood would require a renewal of this building, so we have watched with joy as the rebirth of the Texaco building breathed new life into the whole neighborhood."[66]

Push Comedy Theater

763 Granby Street, Norfolk, VA 23510
(757) 333-7442 / www.pushcomedytheater.com
Admission Fee

Norfolk's only improv and comedy center, Push Comedy Theater is a ninety-seat venue housed in a 1916 automobile dealership. Run by The Pushers, whose founders Brad McMurran and Sean Devereux trained at Upright Citizens Brigade in New York City and performed side gigs in Norfolk bars for years, the theater opened in 2016 after a successful Kickstarter

campaign.[67] Thursday through Sunday evenings, plan a stop at Push to catch one of its signature improv or sketch comedy shows, such as "Date Night" or "Sketchmageddon." In addition to the weekly riot fests, Push produces two big comedy events per year: "Panties in a Twist," which is written, produced and acted by all-women crew, and the Norfolk Comedy Festival, which brings in national and regional comedy acts.

La Brioche
765 Granby Street, Norfolk, VA 23510
(757) 226-9745 / www.facebook.com/labriochenorfolk

Next door to Push, the heady smell of bread baking beckons from La Brioche. Although it was originally part of the car dealership that housed nos. 763 and 765, the French bakery now stands alone at 765 Granby Street. A recent addition to the neighborhood, La Brioche will transport you to the streets of Paris with its fresh croissants, baguettes and wondrous confections baked daily by owners Jacqueline and Yvan Devulder.

Decades ago, though, the building held one of the first arts uses in the neighborhood: Old Dominion University's Wonder Gallery. As former ODU student and eventual leader in founding the NEON District, Cheryl White, recalled, "It was the first gallery in Norfolk I ever recall visiting, and the street was nearly desolate. There was an exhibition of photos by ODU professor David Johnson on display. I remember the class sitting on the floor of the mezzanine listening to him talk about the series and the Norfolk art scene of the 1970s. How artists dressed in construction overalls and removed the original neon tubes from the signs on all the abandoned buildings downtown. I often find myself working from that same space and thinking about the ways the local art scene helps us preserve our history and still manages to reinvent itself."[68]

The Plot
776 Granby Street, Norfolk, VA 23510
(757) 623-1757 / www.downtownnorfolk.org/explore/the-plot
Free Admission

The NEON District's town square, the Plot, is a city block of greenspace created by hundreds of volunteers using reclaimed materials. As of this

writing, it awaits future development. After a stint at an initial location in downtown Norfolk, the temporary park was reassembled in NEON in the spring of 2014 to provide residents and visitors an attractive neighborhood meeting place with greenery, a performance area, play opportunities and public art. Don't miss a photo op in front of the colorful fence or a peek inside the interactive sculpture *Cementiscope* by female glass team Glassitorium. The Plot is open to the public for daily park use and can be reserved for events, rehearsals, yoga classes or other pop-up events. Each fall, the NEON Festival lights up the Plot for two nights of art and music that radiate out into the district.

The site's long history is just as colorful. Listed in records as 772–788 Granby Street, the 1910-era building was constructed for the Goodlee Sanitary Milk Company, with the dairy's owners residing on the second floor. Until it was demolished in 2013, it changed hands often, housing an ice cream factory, a car showroom, a furniture store and, lastly, Zedd's Auctioneers, famous for a painting of the owner Calvin Zedd atop a circus elephant.[69] Remains of the building's previous lives linger at the Plot. Granite floors from a renovation in 1952 still cover the Plot's ground. The Zedd's billboard was repurposed for *Cementiscope*'s kaleidoscopic lighting. Artists who painted the abandoned buildings' boarded-up windows through the community art project Hampton Roads, The Canvas return to NEON for permanent projects. The spirit of old and new that is at the heart of NEON is evident nowhere more so than at the Plot, as it waits for the next reinvention.

Zeke's Beans & Bowls
800 Granby Street, Norfolk, VA 23510
(757) 963-5220 / www.facebook.com/zekesnfk

One of the only buildings left in the neighborhood that was constructed for residential use, 800–800½ Granby was built for the Allyn family circa 1909. Joseph T. Allyn (1840–1904) was a prominent real estate attorney in Norfolk who constructed several high-profile buildings downtown, including the Essex Building, which is still standing on Plume Street.[70] In 1920, the home was significantly altered to create a storefront on the first floor, and a century later, it is thriving as the Norfolk location of Zeke's Beans & Bowls. A popular coffee, smoothie and lunch spot, Zeke's opened in 2015 just as the NEON District was taking root. Grab a signature tuna poké bowl and pour-

over coffee and hang with neighborhood locals amid the comfy booths and eclectic décor that features local artists. For some fresh air, head out back to claim a seat on the quirky "cat-io," Zeke's outdoor dining space for coffee connoisseurs and cat lovers.

801 Condominiums
801 Granby Street, Norfolk, VA 23510

Swimming upstream in a colorful line, tropical fish painted on the exterior of 801 Granby Street camouflage the exterior of a 1917 automobile dealership. After architects added a second and third story in 1920, it was significantly altered again in 1987–89 when it was converted to condominiums. Residents also built a hidden rooftop deck that affords a prized bird's-eye view of downtown and the NEON District. Besides proximity to the area's cultural scene, the building holds a treasure-trove of public art and is one of the most photographed mural sites in NEON. In 2015, over an August weekend and with only a few hundred dollars for supplies, Virginia Beach painter Troy Summerell transformed the corner of Wilson Avenue and Granby Street with his mural *Happier Times*. Working under the moniker OnieTonie, Troy now paints sea life murals throughout the region, but the fish on 801

801 Condominiums. *Courtesy of the Downtown Norfolk Council.*

were his breakout moment. He later wrapped his piece around to the rear of the building with a painted cityscape.

The alley behind 801, known as Magazine Lane, also features a mural "rug" that the Governor's School for the Arts students repaint on the asphalt every two years. On the north wall of the condominium, *Seep NFK* oozes over the roof and down the side. A bright-pink neon sculpture on long-term loan to the district from Chicago artist Erik L. Peterson, the piece was initially shown in 2015 during AGLOW, the first art exhibition to feature neon and glass art at the Texaco Building. Peterson fell in love with Norfolk's watery past and future, retrofitting *Seep*

for exterior placement as a symbol of floodwaters and creativity bubbling up from below. It is the largest neon work to be found in the district, its glowing pink hues signaling to visitors from blocks away.

Commonwealth Tattoo Gallery
804B Granby Street, Norfolk, VA 23510
(757) 578-2085 / www.commonwealthtattoonfk.com

Xchange Norfolk
804A Granby Street, Norfolk, VA 23510
www.facebook.com/XchangeNorfolk

The retail shops along the 800 block of Granby Street are some of the busiest along the historic street, just as they were a century ago. One of the least-altered original automobile dealerships in the NEON District, the combined addresses of 804, 806 and 808 Granby Street make up a very large space that now holds a tattoo shop and streetwear retailer. From its construction in 1916 until the late 1950s, the building was home to a variety of car dealerships, showrooms and body shops. In 1961, the Cuthrell family began selling bicycles and lawnmowers from the store, eventually purchasing the adjacent properties at 810 and 812 Granby, all of which remain family owned. After a run as a furniture store in the 1980s and 1990s, the retail space and warehouse became ground zero for the developing arts scene that would lead to NEON.

Founded in 2013, Alchemy NFK was the brainchild of Careyann Weinberg and Charles Rasputin, two young artists with a powerful vision for Norfolk's art scene: "to share ideas in a community environment."[71] Started as a pop-up in 804–806 Granby Street, the collaborative work center held studios, event spaces and gallery walls in the raw, industrial space. Artists, designers and musicians flowed in and out, many who still contribute to the district years later. After Weinberg and Rasputin moved on to managing and curating Work|Release at the Texaco Building, the space was divided into separate shops, paving the way for a new wave of businesses. The warehouse's rear façade received a facelift by way of Norfolk State University art professor Solomon Isekeije. As local tour impresario Joshua Weinstein said, "As a Norfolk native and tour guide of the NEON District, I've watched the neighborhood blossom and the walls brighten with joy. Although it's hard to pick a favorite work of art in the

NEON, the one that resonates the most with me is *Symbiotic Nuances* by Solomon Isekeije. Its color palette is unlike any other mural in the district, and the way it weaves together Cubist-inspired depictions with African patterns, objects and flavors is distinct, vibrant and a pleasure to view and discuss. It is a testament to the quality and diversity of artists and styles represented in the NEON District."[72]

Norfolk Printing Company
805 Granby Street, Norfolk, VA 23510
(757) 627-1302 / www.norfolkprintingcompany.com

The oldest print shop in Norfolk still operating under its original name, Norfolk Printing Company, was founded in 1932 by Al Leibowitz. Mr. Leibowitz ran the shop from its downtown location on Plume Street until 1960-era plans for redeveloping downtown spurred a move to the Auto Row shop.[73] Built in 1919 for General Machinery & Welding Corporation, 805–807 Granby Street still hums with machinery, even a cranking antique letterpress longtime owner Michael Phelps keeps in the front office.

Hummingbird Macarons & Desserts
809 Granby Street, Norfolk, VA 23510
(757) 622-7757 / www.hummingbird-macarons-desserts.myshopify.com

A recent and most welcome addition to the NEON District, Hummingbird Macarons & Desserts is a worthy stop on any culinary tour of the neighborhood. Owner Kisha Moore is widely acclaimed for her sweet confections, creating gorgeous multi-layered cakes and delicate macarons packed with flavor. After stints in several other Norfolk locations, she couldn't resist the giant, historic building at 809 Granby. Built in 1944–45 for Norfolk Glass & Mirror Company, the space is big enough for a commercial kitchen, retail shop, tearoom and future classroom for budding confectioners. Cool off with a delectable ice cream macaron sandwich in the summer or sample the signature Hummingbird macarons all year long—banana, coconut, pineapple, macadamia and pecan flavors wrapped up inside one little cookie.

Amplified IT

812 Granby Street, Norfolk, VA 23510
(757) 774-5047 / www.amplifiedit.com

Now the home of a bustling tech company with mod furniture, whiteboards and stocked breakrooms, dig backward and you'll find a long history inside 810 and 812 Granby Street. Prior to the Auto Row era, it was a large, two-story brick home built in 1892 for James A. Prince.[74] After being used as a boardinghouse for many years, the residence was demolished in 1964, and a new building was combined with the adjacent Cuthrell's Inc. at 812 Granby. The two buildings' deep retail and warehouse bays were well suited for artist studios as the neighborhood moved toward establishing an arts district. First inhabited by industrial designers with a metalworking shop, the spaces became Studio Colab in 2012, a shared workspace for designing and fabricating large-scale works. Along with neighbors at Alchemy NFK, artists were busy in creative endeavors that would plant the seeds for the NEON District.

Culture

814 Granby Street, Norfolk, VA 23510
(757) 655-1433 / www.facebook.com/culturelounge757

Sanctuary

109 Addison Street, Norfolk, VA 23510
(757) 583-8755 / www.instagram.com/sanctuary10x80

For the traveler wishing to explore the NEON District's nightlife, the end of the 800 block features casual and funky eateries Culture and Sanctuary. The neighboring restaurants inhabit different additions to what was originally an 1894 single-family home. In 1919, the home was converted to a combination store and residence and then remodeled again in the 1940s with a new façade and rear addition.[75] Another long and low cinder block space was added facing Alexander Street (now Addison) in 1956, home now to the ten-by-eighty-square-foot Sanctuary Norfolk. The most significant feature today is perhaps the most loved mural in NEON: Esteban del Valle's *We Can Create What We Can Imagine*.

At three stories high, the mural is unique for its size and scale, but also for the unusual incorporation of three-dimensional art into the painting itself.

The work is one of three commissioned to celebrate the launch of the first NEON Festival in 2015 that matched a muralist with a local glass or light artist. Del Valle was paired with Chrysler Museum Glass Studio artist Julia Rogers. Together they designed a sweeping ode to the stroke of inspiration, a writer at his typewriter with dreams lit by an LED lighthouse, a movie house marquee, Edison bulbs, a twinkling night sky and real glass candle flames. Today, the mural is a symbol of all those who find their way to the district, hoping to light a spark of imagination.

The Neon House

819 Granby Street, Norfolk, VA 23510
(757) 496-3900 / www.theneonhouse.com

A row of brightly painted brick storefronts anchors the 800 block of Granby Street on the west side. Large shop windows and roll-up garage doors in 813 to 819 Granby Street reveal exposed brick walls and timber beams that were built in 1919 for commercial use. After decades spent as antiques and furniture stores, the warehouse-style spaces are now booked regularly under event rental company the Neon House. Led by a husband-and-wife team of caterers, the Neon House is extremely popular for weddings, parties and celebrations of all kinds. As a nod to the landlord's former furniture business Exotic Home, a large mural depicting houses from across the globe spreads across the north façade. A Chrysler Museum Glass Studio assistant added space-themed neon art pieces atop the mural in 2015, while Ohio artist Charley Frances painted a very whimsical chameleon roller-skating on the rear of the building in 2019. As is typical for the NEON District, each corner of the buildings holds a new discovery.

Chapter 5

ALONG THE HAGUE

LIFE IN HISTORIC GHENT

Raven Hudson

INTRODUCTION

Imagining a walk along the Hague at the turn of the twentieth century is not exceedingly difficult to muster. Sharp businessmen in their three-piece suits cross the steel-riveted bridge after a day's work in Norfolk's commercial district of downtown and head to their beautiful waterfront homes in the quiet oasis of Ghent, the premier residential neighborhood in Norfolk. The streetcar bell dings as more passersby head into town, admiring the distinct European-inspired architecture of the Mowbray Arch skyline as the trolley car passes over the Botetourt Street Bridge. Women—with their corseted waists, high-fashion hats posed just so and their wicker prams—are scouring the artfully designed Trinidad asphalt block streets, sharing pleasant looks at their high-society neighbors. A series of church bells ring off throughout the walk, echoing from the many denominations of churches over in the Stockley gardens. The Victorian era of opulence is ending in the Western world with the death of Queen Victoria in 1901, but it seems to just be beginning in the silver maple– and magnolia-lined streets of Ghent.

Although the streetcars are gone and have been replaced with automobiles lining the streets, and the fashionable clothing of Ghent residents and visitors has been replaced with modern athletic apparel, the architecture of Ghent persists and leaves its visitor with the notion that you are entering a different time as you cross over the pedestrian bridge into Historic Ghent or drive from the business district on Colley Avenue into Ghent Square. The streets are teeming with period homes and apartments complexes dating back to

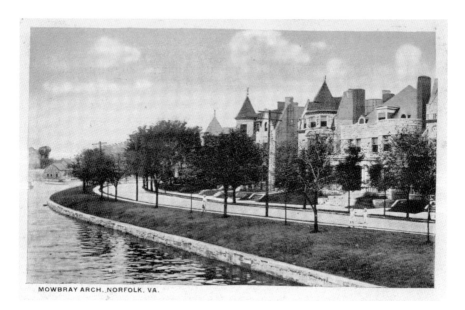

MOWBRAY ARCH, NORFOLK, VA.

The Mowbray Arch Skyline. *Postcard image courtesy of Raven Hudson.*

as early as 1892. The area known locally today as "the Hague" takes on the colloquial name for the body of water that forms its southern boundary and is also bounded by three streets—Brambleton Avenue, Olney Road and Virginia Beach Boulevard. This area is Ghent's Historical District and was added to the Virginia Register of Historic Places on June 19, 1979. Created and built in a span of fifteen years, this historical district is unique in its intact collection of architecturally significant homes, ranging from rows of townhomes to large apartment buildings and mostly consisting of single-family homes designed by architects in distinct styles. Of the plethora of styles erupting from this district, the majority pull from the traditions of many European and American styles—Federal, Colonial, Gothic, Greek, Romanesque, Dutch Colonial, English Tudor, Italianate, Beaux Arts, English Half Timber and Tudor-Jacobean. Among the incredible districts of Norfolk, what makes Ghent special is the resemblance that it has to its former self through the unique architecture that remains. A walk in Ghent is a microcosm of Norfolk's past life before the redevelopment of the 1960s took much of Norfolk's material history with it.

Although Norfolk's history dates back centuries, the Historic District of Ghent that can be seen today was primarily constructed from 1892 to 1907, with many other sections of the district being built later and

considered parts of other regions. Today's Ghent includes sections that were considered separate districts at the time or nonexistent, including the Brambleton neighborhood, which was its principal suburb predecessor; Atlantic City, which encompassed the southern end of Colley Avenue up to the Norfolk and Western train tracks; and parts of Park Place and Colonial Place, which were popular residential neighborhoods after the streets of Ghent Square were filled.

The creation of Ghent, and where the name of the neighborhood is derived, began in 1810 when Mr. Jasper Moran was deeded the land that encompasses much of modern-day Ghent by Dr. William Martin. At this time, beyond Smith's Creek and the inlet of the Elizabeth River, acres of farmland existed, known as Brushy Neck or Pleasant Point. While no one officially gets credit for the naming of Ghent, there are two predominant stories about its derivation. Some say that Moran named his new plantation Ghent in 1815 after the Treaty of Ghent was ratified by President James Madison and signified the ending of the War of 1812 between Britain and the United Sates, opening up trading routes off Norfolk's shores and encouraging economic prosperity. Another tale goes that two years after Moran's death in 1828, Commodore Richard Drummond purchased Moran's land and branded it with its new name after his personal ship transported the treaty document back to the United States. Whether Drummond or Moran gets credit for the name, it is clear that the name stuck around and even inspired developers to look to its European roots to design a neighborhood with the same arched bridges and rowhomes in mind.

Ghent's inception began in 1890 when a new real estate company called Norfolk Company purchased 220 acres of land that encompassed today's Ghent. It hoped to establish a manicured and developed community for the rising upper-middle-class and upper-class residents of Norfolk. This parcel of land seemed like a promising investment due to the major transportation expansion projects in the city, including the recently completed toll bridge that crossed Smith's Creek just north of Duke Street at Botetourt Street, as well as an expansion of trolley car routes west of Smith's Creek. Trolley car routes were prolific in expanding cities at the end of the nineteenth century, sprouting suburbs around major city centers and providing more room for major estates to be built on previously rural farmland. The Norfolk Company took the opportunity to build in Ghent because of a recent deviation in Norfolk's building codes that enticed developers to the project. Two Dutchmen, J.P. Andre Mottu and Adolphe Boissevain, were instrumental in envisioning Ghent's waterfront area to mimic the waterways of their

homeland of the Netherlands. To further this correlation, the western arm of Smith's Creek was rebranded in 1897 as the Hague to further evoke the romantic feeling of Europe along the newly renamed shore. The Hague is a city on the western coast of the Netherlands on the North Sea coast.

John R. Graham would not only be the civic engineer hired out by the Norfolk company to design the layout of the suburb, but he would also possibly become Ghent's first resident after completing his own house and the first house built in Ghent in 1892 at 502 Pembroke Avenue (although multiple houses were being built simultaneously). Graham's plan for the neighborhood was a grid that only deviated along the curvature of Mowbray Arch's waterfront location. The 400 block area of Mowbray Arch was the premier street to be seen from the water and the most romantic view of its European-inspired architecture. The semicircular street was completed by filling in the shoreline and was intersected by Colonial Avenue, another street destined to be lined with the mansions of Norfolk's most prestigious residents. Ghent's streets are laid in a curvilinear pattern and allow for purposely placed parks in between large building sites. Examples of these inner-city gardens can be seen today with Beachwood Place, Botetourt Gardens and Stockley Gardens. Graham's plan included high-class amenities in urban life such as sewers, gas pipes, water mains, paved and widened streets and sidewalks. Building took place from 1892 to 1907, and an astounding ninety-five houses were erected in just eight years according to the census of 1900.

The new, posh residents of Ghent mostly consisted of families of civic leaders, businessmen, professionals, military leaders, members of the Norfolk Common Council, bankers, local lawyers, railroad executives, gas company executives, doctors, teachers and cotton merchants. Some of these families were the influential citizens who had been in Norfolk for more than a century, many of them finally getting back to business in the 1880s after Reconstruction had slowed Norfolk's economy. Newcomers from the northern states also found their new homes in Ghent. It is thanks to the perseverance of Norfolk Company executives that Ghent was fully developed and popularized in such a short time. John R. Graham Jr., Fergus Reid, Richard B. Tunstall, Robert Baylor and Horace Hardy are a few of the very first Ghent residents, and all were part of the Norfolk Company, which would later be renamed the Ghent Company. By the time many houses were under construction in 1893, Norfolk's economy would start to tank due to multiple bankruptcies nationwide, high unemployment rates and a crash in the stock market. These investors and businessmen shifted their attention to lending money to prospective residents to encourage

well-off Norfolkians to invest in property across the creek in what they could see would be the next leading suburb.

With the influx of people in Ghent came cultural, medical and educational institutions that signified the buzzing of life in the community. Horse-drawn streetcar services dominated the streets, delivering ice and groceries to residents and providing transportation. The Norfolk Company worked diligently to get the first electric streetcars into Ghent by October 1894, spurring more commerce and continued development of the region. New street improvements and water main systems enticed businesses to build in Ghent. Several hospitals or medical practices were opened in Ghent after 1900, including Sarah Leigh Hospital (later Sentara Leigh Hospital) and Norfolk Protestant Hospital (later Norfolk General). Private schools also opened in Ghent, including Leache-Wood Seminary and the St. George's School for Boy and Girls. Lastly, the streets of Ghent were soon ringing from the countless bells of many new churches, including Christ and St. Luke's Episcopal Church, First Presbyterian Church, Ghent United Methodist Church, Ohef Sholom Temple and more.

While the Mowbray Arch area of Ghent was the primary focus of the Norfolk Company from 1892 to 1900, development past Onley Road began in 1899 and continued into the 1920s. More development took place in the western section of suburb, now known as West Ghent. The Norfolk Company issued a statement in April 1899 that communicated its intent to build north of Onley to Redgate Avenue and west of Colonial Avenue to Colley Avenue, including Stockley Gardens. The Ghent neighborhood that we see today uses these boundaries, dividing Ghent into districts: Ghent Historic District, Ghent Square, North Ghent and West Ghent.

North Ghent was built up between 1910 and 1928 with many three-story and four-story apartments, townhomes and clusters of smaller, less ornamental single-family homes south of Westover Avenue and Redgate Avenue and east of Colley Avenue. The completion of Maury High School in 1911 brought more residents into Ghent, spurring the need for more housing. Ghent continued this upward momentum of growth until other suburbs well outside the city began to become more popular as cars gave people the ability to branch out farther. The biggest change came in the 1940s.

During the Second World War, temporary barracks were built in places wherever possible, and Ghent was no exception. Barracks were placed on Mowbray Arch out in front of the Norfolk Museum of Arts and Sciences, the current Chrysler Museum, which was opened in 1933. The stately mansions and homes of Ghent were converted for temporary stays and

rented rooms, and eventually more of the historic homes were split into multi-family homes or taken over by commercial development. Much of Ghent deteriorated after the war ended. Integration of public schools coupled with the high population of African Americans moving to East Ghent (now Ghent Square) caused white flight, the phenomenon of white citizens moving out of urban area into suburban areas to escape a recent influx of minority populations. The wealthy citizens of Ghent deserted their once beloved suburb and created new ones farther from Norfolk's city center in Larchmont or Virginia Beach.

However, the notion that mostly white people resided in Ghent before the 1940s ignores the lives of domestic workers in Norfolk homes. In the early twentieth century, almost every single home in Historic Ghent had live-in nurses or nannies, butlers, housekeepers, cooks and/or maids. Most of these servants were African American women who were paid anywhere from six to ten dollars per week. There were some African American men and white women who worked in domestic service as well. Of the 540 people living in Ghent in 1900, about 20 percent of people were African Americans living as domestic workers in wealthy white homes.

Nevertheless, in the years after the Second World War, the houses in Ghent became abandoned, sectioned off into low-income housing, and fell into disrepair, especially in East Ghent. In 1964, a grant from the Norfolk Foundation spurred renewal projects in East Ghent by urging landlords in Ghent to follow building codes and make the homes of poor tenants safe and sanitary. This model was unproductive and led to the razing of sixty-five acres of East Ghent, and private development of the land was overseen by the Norfolk Redevelopment and Housing Authority. This area today is known as Ghent Square and consists of single-family detached townhomes for middle- and upper-class families. Although much of Ghent was considered conservation area by 1964, more than two hundred historic structures were demolished between 1964 and 1970.

The Ghent Neighborhood League was formed by affluent residents of Ghent in March 1962. Their goal was to preserve the historically significant parts of the neighborhood and deal with the "slums" of East Ghent to preserve the neighborhood's integrity. Although an eyesore to some, the building of Hague Towers across from Mowbray Arch in 1965 was an attempt to revitalize and bring back life into the area. A blow to the neighborhood was the construction of the Brambleton Street Bridge in 1960, which cut off personal and commercial boating traffic in the Hague, which many residents thought added to its charm and popularity. Picturesque

Ghent had been changed for good in the 1960s, but the resilience of Ghent residents persisted. The Botetourt Street Bridge (Ghent Bridge) was salvaged and restored into a pedestrian bridge. Many of large homes were bought at cheap prices, restored or conserved by family members of the original homeowners. By the 1980s, Ghent had been fully revitalized and protected.

A walk along the Hague today transports visitors to a bygone era. The unique architecture that survives is a testament to the vision that early Ghent residents had for the area. Much of North Ghent has become just as popular at the southern historic district. The streets of Colley Avenue and Twenty-First Street are teeming with eclectic coffeeshops, local artisans, pubs, restaurants and a sense of community above all. Today, there are more than thirty blocks to explore in Ghent, and within each of the streets are the remnants of its beginning.[76]

SITE GUIDE

The Hague or Smith's Creek

Samuel Smith's Creek is a small branch of the eastern branch of the Elizabeth River. It curves around from the Chrysler Museum of Art on one end to Onley Road and the Stockley Gardens on the opposite end. Smith Creek was rechristened as the Hague in 1897 by the promotors of the Norfolk Company to evoke a romantic connection to the European city of Ghent, Belgium, and to honor Adolphe Boissevain, who founded the Dutch banking house that sponsored the development of Ghent. The waterfront area is what enticed investors to the farmland that would become Ghent. Its

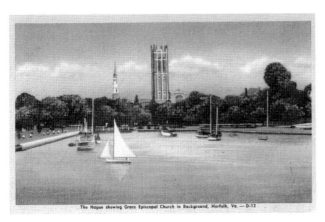

The Hague and sailboats, with Christ & St. Luke's Church in the background. *Postcard image courtesy of Raven Hudson.*

development revolved around the notion of creating a beautiful and peaceful waterfront community. Mowbray Arch boasts a most unique collection of Victorian homes built in numerous European styles along the water. The shoreline was filled in, and the streets were paved with oyster shells. The City of Norfolk had built a retaining wall around the water by 1919.

Once just marsh and farmland, the land around the Hague was populated with wealthy residents who admired the Hague for its beauty and its function for sport. The west bank of the Hague once was crowded with commercial boatyards and anchorage space for sailboats, yachts, oyster boats and barges. An extension of Brambleton Avenue with a fixed bridge to connect to Hampton Boulevard would cut off boats to the Hague Marina and commercial water traffic and yachters from entering into the Hague in 1960. When standing on the Ghent Bridge today, imagine what the waters of the Hague would look like with dozens of sailboats and yachts dotting the landscape.

Botetourt Footbridge or Ghent Bridge
The Hague at the intersection of Botetourt, Mowbray Arch, and Drummond Place

For more than two hundred years, a wooden footbridge ran across Samuel Smith's Creek to connect plantations to the city of Norfolk. In 1889, the bridge was washed away in a storm. To replace this bridge, a spectacular steel-riveted bridge (costing $38,000 to construct) was designed by John R. Graham Jr. and completed in March 1891. Ten gas lamps with three gas jets each sparkled splendidly over the waterway, providing residents and guests of Ghent a scenic walk into the community. Eventually, two trolley lines would cross the bridge, allowing for public transportation into Ghent, as well as a toll road for cars crossing into the neighborhood, until passage was limited to pedestrians and cyclists only due to the bridge's deterioration in 1963. At the time it was built, residents referred to it as Botetourt Street Bridge, as it was a continuation of Botetourt Street from the Freemason District across the creek into Ghent, but today it is often known as Ghent Bridge.

Thankfully, in the 1970s, when the City of Norfolk was faced with maintenance and possible replacement of the bridge, it decided to preserve Graham's original steel-riveted bridge as much as possible. It opted to create a new footbridge incorporating parts of the old bridge into the new structure. Charles Thayer Jr. evaluated the state of the old bridge in 1974

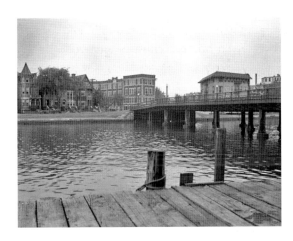

May 3, 1940 photograph of the footbridge at the Hague. *Courtesy of the Sargeant Memorial Collection, Norfolk Public Library.*

and concurred that the old pile caps, pedestals and ironwork hand railing could be reused to construct an eighteen-foot-wide footbridge with two sets of pedestals. Today, the bridge is a landmark in Ghent and marks the southern boundary of Ghent Historical District. It provides the community with a place of respite and a wonderful view of the Mowbray Arch skyline, coupled with a view of the Chrysler Museum of Art that can be viewed on foot or on bicycle.

The Holland Apartments
200 Drummond Place

The Holland Apartment building was constructed from 1904 to 1907. It was designed by the local architect Clarence Neff of Neff & Thompson in the Beaux Arts style at the foot of the Botetourt Street Bridge. Neff was said to have become enamored of the style when traveling to Holland in 1900 and used that trip as inspiration to design the first apartment complex in Ghent, perhaps even replicating a Dutch architect's design. This coincidence further extends the intention of the Norfolk Company's branding of Ghent to its European-inspired roots. The Holland Apartments were built in preparation for the Jamestown Exposition of 1907, a popular world's fair that commemorated the 300th anniversary of the founding of Jamestown. The apartments were intended to serve as temporary housing for workers coming into Norfolk for the exposition. It originally contained a dining room, the Holland Confectionery or store, a barbershop and a kitchen for its residents on the first floor, with each

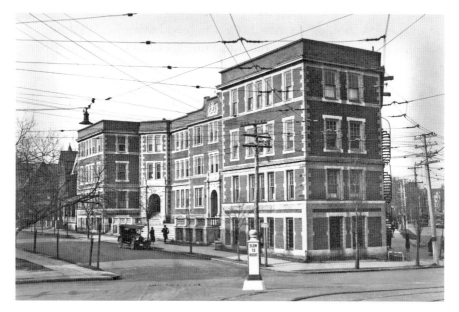

Holland Apartments as seen in 1925, surrounded by overhead trolley wires. *Courtesy of the Sargeant Memorial Library Room, Norfolk Public Library.*

apartment having access to dine via the dumbwaiter system. The kitchen became a popular lunchtime restaurant for Ghent residents from the 1930s through the '50s.

The building fell into despair in the 1960s, as much of historic Ghent did, and it was used as a homeless shelter in the 1980s before being renovated in 1983 by R.G. Bosher and R.A. Lawson Corporation. The original dumbwater kitchens were repurposed into laundry rooms with washer and dryer hookups, along with modern amenities such as central air conditioning and heat pumps. The exterior of the building still has its original charm and appearance and currently has twenty-four units that are rented out.

Sarah Leigh Hospital
Mowbray Arch (no longer standing)

The construction of Sarah Leigh Hospital in the Beaux Arts style on Mowbray Arch in 1902 signaled the importance of medical care facilities to meet the demands of Norfolk's growing population. Ghent seemed to

be the perfect location for new hospitals to be built—Norfolk Protestant Hospital (later Norfolk General) went up just blocks away from Sarah Leigh and almost simultaneously. Sarah Leigh was founded by premier surgeon Dr. Southgate Leigh and opened in 1903 with 28 beds. It was the forerunner to Sentara Leigh Hospital and included a state-of-the-art design with round corners for easy cleaning, a basement-based air-cooling system and a fire suppression system. Two wings were added to the hospital, and it stayed in operation until it was destroyed by fire in June 1987. Norfolk General and Sarah Leigh formed the foundation of Sentara Healthcare in 1972, a nonprofit healthcare organization serving Virginia and northeastern North Carolina. Sarah Leigh would be renamed to Leigh Memorial Hospital and relocated to its present-day location as Leigh Memorial Hospital on Kempsville Road, housing 250 beds.

Wesley W. Hozier Home
400 Warren Crescent at Pembroke Avenue

One of the most highly ornate residences in Ghent, the Hozier Home is a spectacle to behold. It was built in 1897 of brick and stone with six slim columns supporting a front porch with a floral-adorned band atop a stone archway. The Pembroke Avenue side of the house boasts arched windows and a profusion of Greek key and egg dart molding. A domineering turret juts out high above into the treetops, begging its visitor to imagine what the view would look like from above. Hozier owned a Main Street stationery store and had this beautiful home built for a little less than $7,000. The architect is unfortunately unknown. Today, the house has been split into multi-family apartments.

William L. Tait Home
436 Mowbray Arch

This whimsical English Tudor home with Shingle-style elements has an interesting and romantic origin story. William Tait's daughter supposedly met a young architect while off at boarding school in England. She returned to her family in Norfolk, where they were living on Colonial Avenue. This unknown architect and lover was said to have sent her the blueprints to build this unique home on Mowbray—with mismatched, asymmetrical

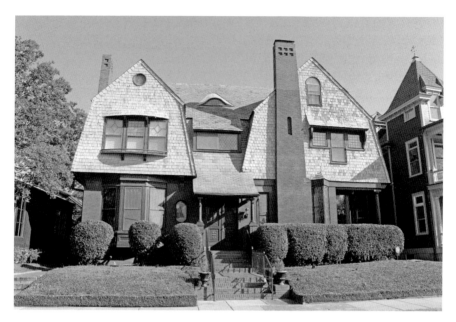

Photo of the Tait Home. *Courtesy of Raven Hudson.*

and folk elements—as a symbol of his devotion. While the Tait daughter eventually married another man, it was these blueprints that brought this treasured, quirky home to Ghent as the Tait family home in 1900. The Tait family moved back to England, and by 1913, the house was occupied by William Rodman, general solicitor of the Norfolk Southern Railroad Company and John L. Roper Lumber Company. This story is recorded by Amy Waters Yarsinske in her book *Ghent: John Graham's Dream, Norfolk, Virginia's Treasure*.

Horace Hardy or Hardy-Twohy Home
442 Mowbray Arch

This Romanesque Revival home was built in 1892 by Horace Hardy, a Norfolk/Ghent Company promotor and businessman. It has also been occupied by three generations of the Twohy family. Hardy sold the house just a few years after building it due to the hefty mortgage on the house and the depression of 1893. It was the only house on Mowbray Arch at the time when Fergus Reid purchased it; he failed to get a tenant for a few years while it sat vacant. In 1899, when an Irishman, Mr. Twohy, purchased the

house for $21,000, seven other houses had joined the home on Mowbray Arch. He was the superintendent of Lambert's Point Coal Piers, president of Lambert's Point Tug Boat Company and a member of the Norfolk City Council. The home is missing its cupola and takes on a more modern appearance than it did in the 1890s.

The subsequent generations of the Twohy family to live in the house brought Grace Elizabeth Chapman to Ghent, as she married John Twohy II in September 1924. Grace was an avid gardener and created the Town and Country Garden Club and served as the president of the Garden Club of Norfolk and the Garden Club of America.

Frank S. Royster Home
303 Colonial Avenue at Warren Crescent

The Royster mansion is a sprawling 8,100-square-foot Georgian Revival–style house built between 1900 and 1902 and designed by John Kevan Peebles, one of Virginia's leading architects. A son of a planter from North Carolina, Royster was a successful businessman in many ventures, including fertilizer production, banking, railroads and steamships. He is mostly known as the founder as the Royster Guano Fertilizer Company. Royster and his wife, Mary Rice, had eight children, four of whom lived to adulthood and maintained the house until the Second World War, when the house was sold. Graceful porches once spanned the east and south sides of the house but have since been removed.

View down Colonial Avenue, with the Royster Home on the left. *Courtesy of the Sargeant Memorial Collection, Norfolk Public Library.*

William Whaley House
317 Colonial Avenue

This Dutch Colonial–style house built in 1893 at 317 Colonial Avenue was originally built by the architectural firm Maury and Dodd for thirty-four-year-old spinster Helen Reid, Fergus Reid's sister. Mr. Reid built an impressive house next door, but it became the Whaley home upon completion because Mrs. Helen Reid unexpectedly died before seeing it complete. William Whaley was a lumber merchant from Whaleyville, a neighborhood in Suffolk, Virginia. The Whaley family of seven lived in this house with two African American domestics: Caroline Lane, forty-six, from North Carolina, and Louisa Baily, thirty-four, from Virginia. These women probably shared the small attic space together. In January 1905, a fire sparked from the chimney and significantly burned the roof of the house but was thankfully put out by local fireman. No one was hurt in the fire, and the Whaleys moved out the following year in favor of bigger house on Pembroke Avenue.

Fergus Reid Home
507 Pembroke Avenue at Beachwood Place

Fergus Reid, a cotton broker, and his wife, Mary Wilson Chamberlaine, had their family home built in Beachwood Place across from John R. Graham Jr.'s home. Both Graham and Reid worked for the Norfolk Company and were two of the first residents of Ghent when their homes were constructed in 1892. The architect of the many Ghent homes was John Apple Wilson, including both the Reid and Graham Homes and the homes of Tunstall and Hardy. The Reid Home was the most expensive of the first houses built in Ghent at $11,448.02 and boasts a combination of materials such as shingles, rusticated marble, columned porches with arches and brick chimneys.

This house was a popular place of entertainment in Ghent, most famously visited by President William Howard Taft in 1909, along with other noted guests including industrialist Andrew Carnegie and Virginia governor Claude Swanson. Mary Reid was a well-known Ghent socialite and host. She was a philanthropist interested in the beautification of Ghent and art and with her husband contributed to establishing an arts community in Norfolk. She had three children, two of whom lived into

Photo of Fergus Reid Home, with Graham Home in the background. *Courtesy of the Sargeant Memorial Library Room, Norfolk Public Library.*

adulthood and maintained the home. Their only daughter, Helen, married Baron Jean de Lustrac, a French army officer, making her a baroness. The house remained in the Reid family until Helen's death in 1990.

John R. Graham Jr. Home
502 Pembroke Avenue at Colonial Avenue

Possibly the first residence to be completed in Ghent belonged to a civic engineer from Philadelphia who designed the layout of Ghent's streets: Mr. John R. Graham Jr. This Georgian Revival home was built in 1892 on what seemed to be barren farmland in photos from the year. Another eight or nine houses would quickly be built in the year following its completion, and dozens more were on their way thanks to the persistence of the Norfolk Company's founders who first called Ghent home by settling themselves in stately houses along the waterfront.

Graham had previously served on major projects as an engineer for railroad companies such as New River Railroad and Manufacturing, which was founded by his father. He worked for Norfolk and Western Railroad Company until 1884, when he moved back to Philadelphia to be the manager of the Camden Iron Works. He then came back to Norfolk in 1890

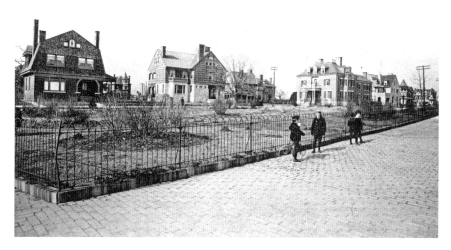

From left to right: Whaley House, Reid House and Graham House. *Courtesy of the Sargeant Memorial Library Room, Norfolk Public Library.*

to be the chief superintendent of the Norfolk Company, the very company that purchased the land to develop Ghent and subsequently made Graham one of the most influential citizens of the new suburb. Graham surveyed the land, laid out outlandish plans to develop a beautiful neighborhood, designed the iconic Ghent Bridge and saw through the creation of an artfully curated collection of impressive homes and a community of successful Norfolkians.

William H. White Home
434 Pembroke Avenue

Built in the Romanesque Revival style, the home of William and Emma Gray White was completed in 1892, the same year as many of its neighbors in Beachwood Place. White was a prominent lawyer and promoter for the Norfolk Company who worked to make Ghent Norfolk's top residential neighborhood. White served as vice-president and general counsel for the City Gas Company of Norfolk. In 1897, he was appointed U.S. district attorney for the Eastern District of Virginia by President Cleveland. White's father served as colonel under General Pickett at the Battle of Gettysburg in July 1863, while the son served as a young private. Walter White survived the battle, but his father perished.

Leache-Wood Seminary
407 Fairfax Avenue

The Leache-Wood Seminary was a school founded in 1871 by two remarkable women, Irene Leache and Annie Cogswell Wood. This was a premier school for girls in post–Civil War Norfolk that educated the girls of Norfolk's most prominent families. It was originally located at 138 Granby Street before being sold in 1898 and moved to 407 Fairfax Street at Mowbray Arch in 1900.

Leache and Wood were lifelong friends and took it upon themselves to host open discussion clubs, poetry readings and other cultural activities in the city during Reconstruction. Although the school officially closed in 1917, the ladies' legacy can be felt all throughout Ghent today, as it was their work in the art community that became a catalyst for what is now the Chrysler Museum of Art. Months after Leache's death in 1900, Wood established the Irene Leache Memorial to honor her friend. The memorial organization hosted cultural activities citywide that led to the creation of Norfolk Symphony Orchestra, the Little Theater, the Norfolk Society of Arts and the Tidewater Artists Association. The legacy of these ladies can still be seen in the Chrysler's galleries today, with twenty-seven artworks being donated to their collection in 2014 from the Irene Leache Memorial Foundation, as well as an endowment for the curator of European art. The building that remains from the old school, just blocks from the Chrysler Museum, is now made up of sixteen apartments varying in size located on three floors.

William and Miriam Hemingway House
410 Pembroke Avenue

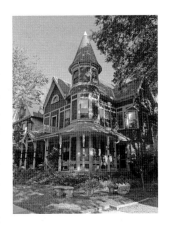

William Duane Hemingway was born in New Haven, Connecticut. He was the resident partner in the firm of H.F. Hemingway & Company, oyster packers. He was thirty-eight and his wife, Miriam, was twenty-eight when they built this $5,000 Victorian vernacular house with gingerbread trim, a marvelous turret and Gothic features. The couple had two daughters, Mabel (five) and Mildred (almost two), when they moved to Ghent from the corner of York and Botetourt Streets. Both

William and Miriam Hemingway House. *Courtesy of Raven Hudson.*

William and Miriam, otherwise known as Minnie, are buried locally in Norfolk at Elmwood Cemetery. This home, built circa 1894, was divided into four apartments with full kitchens.

John W. and Anastatia D. Burrow Home
419 Colonial Avenue

This house was built for the Burrow family in 1894 and stayed in the family until 1933, when it was occupied as the Garrison-Williams School. Mr. Burrow was a wholesale and retail druggist with a store in downtown Norfolk on Main Street in the 1890s. This home cost $14,750 to build and was the most expensive house built in Ghent in the 1890s. His shop eventually became Burrow, Martin and Company Inc. Today, the building operates as the Williams School, one of Norfolk's top private schools for kindergarten through grade eight. It is common to see Ghent residents walking their children to this school or to see outdoor classes in Beachwood Place.

Richard B. Tunstall Home
530 Pembroke Avenue

The Tunstall home, built in 1892, was designed by John Apple Wilson in the Queen Anne style. He was a prominent lawyer and served on the Norfolk Common Council and Sinking Fund Commission.

Edward R. Baird Home
544 Pembroke Avenue

Edward R. Baird was a prominent attorney and partner at Baird, Swink, and Moreland. This home was built circa 1910 in the Colonial Revival style and boasts beautiful yellow brick, a signature symmetrical façade, a handsome dormer window, ornate Corinthian columns and a stately green roof. It is still a single-family home and has five bedrooms and four and a half baths.

Robert Page Waller House
551 Warren Crescent

This Queen Anne–style home was built for Robert Page Waller and his wife, Virginia Pelham Stuart Waller, in 1895. Waller was a wholesale grocer and president of the Daily Roller Mills. His wife was the daughter of Confederate Major General J.E.B. Stuart. Mrs. Flora Cooke Stuart, J.E.B.'s widow, lived at the residence with her daughter and son-in-law. Mrs. Stuart wore traditional black mourning attire for more than fifty years in remembrance of her husband, who died at the Battle of Yellow Tavern in May 1864.

Leonard P. Roberts Home
539 Warren Crescent

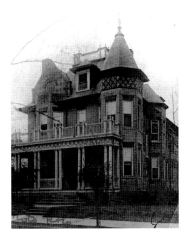

Leonard P. Roberts was a prominent wholesale and retail grocer with a store on Commercial Place. He had this house constructed for his family in 1898 in the Queen Anne style. In 1878, Roberts married Ruth Jordan, who was an orphan who lost her father to the Civil War and her mother to an early death. The two had eleven children, six of whom lived to adulthood. The Roberts house cost just over $14,000 to build and had twelve fireplaces. A unique fact about that Roberts household is that they had twin daughters, the only twins growing up in early Ghent.

Leonard P. Roberts Home in 1910. *Courtesy of Sargeant Memorial Collection, Norfolk Public Library.*

The unusual pattern of brick, complementary slate roof and beautiful turret make it a favorite house of onlookers today.

Ernest L. Woodard Home
524 Warren Crescent

Ernest L. Woodard had this Renaissance Revival home built in 1902. He was a local wholesale grocer. This unique style of home was inspired by Italian architecture of the 1630s and was popular from the 1890s to 1930

in East Coast cities. It is highly varied and sometimes difficult to discern but typically features impressive scale with Classical details such as columns, round arches and balustrades.

C. Moran Barry Home
542 Mowbray Arch at Mill Street

C. Moran Barry was an accomplished businessman as the president of O'Neill-Barry Company, president of Barry, Parks and Roper, vice-president of Mutual Savings and Loan Company Inc. and treasurer of Universal Savings Corporation. Barry, Parks and Roper dealt with real estate, investment banking and insurance loans and has offices in the Bank of Commerce Building at 300 East Main Street. This home was built for Moran's family in 1904 and currently has seven bedrooms and four and a half baths.

William H. Robinson Home
570 Mowbray Arch

The William H. Robinson home was built from 1905 to 1906 in the Jacobean Revival style, which was unique among other homes in Ghent with terra cotta, stucco, wood and leaded glass. Mr. Robinson was president of the American Brazing Company and vice-president of the Standard Manufacturing Company.

Alvah and Mary Martin Mansion / Woman's Club of Norfolk
534 Fairfax Avenue
(757) 625-9318 / www.womansclubofnorfolk.com

The Martin Mansion was built in 1909 as the primary residence of the Martin family in the Georgian Revival style. It is a ten-thousand-square-foot brick building with twenty-one rooms. The Martin family lived next door to the mansion as it was constructed. Mr. Martin served as county clerk from 1881 to 1918. He served on President Taft's Executive Committee and used his influence to secure the Port of Norfolk as the port of entry for the state of Virginia.

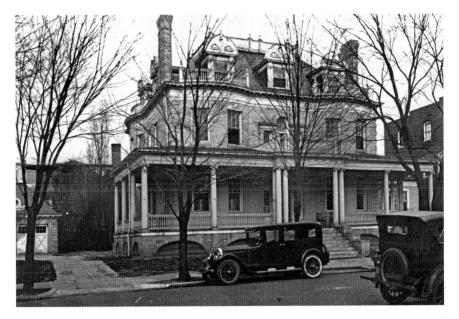

The Woman's Club of Norfolk in 1925. *Courtesy of the Sargeant Memorial Collection, Norfolk Public Library.*

In 1919, the property sold to the Virginia Club, a gentleman's organization. In 1925, the Woman's Club of Norfolk purchased this property for $45,000, which was half what the men paid for it in 1919, and the club still operates here today. The beautiful building has a grand front porch and a wonderful original WPA mural in its entrance hall. It is available for a limited number of rentals per year and has become a popular spot in Ghent for weddings and receptions.

Charles Wesley Fentress Home
621 Colonial Avenue

The Charles Wesley Fentress home was built by a firm renowned for designing some of Ghent's most prominent homes: Carpenter and Peebles. Fentress was a local businessman who owned C.W. Fentress and Company, which was a wholesale dealer in dairy products. A promising young entrepreneur, Fentress opened a grocery store on the corner of Church and Freemason at the age of sixteen. He was one of the founders of Norfolk Refrigerating and Cold Storage Company and acted as director of the City National Bank of

Norfolk. Fentress sadly lost his first wife, Sue Bayton, at twenty-four years old; she also left him with an infant child. He remarried, to Effie Eley, and together they had four more children.

Pelham Place Apartments
521 Boissevain Avenue

The Pelham Place Apartments were built in 1906 as a resident hotel for upcoming guests of the Jamestown Exposition of 1907. In the 1950s, the buildings were renovated to become an apartment complex while maintaining the architectural features of the original structure. There are currently seventy-four units total.

Christ & St. Luke's Episcopal Church
560 West Onley Road
www.christandstlukes.org

Christ Church was constructed in 1909, with its first church service occurring on Christmas Day 1910. The Gothic Revival–style church was designed by the Philadelphia architectural firm Watson and Huckle and boasts an epic 130-foot bell tower with the oldest bell in Norfolk that can be seen all across Ghent. The church banner dates back to 1637 to the English colonists of the Elizabeth River Parish. St. Paul's congregation moved from its third Borough Church in 1800, abandoning a 1739 building at the corner of St. Paul's and City Hall Avenue that was later refurbished and occupied. The congregation moved to another building on Freemason Street when its new building was destroyed by fire in 1826.

In 1909, Christ Church moved to the new suburb of Ghent and laid dual cornerstones for the current building on October 28, 1909. The cornerstone on the left side of the church was for the new building, and the cornerstone for the right side was from the 1800 and 1827 churches. A fire severely damaged the building in 1914, just four years after it opened, but the church quickly restored it and opened again on Easter 1915. The adjoining Parish House was built in 1919 in the same style of the church, and further expansions were completed in the 1950s to include another hall. Christ Church was consolidated with St. Luke's and St. Andrew's due to economic hardship in the 1930s. St. Luke's beautiful building on Granby Street was destroyed by

a lightning fire in 1921. The names merged, forming Christ and St. Luke's Episcopal Church, and St. Andrews became a separate parish again in 1940. Today, the church is frequently used for concerts by local and international musicians due to its incredible acoustic capabilities, as well as a hub of local and international outreach ministry.

Stockley Gardens
Located off Onley Road at Stockley Gardens

The Stockley Gardens section of Ghent is home to the regionally famous Stockley Gardens Arts Festival, which occurs biannually. The gardens are a strip of land that separates historic houses on one side and a street of religious structures on the other side, including Christ and St. Luke's Episcopal Church, Ghent United Methodist Church and Ohef Sholom Temple. Both Ghent Methodist and Ohef Sholom were designed by architect John Kevan Peebles and built in 1902 and 1917, respectively. Most of the area

April 9, 1944 photograph of people strolling through Stockley Gardens on Easter. *Courtesy of the Sargeant Memorial Collection, Norfolk Public Library.*

encompassing Stockley Gardens and the land between Colonial and Colley had been developed by 1910 with apartment complexes and single-family homes. The northern edge of Stockley Gardens was Armistead Bridge Road, now known as West Princess Anne Road.

Bybee Sanitarium
631 Westover Avenue

This impressive home, built circa 1900, once functioned as the Bybee Sanitarium. Dr. Harry Rainey Bybee was a chiropractor and saw patients here from 1911 to 1923, until it was taken over by Cox Funeral Home. Bybee attained national acclaim as president of National and Virginia Chiropractic Associations. He had many famous clients, including Billy Sunday, General John J. Pershing, Frank Sinatra, World Series–winning manager Billy Southworth, Yankee shortstop Phil Rizzut and Al Jolson.

Today, this home is a private residence and has five bedrooms and seven baths. It has been restored and updated to perfection on the interior, boasting a graceful staircase and a grand foyer.

First Presbyterian Church of Norfolk

820 Colonial Avenue at Redgate
www.fpcnorfolk.org

The current First Presbyterian Church of Norfolk, formerly Ghent Presbyterian, was built in 1911 in the late perpendicular Gothic style to replace a smaller church for a larger one at Colonial and Redgate for its growing congregation. It was designed by architect F. Finlay Ferguson, who was also a member of the church. The history of this congregation spans back to 1678, when Scottish immigrants settled on the shores of

the Elizabeth River seeking refuge from religious persecution. The first church building erected by this congregation was built in 1800 at the corner of Bank and Charlotte Streets. In 1910, $50,000 was raised by the congregation, half of which came from prominent Ghent resident Frank S. Royster, to build this impressive place of worship. First Presbyterian and Ghent Presbyterian voted to join in 1912. Today, the remarkable sanctuary is a popular place for public lectures and regular church services.

A snowy view down Colonial Avenue near Raleigh Avenue, March 24, 1940. *Courtesy of Sargeant Memorial Collection, Norfolk Public Library.*

Fred Heutte Horticultural Center

Botetourt Gardens at Raleigh Avenue
(757) 441-2513 / www.genserva.com/fhcgarden

Tucked away in Botetourt Gardens is a beautiful ferry terminal (built in 1887) that was originally located at the foot of Commercial Place in downtown Norfolk for sixty-five years. The terminal closed in 1952 and was left vacant for twelve years after it was rendered unnecessary by the opening of the Norfolk-Portsmouth Bridge-Tunnel. It was moved to the middle of Ghent

Square and restored in 1977 by the Norfolk Redevelopment and Housing Authority and the Federation of Garden Clubs. The reconstructed terminal is now painted gray but would have originally had a red roof and orange walls to match the ferries on the Elizabeth River. The terminal is named in memory of Fred Heutte, a former superintendent of Norfolk Parks and a leading advocate of gardening and horticulture in Norfolk.

Frederick M. Killam Home
820 Graydon Avenue

The spectacular residence of Frederick M. Killam (built in 1905) is one of the most impressive family homes in North Ghent. Killam was the president of F.M. Killam Company and treasurer of the Highland Park Syndicate and Lambert's Point Investment Company. Killam Avenue bears his namesake.

The Wishing Tree
The median on Redgate Avenue near the intersection of Matoaka Street

The wishes and hopes of Norfolkians are scribbled on scraps of paper wrapped around a cedar tree in the median of Redgate Avenue in West Ghent. A sign at the foot of the tree invites passersby to leave a wish attached to the tree for a friend or loved one. Hundreds of tags dance in the wind on a beautiful day in Ghent, sending out pleas for kindness, love, health and grace. Visit the tree and leave an anonymous wish for a loved one or yourself. The woman responsible for maintaining and establishing the tree in 2016 was inspired by a similar tree she witnessed on a trip to California.

The Little Theatre of Norfolk
801 Claremont Avenue
(757) 627-8551 / www.ltnonline.org

A charming local theater is located in the Chelsea neighborhood of Norfolk. The Little Theatre of Norfolk is an intimate 210-seat playhouse built in 1949 for the Norfolk community theater group that had been operating since 1926 on York Street downtown. Today, the group has five main-stage productions each season, including the classics and modern works,

relying heavily on volunteers. Check out a play at this iconic red theater and get drinks at one of the many local pubs, breweries or restaurants in the Chelsea District.

The Naro Theatre
1507 Colley Avenue
(757) 625-6276 / www.narocinema.com

This iconic addition to Colley Avenue opened on February 24, 1936, as the Colley Theatre. William S. Wilder built this single-screen theater for $75,000 to share his love of live theater and movies. It is an Art Deco–style theater with five hundred seats. The opening-night picture was an adaption of Shakespeare's *A Midsummer Night's Dream*, starring James Cagney, Olivia de Havilland and Dick Powell. The theater changed hands in the 1960s when Robert Levine purchased it and renamed it the Naro Theatre, combining the names of his father and mother, Nathan and Rose. Levine unfortunately lost the theater to creditors in the early 1970s, leaving it to the Stein estate, which still owns the property today. By the mid-1970s, the theater had become a playhouse called the Actor's Theatre. In 1977, Tence Phillips and Thom Vourlas leased the theater to showcase foreign, art and independent films. Their company, Art Repertory Films, has run the Naro as an independent theater ever since and still shows a variety of movies—including blockbusters, pop culture features and classic movies—and serves as a gathering place for lectures, live music and public discourse. A large group of patrons came together in 2013 to update the video technology at the Naro to a state-of-the-art projection system to ensure its survival in Ghent as a staple to the arts community. Be sure to stop in for a matinee or to see its popular rendition of *The Rocky Horror Picture Show*, which has run for more than thirty years.

Chapter 6

ON THE SEASHORE

ATTRACTIONS IN OCEAN VIEW

Matthew Whitlock

INTRODUCTION

Ocean View is Norfolk's main coastal region. Spanning roughly seven miles in length, Ocean View boasts excellent views of the Chesapeake Bay, Willoughby Spit and the Norfolk Naval Base, home to the United States' North Atlantic Fleet. Like most of Hampton Roads, Ocean View was part of the Elizabeth River Shire in 1634. It was then considered part of New Norfolk County in 1636. The county was divided the following year, and Ocean View became part of Lower Norfolk County. By 1691, Ocean View was in Norfolk County and remained there for more than 225 years.

William Mahone, a civil engineer, Confederate general during the Civil War and later United States senator from 1881 to 1887, worked to build and then expand the railroad lines throughout the state. Prior to the Civil War, Mahone established the Norfolk and Petersburg Railroad, using logs from the Great Dismal Swamp. Part of his new rail line went through Ocean View, leading to a new railroad town.

During the American Civil War, Norfolk, including Ocean View, started as a Confederate city but became part of the Union in 1862 and remained that way through the end of the war. The City of Norfolk annexed most of present-day Ocean View in 1923 except for eastern Ocean View, which became part of the Little Creek Amphibious Base, a U.S. Coast Guard base.

One of the major appeals to locals and tourists is the lack of hotels, leading to the development of moderately to high-priced housing along

Big seine haul at Ocean View, 1950. *Courtesy of Sargeant Memorial Collection, Norfolk Public Library.*

the shoreline and in neighboring communities. The lack of hotels means more shoreline availability for visitors looking to relax, swim, sunbathe, fish, crab or take a nice stroll and sunrise or sunset.

SITE GUIDE

The First Settlers and Sarah Constant Beach Park
300 West Ocean View Avenue
Norfolk, VA 23510

Named after one of the three original ships (although most know the ship as the *Susan Constant*) making their way with British adventurers to Jamestown, the Sarah Constant Beach Park is an excellent shelling area along Ocean View and boasts excellent views of the Chesapeake Bay. There is a small grove of trees of older trees in the vicinity for those looking for a short walk in nature. City officials claim that the 104 settlers landed at this location in 1607 prior to their arrival in Jamestown. The colonists were looking for an inland site, well defended from both the natives and Spanish ships. Not liking the area, the British continued west through the James River and northwest to present-day Jamestown. A shrine to the settlers landing in Ocean View is marked at this location along the dune line at the beach.

Magagnos Plantation

The original area developed by William Mahone was under the occupation of the Magagnos family, a wealthy family whose lineage might date back to some of the earliest settlers in Jamestown. The Magagnos plantation consisted of 360 acres but was purchased by Mahone prior to his railroad line. The plantation laid the foundation for the future community of Ocean View and also its road system.

City Beach
East Beach Drive near the intersection of Shore Drive

Designated as a "colored beach" during the 1900s, City Beach was a small plot of beach located on the western side of present-day East Beach. In 1930, the Norfolk City Council met about Ocean View beach and its availability to all residents regardless of race. Reporters noted that more than 1,500 people attended the meeting. The city agreed to purchase eleven acres that night to allow African Americans to have a section of beach to swim and relax. Unfortunately, the purchase led to a legal battle, with opponents of the beach arguing that adding the beach would decrease their home values. The court case continued until everything was settled. and City Beach was available for use in 1934 but did not officially open until 1935. Although most of the area has been developed with luxury homes, there are still old, thin wooden fences that line the section designated at the time.

Ocean View Amusement Park
End of Granby Street and Ocean View Avenue

In the early 1900s, the Virginia Electric and Power Company (VEPCO) built amusement rides at the end of its streetcar line in Ocean View. Although locals and tourists flocked to the end of the line to enjoy the uninterrupted beaches, VEPCO realized the need for something better in the area that would only remove a small section of land. By 1905, VEPCO's plan to create a fun activity center prevailed, and there was an increase in demand for streetcars to the Ocean View Station. The earliest thrill ride was the Figure Eight, a sit-down rollercoaster on a wooden track that had an enjoyable turning experience rather than the traditional out and back rollercoaster.

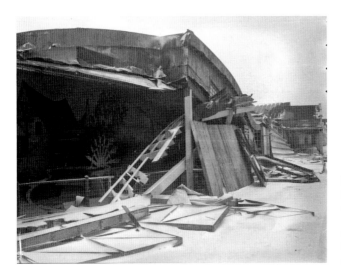

Storm damage at Ocean View Amusement Park, 1940. *Courtesy of Sargeant Memorial Collection, Norfolk Public Library.*

The Figure Eight would be replaced later by the Serpentine and then the Leap-the-Dips, a more traditional wooden rollercoaster that continued to operate until the park's demise.

The slow but methodical approach to expanding the amusement park changed with the park's second owner, Otto Wells. Wells believed that "curiosities" would add to the profit margins. One of the new curiosities was this fascinating new product called an "ice cream cone." The owner of the product, Abe Doumar, claimed to have sold more than twenty-two thousand cones in one day. His son and family currently own Doumar's near downtown Norfolk, where they still make ice cream cones by hand, and you can purchase a large container of the cones to go. These curiosities, combined with the other amusements, made Ocean View Amusement Park one of the best attractions prior to the Great Depression.

The Great Depression was not kind to the park, but people still flocked from all over the South to see new attractions, such as Rosa Le Dareieux attempting to break a world record by staying on a flagpole for more than two months. Her feat was cut short by the hurricane of 1933. The park also received storm damage from a winter storm in 1940. The park changed ownership during World War II, and the new owner, Dudley Cooper, fixed many of the problems but also considered tearing it all down to develop the land, a highly profitable move. The U.S. Navy, practically next door to the park, convinced Cooper to keep it open.

The park flourished by the 1950s, with more than 1 million visitors attending annually. The Ocean View region expanded, and so the park

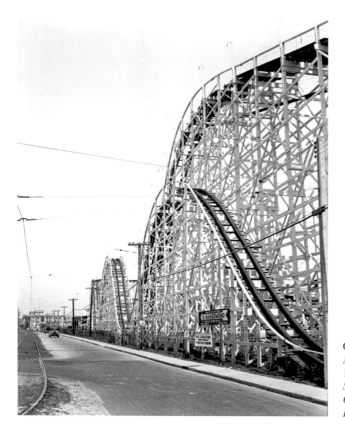

Ocean View Amusement Park, 1937. *Courtesy of Sargeant Memorial Collection, Norfolk Public Library.*

opted to build additional rides and attractions, such as a dance hall and casino. Even children could take part safely in the festivities with Kiddieland, consisting of five rides like the miniature boats and racecars, and Bulgy the Whale, a unique flying coaster. Yes, there was a Tunnel of Love.

The 1960s witnessed the slow downfall of the park as profits decreased while maintenance increased. The rise of other parks in Virginia by the 1970s led to the demise of the park, but not before Hollywood filmed *Rollercoaster*, a thriller movie that did not fare well in the movie theaters. The movie stars George Segal, Henry Fonda and Timothy Bottoms. A young Helen Hunt also plays a minor role in the film. The park was officially closed in 1978, and one final movie, *The Death of Ocean View Park*, would bring down the famous rollercoaster The Rocket. Much to the chagrin of demolition teams and camera crew, it took three attempts to destroy the rollercoaster.

Ocean View's Early Trolley System
Intersection at the end of Granby Street and Ocean View Avenue

Following the Civil War, Walter H. Taylor developed a nine-mile railroad line between Norfolk and Ocean View. The 1880s line name was the Ocean View Railroad, but Taylor and others decided to change the name to the Norfolk and Ocean View Railroad. The name of the train was the General William B. Mahone. This passenger line brought passengers to the beach on the weekends. Within the next twenty years, the rail line would also have trolleys that brought passengers to the Ocean View Amusement Park.

St. Patrick's Day Parade
Starts on Granby Street and continues onto Ocean View Avenue

The Irish community in Ocean View requested that the City of Norfolk allow a St. Patrick's Day parade in 1967. The city agreed, and the first parade was small, consisting of a few hundred people. Today's parade is the largest in the city, and the annual attendance is in the thousands. There are more than two hundred bands and floats, including traditional bagpipers. Make sure to Google the parade for up-to-date information and plan to have a designated driver or alternative ride available, as this is a drinking festivity.

The 1933 Chesapeake-Potomac Hurricane

A powerful, Category 4 hurricane struck Virginia in 1933, termed the "1933 Hurricane." Meteorologists at the time did not name hurricanes, but it was later given the name the 1933 Chesapeake-Potomac Hurricane. The southeastern portion of Virginia receives brushes from hurricanes almost yearly but rarely a direct hit. According to the analysis of storm hunters, the eye of the hurricane went over Norfolk before moving northwest toward northern Virginia. Portions of Norfolk were flooded, and the damage to the state was estimated at $17.5 million. In Ocean View, the Ocean View Amusement Park took the brunt of the damage due to beach erosion, high winds and pounding rain.

Harrison's Pier and Hurricane Isabel
Present location of Ocean View Fishing Pier
400 West Ocean View Avenue

Harrison's Fishing Pier, 1947. *Courtesy of Sargeant Memorial Collection, Norfolk Public Library.*

Harrison's Fishing Pier opened in 1947 as a four-hundred-foot-long wooden pier. The pier was only ten feet wide and had railings on one side. Harrison's was popular among locals willing to try fishing or crabbing and others looking for a nice walk on the Chesapeake Bay. The pier was named after Harry Harrison and was remodeled throughout the years until 2003, when Hurricane Isabel destroyed the pier. The Category 1 hurricane left the pier in such disrepair that the city requested it be demolished. There are still some pylons under the water at the new fishing pier.

Ocean View Fishing Pier
400 West Ocean View Avenue

Opened in 2005, the Ocean View Fishing Pier is 1,690 feet long on the Chesapeake Bay. The pier provides opportunities for locals and tourists alike to catch Chesapeake Bay blue crabs and a variety of fish that travels through the Bay throughout the year. You can also walk on the pier and catch a glimpse of some of the naval fleet going in and out of port, such as aircraft carriers and submarines. The pier also has a headboat fishing excursion for those who would like to venture into the Chesapeake Bay and fish. If you are hungry, there is a full-service restaurant. The pier also provides bait and tackle, including fishing rods and reels if you need to rent equipment.

Nansemond Hotel

Prior to World War II, the Nansemond Hotel was the largest hotel in Ocean View. It was established in 1920, although an earlier hotel built in 1907 for the Jamestown Exposition burned to the ground. Conveniently located near the Ocean View Amusement, the hotel welcomed vacationers until August

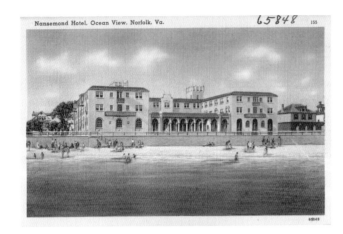

Postcard of
Nansemond Hotel.
*Massachusetts
Collections Online.*

17, 1942, when the Amphibious Force Atlantic Fleet (AMPHIBLANT) of the Naval Operating Base in Norfolk commandeered the hotel. The hotel became the headquarters for the Amphibious Force, U.S. Atlantic Fleet, in September 1942. Forces practiced "storming the beach" in front of the hotel. Major General George S. Patton arrived from California, stayed in the hotel for a short time and planned the TORCH attack in World War II. Throughout the remainder of World War II, plans were established in the hotel for invasions, including for Normandy, France. The hotel returned to a tourist destination in August 1945. The hotel burned down in November 1980, and many artifacts and mementos provided to the hotel after the war were lost in the fire.

The Sand Hills and "Thrill Hill"

Previously located from East Ocean View Avenue and Capeview Street west to Fourth View Street and east to the Little Creek Amphibious Base

The question remains: why is Ocean View called Ocean View? The answer might be found in a set of hills and dunes that existed prior to World War II known as the Sand Hills. The larger hills in Ocean View allowed someone to see the Atlantic Ocean if they looked to the southeast. Some of the hills were more than one hundred feet tall and three hundred feet wide. The onset of World War II saw the military move the sand out of present-day Ocean View. One of the few reminders of the Sand Hills is on Ninth Bay Street known as "Thrill Hill," where you drive up a steep incline and can turn around and drive down the same way!

East Beach
East Ocean View Avenue

This was an investment by the City of Norfolk in the 1990s. The city tore down more than 1,600 buildings and established a master plan based on quaint seaboard coastal homes. The city and state invested in a beach restoration project in 2003 with the plan to protect the shoreline from coastal storms. East Beach was recognized as one of the top restored beaches in the nation in 2007.

Ocean View Station Museum
111 West Ocean View Avenue

If you want to learn more about the history of Ocean View, make sure to stop at the Ocean View Station Museum. The museum contains old memorabilia of the area, as well as items from Ocean View Amusement Park. You can visit the museum at the Pretlow Library.

Hampton Roads Bridge-Tunnel
Interstate 64

Built in 1957, the Hampton Roads Bridge-Tunnel (HRBT) was a two-lane construct consisting of man-made islands and tunnels over the span of 3.5 miles. The second span of the HRBT opened in 1976. The HRBT is an important shipping channel and travel lane for U.S. naval warships. For automobiles and tractor-trailers, the HRBT allows travelers to move

from Norfolk to Hampton. On the Norfolk side, the bridge takes drivers across the Willoughby Spit and Willoughby Bay, with views of the Norfolk Naval Station.

Hampton Roads Bridge-Tunnel construction, 1956. *Courtesy of Sargeant Memorial Collection, Norfolk Public Library.*

A. Otto Lynch's Anchorage Cottage
850 West Ocean View Avenue

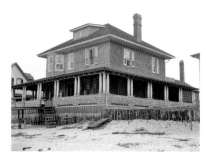

Arundah Otto Lynch built a waterfront cottage in the Willoughby Spit section of Ocean View in 1931. As the commonwealth attorney and later Norfolk County treasurer, Lynch used his cottage as a place to relax and reflect. Lynch's cottage still stands in its previous location but is now owned by the American Legion.

A. Otto Lynch's Anchorage Cottage, 1931. *Courtesy of Sargeant Memorial Collection, Norfolk Public Library.*

Willoughby Spit

In 1610, Captain Thomas Willoughby came to the land known as Virginia and received land grants in the Norfolk region. Thomas Willoughby II, Willoughby's son, and his wife lived in the present-day Willoughby Spit area

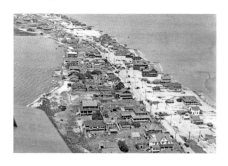

Willoughby Spit and West Ocean View, circa 1930s. *Courtesy of Sargeant Memorial Collection, Norfolk Public Library.*

in the 1660s and noted that after a terrible storm, there was land in front of their home that was once water. The family quickly amended their land grants in the area to gain more property. Other storms over the next two centuries molded the area and added new sand to what is now a land peninsula. The city invested millions in replenishing the shoreline following Hurricane Isabel in 2003.

Chapter 7

LEISURE IN LARCHMONT

LIFE NEAR THE HERMITAGE MUSEUM & GARDENS

Jennifer Lucy

INTRODUCTION

In 1906, a group of Norfolk businessmen purchased two hundred acres in the area known today as Larchmont to develop what they advertised as "Norfolk's only high-class suburb" in the *Norfolk Ledger-Dispatch.* They constructed streets and a water system and designed landscapes to set the burgeoning neighborhood apart from downtown. Spearheaded by T. Marshall Bellamy and J. Thomas Hough, Larchmont was sold in plots through the Larchmont Realty Corporation. Bellamy owned an 1833 home in the area, called the Vanderberry House, and oversaw the construction of Jamestown Crescent to lead to it.

In 1907, a streetcar was built on Atlantic and Jamestown Boulevards (today Hampton Boulevard), which outlined the eastern edge of the neighborhood. The line was built to transport visitors to the Jamestown Exposition, a seven-month international fair held at Sewell's Point to commemorate the 300th anniversary of the founding of Jamestown. During this time, new roads, railways, hotels and piers were constructed for the event, which drew 3 million visitors to the region. As a result, the Larchmont neighborhood received greater access and visibility. However, potential investors remained hesitant to purchase lots in an area they considered rural, located five miles from downtown. To remedy this, Bellamy created the Larchmont Transit Company, his own bus line, for automobiles that ran from downtown to Larchmont for five cents, or a "jitney" per ride. The line became known as the "Larchmont Jitney." Bellamy's idea was

a resounding success, and as more Norfolk citizens made their way from downtown to the suburbs, a 1916 article in the *Virginian-Pilot* sought a remedy for growing congestion. Of importance is the fact that the line began at the Confederate monument in the Commercial Place section of downtown, a location that may have suggested its destination was not as welcoming for nonwhite citizens.

New owners in Larchmont were required to purchase two to four twenty-five-foot lots to ensure distance between homes, and sixty-four had been sold by 1912. Of Norfolk's developments at the time, the only other neighborhood to grow more rapidly was Ghent. The majority of homes in Larchmont were built in the Colonial Revival style, which combined elements of Classic and Colonial styles to allow for a broad variety of more relaxed forms. Norfolk's style in particular embraced deep front porches that ran the length of the façade, side wings, ornate cornices and entrances, classical columns and the frequent pairing of tall, multi-pane windows, boxed eaves and a symmetrical balance of windows and doors on the façade. A majority of façades included six-paneled doors and shutters, and some homes adopted a gambrel roof, a symmetrical roof with two slopes on two sides. Some Craftsman bungalows and Victorian homes were also constructed in the neighborhood. The houses and lots in Larchmont and neighboring Lochhaven tended to be larger than the oldest homes in the city at the time. Sidewalks and street trees were incorporated into the neighborhood designs, including an abundance of crepe myrtles, adopted as the official tree of Norfolk, and 150-year-old trees along Magnolia Avenue. Homeowners often landscaped their front and side yards and added wood and wrought-iron fences.

Larchmont became known as a family-friendly community with tree-lined streets, access to a new elementary school in 1923, a library and higher education courses at what would become Old Dominion University. Larchmont and adjacent neighborhood Edgewater were combined and annexed to Norfolk in 1923. Census data from 1940 reveals that the majority of homeowners in North Larchmont were Caucasian, married and had children. Only two African American residents were listed as servants. Most residents were from Virginia or North Carolina, with the exception of two naturalized citizens from Canada and Lithuania. All male residents were employed, many in management and supervisory positions, and some women worked as teachers. Residents in Edgewater were also predominantly Caucasian, college-educated and ranged in age and profession. Several current and retired Navy servicemen lived in the

neighborhood, and Edgewater contained more owners originated from out of state than Larchmont.

Today, Larchmont-Edgewater begins at the corner of Hampton Boulevard north of Forty-Ninth Street and has a natural border of the Lafayette River to the east and north and the Elizabeth River to the west and ends at the border of Old Dominion University and Fifty-Second Street to the south. More than 5,600 residents lived in the neighborhoods as of the 2000 census, with a median age of thirty-three. The average household income is more than $100,000, and most residents are college educated.

Just across the Lafayette River, originally called Tanner's Creek, a similar, more affluent neighborhood began taking shape as early as 1908, when William and Florence Sloane started developing their "Hermitage," or remote retreat, a five-room summer cottage located on a private peninsula. The same year, several acres were purchased nearby for the development of a new Norfolk Yacht and Country Club. The Hermitage and club land was annexed by the city along with Larchmont-Edgewater in 1923, and a large portion of it became the Lochhaven neighborhood. Census data from 1940 shows that most households in Lochhaven were college educated, with men who held prestigious positions such as company presidents, lawyers and doctors, while their wives stayed home. Families were predominantly middle to upper class and were born in Virginia.

The Sloane family, originally from New York, relocated to the Berkley section of Norfolk in 1893 to run the first of three textile mills owned by William's uncle Foster Black. During this time, the Sloanes befriended English master woodcarver Charles Woodsend, who would oversee and assist with the construction of the Hermitage exterior and interior until his death in 1927. The original five-room home was reminiscent of a typical northern estate of the time, with half-timbering, brick and white cypress shingles. From 1910 to 1912, a stable and gardener's cottage were added to the property, followed in 1914 by a cabin; by 1916, the Sloanes had two children, William Jr. and Edwin Knapp, or E.K., and had decided to make the home their permanent residence. Florence oversaw the reorientation of the home into an Arts and Crafts–style mansion that included Gothic and Tudor elements. The Sloanes hired W. and J. Sloane and Company to add a new wing, including a master suite, a library, a formal dressing room and a morning room. Around this time, the family also purchased adjacent lots in the neighborhood to give and sell to acquaintances and friends. The Sloanes would continue adding and modifying the Hermitage for almost thirty years, ending in 1937 with forty-two total rooms.

Before the expansions, the Sloanes began to amass a substantial amount of wealth, as their mills produced garments for Soldiers serving in World War I. This enabled the family to expand their estate as well as grant them the opportunity to give back—to provide space for entertainment and retreat for servicemen. The family opened their grounds and partnered with groups including the Red Cross, YWCA and YMCA to invite American and overseas Allied forces to several parties and events with tea, music, games and swimming. They also donated additional properties and a boat, the USS *Caprice*, to aid in the war effort.

In the early 1920s, Florence bolstered her interest in collecting art while visiting her sons at Oxford University and traveled extensively throughout Europe, collecting what is today the foundation of the Sloane Collection, a collection of more than five thousand objects spanning more than five thousand years and representing thirty countries. Florence befriended and maintained relationships with art dealers, artists including Douglas Volk, Helen Turner and Harriet Frishmuth, and contacts at the Smithsonian including A.G. Wenley, the second director of the Freer Gallery, to build what would be considered one of the most thoughtful, eclectic collections in the state and one of the largest collections of Asian art in the Southeast. Simultaneously, she oversaw the design of the estate's gardens and incorporated more than ninety millstones, a sunken garden, a tennis court, a formal English rose garden, a millstone alley with aviaries, a large southern magnolia tree by the shoreline and more. The Sloanes were also avid supporters of the arts in Norfolk and were heavily involved in the construction of the first wing of the Norfolk Museum of Arts and Sciences, today the Chrysler Museum. Florence's efforts to promote the arts were recognized with the award of Norfolk's First Citizen medal in 1932; she was the first woman to receive the honor.

In 1937, while still in residence, the Sloanes decided to open the Hermitage to the public and established the Hermitage Foundation. Their mission was to "encourage the development of arts and crafts and promote the arts within the community," as they sought to "prove that the arts play a role in everyday life." The Hermitage hosted exhibitions, events and art classes and welcomed visiting artists. Today, the museum is considered one of Norfolk's "hidden gems," and the foundation continues as a nonprofit 501(c)(3). Florence's legacy is continued through a year-round schedule of exhibitions, programs, concerts, art classes and camps, tours, weddings and more for the public. Curators also maintain relationships with artists and national and international museums and galleries to bring new perspectives to the region.

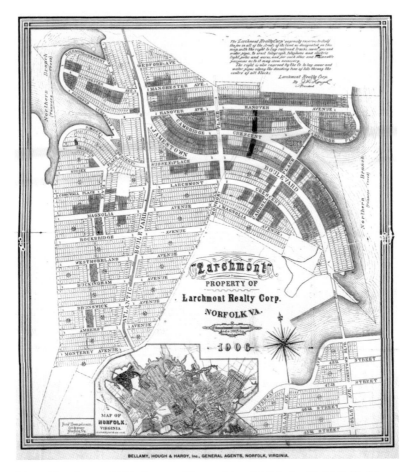

Map of Larchmont, 1906. *Courtesy of Sargeant Memorial Collection, Norfolk Public Library.*

Today, the Larchmont-Edgewater and Lochhaven neighborhoods face uncertain futures with the increase of global warming and sea level rise, which is predicted to rise 2.5 feet in the next fifty years in Norfolk. Several streets in both neighborhoods experience precipitation, storm and tidal flooding. Both communities are designated Zone A, "most at risk during flooding and storm surge," and are among the first areas to evacuate. To combat these concerns, Virginia was recently awarded $120 million in 2016 from the U.S. Department of Housing and Urban Development, and the City of Norfolk received the largest portion of the grant. Groups and experts at Old Dominion University, the Massachusetts Institute of Technology, Naval Station Norfolk and Rise Resilience Innovations are

just a few of the teams brainstorming how Norfolk can adapt to become a thriving coastal community of the future. These neighborhoods are a glaring reminder of what risks being lost: family histories, distinct architecture and even priceless artifacts.

SITE GUIDE

Larchmont School

In 1912, the original Larchmont Elementary School was built on the corner of Hampton Boulevard and Boiling Avenue under the jurisdiction of the Tanner's Creek School Board. Two teachers, Mrs. Rose and Mrs. Covington, served about 120 students in grades one through three and four through seven. Within its first decade, the school was expanded to accommodate population growth in Norfolk's suburbs following World War I. In the late 1920s, an even larger location was required, and the City of Norfolk constructed a new school across the street. The original building was given to the College of William & Mary, which had been using the facility to offer extension courses since 1919. Renovations to the building and the purchase of an additional twelve acres adjacent to it enabled the college to establish a Norfolk Division, which would form the foundation for Old Dominion University. The first class of about two hundred students was admitted in the fall of 1930. Through 1975, the building served many uses as an administration building and a science building and provided classrooms for art, political science and English, among others. Today, a brick field with a historical plaque stands where the school used to sit.

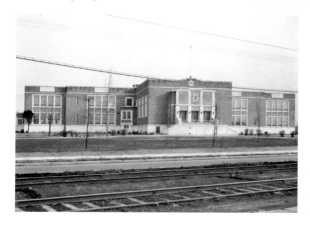

Larchmont School, 1930. *Courtesy of Sargeant Memorial Collection, Norfolk Public Library.*

Larchmont Library
6525 Hampton Boulevard

The original library for the Larchmont neighborhood was known as the Tanner's Creek Branch and was housed in the Larchmont Elementary School beginning in 1923. When a new Larchmont School was built across the street in 1931, the library relocated along with it until a separate location was constructed in 1968 and renamed Larchmont Library. The new site had been utilized in previous years as a station to charge street cars. Today, the library remains at the location and is a popular destination for families. It is located along the Elizabeth River Trail, a 10.5-mile trail that runs between Harbor Park Stadium and Norfolk International Terminals. Adjacent to the library are the Birdsong Wetlands, Norfolk's first living shoreline restoration project. Led by the efforts of the Elizabeth River Project, the project restored about three hundred feet of shoreline and more than fifteen thousand feet of wetlands in 1997 and "persists as one of the earliest and most long-lasting demonstrations of living shoreline erosion control techniques in South Hampton Roads," according to the Chesapeake Bay Foundation.

Larchmont United Methodist Church
1101 Jamestown Crescent
https://www.larchmontumc.org

The original Larchmont United Methodist Church was built in 1911 through the vision of six neighborhood members. The church was rebuilt in 1954 in brick, with abstracted Classic and Colonial styles, popular motifs featured on churches built in Norfolk in the 1950s. As the congregation grew, the building was expanded and renovated again in 2014.

Magnolia Avenue

The magnolia trees found along Magnolia Avenue are more than 150 years old and may be the oldest historic landscape element remaining in the city. The trees were originally planted by Lieutenant Andrew Weir and his new bride, Mary Allen, to line the drive leading to their grand home in 1844. The Weirs' home, located at the end of the avenue and facing the Lafayette

Magnolia Avenue trees. *Courtesy of Jennifer Lucy.*

River, was constructed in 1793 by Lieutenant Weir's grandfather and was formerly called Lebanon. A plaque commemorating the Weirs stands today at the corner of Magnolia Avenue and Monroe Place.

Powhatan Avenue

Named after the prominent Native American chief who led more than thirty tribes at the beginning of the 1600s and encountered the first Jamestown settlers, this 1.6-mile avenue travels through land once owned by Sir William Beckley, a colonial governor in the 1600s. Before the avenue's construction in 1894, this section of Norfolk also contained waterfront windmills in the early 1800s and farmland. Around 1907, the year of the Jamestown Exposition, adjacent streets including Argall and Rolfe were added to refer to other prominent historical figures of Jamestown.

Boush-Tazewell House
6225 Powhatan Avenue

This private, historic residence was built by shipwrights in 1783–84, commissioned by the grandson of the first mayor of Norfolk, John Boush. Designed as a late-Georgian town mansion, the two-story home was originally constructed in downtown Norfolk and is considered the "first significant dwelling erected in the old borough of Norfolk after the city burned in 1776" by the Virginia Department of Historic Resources. Additions to the home included a two-tier portico suspended by slender Tuscan columns added in 1791 and waterfront Greek Revival wings that were added in the mid-1800s. In 1810, the house was purchased by Littleton Waller Tazewell, a politician who worked under Presidents Madison and Jefferson and served as a U.S. senator and governor of Virginia. Tazewell entertained notable guests, including John Tyler, Henry Clay, Lafayette and Andrew Jackson. Today, the house is noted to contain the original Federal woodwork interior. The residence was relocated to Powhatan Avenue around 1902 by Mr. and Mrs. Arthur Clarico Freeman, who believed that the new location was reminiscent of the original site.

Exterior view of the Boush-Tazewell House. *Courtesy of Jennifer Lucy.*

Norfolk Yacht and Country Club
7001 Hampton Boulevard
https://www.norfolkyacht.com/About_Us/NYCC_Today

The first Country Club was established in what is today the Edgewater neighborhood in 1896 to encourage outdoor sports including tennis, bicycling and riding. In 1902, the club relocated and expanded to a thirty-five-acre site near Sewell's Point but quickly faced accessibility challenges due to poor road conditions and unreliable trolleys. The city, however, planned a major development project at the site for the Jamestown Exposition, an international fair to celebrate the 300th anniversary of the Jamestown Settlement, and the club sold the property in 1906 for $500,000. In 1908, the club's final location,

Swimming pool at the club, 1954. *Courtesy of Sargeant Memorial Collection, Norfolk Public Library.*

adjacent to the Atlantic Avenue trolley and bridge, was selected along the Lafayette River. The site included a clubhouse, four tennis courts and a nine-hole golf course later expanded to eighteen. At the beginning of World War I, the club's prior location at Sewell's Point was sold to the U.S. Navy to serve as an essential military center. The government also asked the club to give up part of the golf course to become a cargo terminal to aid in the war effort, today the Norfolk International Terminals. Around 1927, the club sold the remainder of the golf course to become a large portion of the Lochhaven neighborhood. The club's name has been changed twice, first in 1923 when it was annexed to the city of Norfolk and again when a marina was added in 1936 to the full name "Norfolk Yacht and Country Club."

Marine Hospital
6506 Hampton Boulevard

This hospital was built in 1922 to replace the first U.S. Marine Hospital, constructed in 1787. The original building was located in the Berkley section of Norfolk and was utilized both as a barracks for Confederate troops during the Civil War and as an Army hospital during Union occupation. The new location served Coast Guard members, fishermen, ship crewmen and merchant marines until it was closed in 1982 and purchased by the U.S. Navy. Today, the building houses the Naval Facilities Engineering Command, an integral, global command that provides the U.S. Navy and U.S. Marine Corps with the support and training bases they require.

Hampton Boulevard Bridge

The bridge connecting Larchmont and Lochhaven, formerly known as the Tanner's Creek bridge, has seen many iterations beginning as early as 1862, when Confederate forces burned it during Norfolk's surrender. In 1900, a new wood and steel drawbridge more than two thousand feet long was completed. The bridge contained both rails and lanes for vehicles. Beginning in the 1930s, new bridges at this location have become known as the Hampton Boulevard Bridge.

Hampton Boulevard Bridge, 1927. *Courtesy of Sargeant Memorial Collection, Norfolk Public Library.*

Private Residence
8005 Blanford Road

Located on the Lafayette River, this private Dutch Colonial Revival home was built in 1912 by William Rogers Martin of the Burrow-Martin Drug Company. During extensive renovations in 2010, eight symmetrical brick-lined gardens reminiscent of typical English gardens were discovered. The gardens were restored along with a fountain and pond.

Private Residence
1543 Cloncurry Road

This private Colonial Revival home was built in 1925 and features an expansive backyard filled with roses, native plants and grasses that overlooks the Lafayette River and Hermitage Museum. The interior includes a 1960s wood-paneled den designed by architect John Paul Hanbury, who also oversaw the restoration of more than twenty historic buildings in Virginia, including the Wells Theatre and Freemason Street Baptist Church in Norfolk.

Hermitage Museum & Gardens

7637 North Shore Road
www.thehermitagemuseum.org
Tuesday through Sunday, 10:00 a.m.–5:00 p.m.
Free Admission

The Hermitage Museum & Gardens is a twelve-acre estate located on a riverfront peninsula in the Lochhaven neighborhood. William and Florence Sloane, wealthy New Yorkers who moved to the area to operate textile mills in the 1890s, purchased the land in 1908 to build a five-room summer cottage in the Arts and Crafts style. By 1916, the couple had decided to make the home their permanent residence, and Florence oversaw its reorientation and expansion to forty-two rooms through 1936. The Sloanes were educated art collectors dedicated to bringing the arts to Norfolk. As a result, they were pivotal founding members of the Norfolk Museum of Arts and Sciences, today the Chrysler Museum, and the couple decided to transition their private residence into a nonprofit public museum in 1937. Through Florence's vision, the Hermitage was transformed into a dynamic center for the arts where visitors could experience a collection of more than five thousand artworks from around the world, enjoy walks through formal gardens and an aviary, attend community events and elaborate parties and take classes at the Visual Arts School, formerly a horse and cow stable. Today, the Hermitage is a proud member of the Smithsonian Affiliations Program, is accredited by the American Alliance of Museums and is protected by a Conservation Easement awarded in 2017. Commonly referred to as a "hidden gem," the estate today offers changing indoor and outdoor exhibitions by renowned artists from around the world; an annual calendar of original programs, including a performance series, concerts, lectures and classes; weddings and private event rentals; and more.

Exterior view of the Hermitage Museum and Gardens. *Courtesy of Jennifer Lucy.*

Chapter 8

HISTORY THROUGH THE HEADSTONES
NORFOLK'S HISTORIC CEMETERIES

Shannon Stafford, with an Introduction by Jaclyn Spainhour

INTRODUCTION

The rural cemetery movement became popular in the mid-nineteenth century due to a variety of concerns over the unsanitary conditions and disrepair associated with burial grounds adjacent to urban churches. Rural cemeteries, located between two and five miles outside the city center, developed as a result. This was also the case in Norfolk, as cemeteries developed on the outskirts of town. Many of these cemeteries are still accepting burials today, while others simply offer a place of quiet refuge for residents.

From their inception, cemeteries were intended as civic institutions designed for public use. Before the widespread development of public parks, such as Central Park and others, the cemetery provided a place for the general public to enjoy outdoor recreation amid art and sculpture previously available only for the wealthy. It featured paths for carriages to ride through and many varieties of foliage and plants. The "streets" were often named after flora and fauna popular with people of the era, which was a big selling point when marketing the plots to potential buyers.

Botanicals were often reflected within the imagery on the headstones themselves. For instance, ivy often represented memory, poppies meant sleep, acorns indicated life and oak leaves were popular representations of immortality. These images could often be viewed alongside cherubs, different types of angels—such as recording and guardian—and symbols reflecting

the newly popular ideas of death as hope, sleep and immortality reflected in the impending resurrection.

Often, these cemeteries featured large-scale monuments created for wealthy and influential families of the period. These tombs served as a way for families to have immortality and act as symbols of enduring status. Visitors can view such monuments at Norfolk's historic cemeteries today.

Some of the larger cemeteries erected between the nineteenth and twentieth centuries became destinations in their own right, such as Hollywood Cemetery in Richmond. While Norfolk's historic cemeteries are not quite as large or elaborate as those in larger cities like Richmond, New York or New Orleans, their beauty is undeniable. Grab a book, pack a picnic and find a seat below the magnolia trees to enjoy the charm of these memorial gardens.

SITE GUIDE

St. Paul's Episcopal Church

201 St. Paul's Boulevard, Norfolk, VA 23510
(757) 627-4353 / http://www.stpaulsnorfolk.org

By far the most historic spot in all of Norfolk is St. Paul's Episcopal Church and the surrounding burial grounds. The church was a place where all visitors through the decades would make it a point to visit and take a pleasant walk through the graveyard, stopping to read the historic epitaphs on centuries-old slate headstones that can be found throughout the burial ground. The church and the graveyard have survived many significant events, including the Great Fire of 1776 and the bombing by Lord Dunmore, evidence of which can still be seen today if you spot the cannonball fired by the HMS *Liverpool* embedded in the wall of the church. This church is the sole colonial-era building that survived various wars and numerous rezoning projects of Norfolk.

The church you see now was built in 1739 and replaced the original structure, which was built in 1641. This church was the only place the people of the borough of Norfolk could worship until 1773. Following his defeat at the Battle of Great Bridge, Lord Dunmore attacked Norfolk from the sea as he fled Virginia on January 1, 1776. In retaliation, Patriots set fire to the homes of Loyalists; however, the fire became unmanageable, and nearly the entire town was destroyed by the flames. Following the bombardment and burning of Norfolk in January 1776, only the thick walls of the church remained standing.

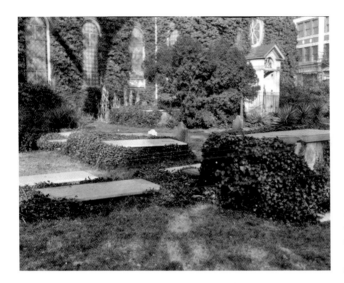

St. Paul's graveyard, circa 1930s. *Courtesy of Sargeant Memorial Collection, Norfolk Public Library.*

The church was a place of many historical events throughout the last few centuries. The formal commemoration of the death of George Washington in 1800, a yellow fever epidemic in 1855, the Union occupation during the Civil War and the funeral of General Douglas MacArthur in 1964 are just a few of those notable events visitors may recognize.

St. Paul's Episcopal Church burial ground is the oldest in Norfolk and the Hampton Roads area, and it remained the only official burial ground for the city of Norfolk until 1825. The graveyard was in use for more than two hundred years, and although many stones do not exist today to display its full contents, the graveyard is full in capacity. The causes of the losses of the grave markers are many. Some of the stones were destroyed during the bombardment of the church during the Revolutionary War, while others succumbed to natural decay and weathering over the decades. Many people of the colonial period could not afford stone because they were imported from England and very expensive, another reason why fewer stones than bodies are present in the burial ground. St. Paul's also boasts three stones of significant age that can be dated back to the seventeenth century: two hanging on the walls and one lying flat just south of the church. The graveyard is dotted with stones of various materials, which indicates the longevity of its use. Sandstone headstones, hip and box tombs and ledger stones can all be found in this burial ground. The graveyard is open to the general public seven days a week.

St. Paul's burial ground is also notable for the veterans interred on the property, twenty-four of whom served during the Revolutionary War and

twenty-two of whom served during the War of 1812. There are no other burial grounds in Norfolk that contain remains of veterans from these conflicts. Norfolk's founders can also be found under in the dark tree canopy and along the brick wall that surrounds the property on the south side of the church. On the north side of the church, you can find the headstones of the founding fathers of the Freemason Society, with some of the earliest stones in Virginia noticeable, as they display the right angle and compass on the headstones. One other notable individual interred on the property is John Stratton, who was born on August 19, 1769, and passed on May 10, 1804. Stratton was an eighteenth- and nineteenth-century congressman and lawyer from Norfolk, Virginia, who represented Virginia in the United States House of Representatives from 1801 to 1803. His grave is unmarked just north of the fountain.

Cedar Grove Cemetery

238 East Princess Anne Road, Norfolk, VA 23510
(757) 441-2576 / https://www.norfolk.gov/851/Bureau-of-Cemeteries

In the early 1820s, the City of Norfolk knew that it had a problem: people kept dying, and St. Paul Episcopal Church burial ground was almost at capacity. Norfolk's leaders had to decide, like many other cities throughout the country at that time, to create a publicly owned cemetery that was open to all dominations. This was forced further as the population continued to grow and the rural cemetery movement took hold. In 1825, following the closure of St. Paul's churchyard, the city enacted a borough ordinance aimed at curbing yellow fever. The ordinance stated that the burying of the dead in private lots residing on public and populous streets was injurious to the health of the citizens of the city. The ordinance also restricted the creation or the continued use of private burial grounds within the city, like St. Paul's. To this end, the decision was made to use twenty acres of land on the northern outskirts of the city for a new burial ground. This plot of land became known as Cedar Grove Cemetery and is Norfolk's oldest publicly owned cemetery.

The cemetery was designed as a garden cemetery by Thomas Williamson. Garden cemeteries were designed to be like parks, with benches, bushes and many different species of trees as part of the rural cemetery movement, which pushed cemeteries to the outskirts of town rather than the city centers. Cedar Grove Cemetery was a popular place for people to spend

John Randolph Tucker's tombstone at Cedar Grove, circa 1930s. *Courtesy of Sargeant Memorial Collection, Norfolk Public Library.*

their weekends picnicking and visiting passed loved ones, as was custom during the nineteenth century. The earliest grave in the cemetery is actually 1806, located in the potters' field section of the cemetery, which predates its official founding. This is not unusual, especially in areas where the poor would bury their dead when finances could not afford a proper burial in the already-established burial grounds. Cedar Grove has several large family vaults, which were popular from the opening of the cemetery to late eighteenth century. These vaults are situated half above the ground and half below the ground and are usually arched with bricks, which contained shelves on which to place coffins. Family vaults were large investments and could hold up to twenty family members. Cedar Grove also has some unusual honeycomb tombs visitors can view, which are denoted by a rectangular chamber enclosed by an arc of outer walling so that the graves multiply outward from the original single cell at the center.

Notable burials in Cedar Grove include Civil War Soldiers and some of Norfolk's founding families. Individuals of note include Thomas Hare, a radio pioneer located at Block 58, Lot 1; Martha Butt, a writer and early suffragette located at West Walk, Lot 5; Carol Tevis, a movie star located at Block 50, Lot 2; Louis Jaffe, an editor and the father of Virginia's anti-lynching law, located at Salter Street, Lot 10; William Bagnall, an Underground Railroad hero, located at 1st Alley West, Lot 4; and Lewis Warrington, an officer in the U.S. Navy during the Barbary Wars and the War of 1812. Warrington temporarily served as the secretary of the Navy and is located at 1st Alley West, Lot 21. Visitors can also find Stephen Wright, a Revolutionary prisoner of war, at 1st Alley, Lot 46.

Cedar Grove is also one of three known sites containing mass burials of the victims of yellow fever, which struck Norfolk in 1855 and killed one out of every three people. Throughout the pandemic, nearly one hundred Norfolk citizens died on a daily basis. This caused quite an issue for the

city in terms of burial space and timing. The bodies of most victims were loaded onto wagons and brought to Cedar Grove Cemetery to be buried in their family lot or a mass grave, which is located in the potters' field along the back brick wall.

Elmwood Cemetery

238 East Princess Anne Road, Norfolk, VA 23510
(757) 441-2576 / https://www.norfolk.gov/851/Bureau-of-Cemeteries

Elmwood Cemetery is a fifty-acre municipal cemetery established in 1853 to replace the rapidly filling Cedar Grove Cemetery across the street. Elmwood is also an example of a garden cemetery design, filled with monuments and mausoleums that exemplify the symbolism of the Victorians' fascinating relationship with death. The majority of cemetery headstones at Elmwood date from the Victorian era, as is evidenced by the romantic symbols throughout the area. It is important to note that all headstones are placed in the classic Christian east–west manner and that some of the graves are marked by a headstone, footstone and side barriers that make the grave look like a bed frame. Blankets of ivy nestled between the headstone and footstone are meant to portray death as a sleep, a romanticized Victorian notion of death prevalent throughout the nineteenth century. Elmwood was placed in the National Register of Historic Places in 2013 and is now commemorated with a Historic Highway Marker along Princess Anne Road.

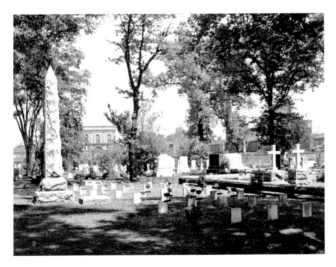

Pickett-Buchanan section at Elmwood Cemetery, 1938. *Courtesy of Sargeant Memorial Collection, Norfolk Public Library.*

The Core Mausoleum, located in Block 19 and considered the largest mausoleum in Hampton Roads, was constructed between 1910 and 1915. Its architecture and accompanying sculptures reflect the Greek, Early Romanesque and Egyptian Revival styles. When John Core died in 1910, he stated in his will that construction of this mausoleum was to total exactly $100,000. In his will, Core also requested for the mausoleum to face south to represent his service in the Confederacy during the Civil War and his loyalty to the Southern cause.

The LeKies Mausoleum, located at Elmwood Block, 7th Alley East, Lot 24, is also notable as an example of Gothic Revival architecture. Emma LeKies commissioned John D. Couper of Couper Marble Works to build a mausoleum to entomb the remains of her husband, John, after his death at the age of fifty-one. The mausoleum was completed in 1892 and resembles a small church or chapel. This is the second-largest mausoleum in Hampton Roads and the only mausoleum done in Gothic Revival style in the area.

Elmwood cemetery is a living museum for the Civil War for both the Confederacy and the Union forces. The Pickett-Buchanan Memorial Lot contains forty graves belonging to Confederate soldiers who fought under General George Edward Pickett, known as the hero of Gettysburg, and is located at the corner of 7th Alley East and Main Cross Alley. General Pickett's brother, Charles Pickett, was from Norfolk and served under his brother in the Battle of Gettysburg and is buried in Elmwood at Block 28, Lot 7. Also of note are the graves of militia members of the Norfolk Light Artillery Blues, which was originally formed in 1828. The group was placed on active duty in April 1861 as Company H, 16th Virginia Infantry Regiment. The Norfolk Light Artillery Blues lot contains nineteen graves of militia members, thirteen of whom remain unidentified. The gate to the Norfolk Light Artillery Blues lot is one of the few original gates remaining at Elmwood and is notable for its motif of crossed cannons. The gate includes the date of the Virginia militia unit's founding, 1828. Perhaps more recognizable are the graves of Henry Ramsay, the chief engineer of CSA *Virginia* during the first battle of the ironsides, located at 1st Alley West, Lot 28; Walter H. Taylor, the adjutant to Robert E. Lee who oversaw the paperwork and administrative functions of the Confederate general's commands, located at 2nd Alley West, Lot 35; and William M. Carr, a Union Navy Sailor in the American Civil War and a recipient of the U.S. military's highest decoration, the Medal of Honor, for his actions at the Battle of Mobile Bay, located at 3rd Alley East, Lot 39.

Elmwood Cemetery is the final resting place for many historical figures who help shaped the United States as we know it today. Littleton W. Tazewell,

for instance, is interred at 2nd Alley East, Lot 12. He was a Virginia lawyer, plantation owner and politician who served as a U.S. representative, senator and the twenty-sixth governor of Virginia, as well as a member of the Virginia House of Delegates. Pauline Adams, an Irish American suffragist who took a militant approach to the campaign and then went to prison for her political beliefs, is interred at Block 17, Lot 1, and is best known for starting the Norfolk Equal Suffrage League. Also of note is Maud Jamison, who was among the first "Silent Sentinel" picketers who, on January 10, 1917, protested President Woodrow Wilson's refusal to support a federal suffrage amendment. After the United States entered into the world war in 1917, Jamison was one of twelve suffragists arrested on June 25 of that year and among six suffragists tried on June 27 in police court in D.C., making her one of the first suffragists in North America to be sentenced to prison. She can be located at 8th Alley East, Lot 100. Robert Marr, who created the first floating sea mines with balsa wood that sunk seventeen U-boats in World War I, can also be visited at 2nd Alley East, Lot 57. William Couper, one of America's most noted sculptors of the late nineteenth and early twentieth centuries and the sculptor of various ornaments in Elmwood, can be found at Block 17, Lot 8. Sarah Lee Fain, one of the first two women elected to serve in the Virginia General Assembly, can be located at Wall A, Lot 14. Mary Ludlow Selden, who was born in Norfolk and through marriage became Baroness Von Zollikofer-Altenklingen of Austria-Hungary, is the only royal in the cemetery. She can be located at 1st Alley West, Lot 6. Susan Watkins, a well-recognized American artist known for painting in the styles of realism and impressionism, became the first woman to be elected an associate member of the National Academy of Design in 1910. She can be visited at Block 16, Lot 8.

West Point Cemetery

238 Princess Anne Road
(757) 441-2576 / https://www.norfolk.gov/851/Bureau-of-Cemeteries

For more than one hundred years, Norfolk's free and enslaved African American communities had to bury their dead in their backyards, fields and sometimes even out in the swamps. Permanent places for their remains were not on the top of the city's to-do list. In 1827, the Common Council created a Black potters' field located between Liberty, Scott, Hawke and Cumberland Streets in Norfolk to allow for burials. In 1873, the Common

Council established another potters' field located next to the west wall of Elmwood Cemetery, which officially became known as Calvary Cemetery in 1877. During this time, the original potters' field was moved to West Point Cemetery. African American city councilman James E. Fuller petitioned to change the name of the cemetery to West Point and to set aside a section for Black Civil War veterans to provide a place of dignity for the departed.

Section 20 is where the remains of fifty-eight African American veterans who served in Civil War are resting in peace, located in three rows. Standing watch over the grave sites is a life-size statue of an African American Union Soldier. Each veteran buried in this section has a government-issued veteran headstone. The West Point monument is a rare monument in the South, honoring African American Union veterans of the Civil War. There is also one mausoleum in West Point of note. This mausoleum was constructed of bricks and cement in 1876 by a mason who identified himself as O'Rourke. The badly deteriorated structure has been restored to its former glory and can be viewed today. A group of fifty-five badly weathered limestone headstones also survive in Section 27, which is called Pinner's Garden. This section predates the creation of the cemetery in 1873, possibly designating this as an early potters' field. The earliest burial date found in this section is in 1843, with many burials dating in 1855, when death rates were high and space was scarce as the yellow fever epidemic raged in Norfolk.

Calvary Cemetery

1600 St. Julian Avenue, Norfolk, VA 23504

(757) 441-2654 / https://www.norfolk.gov/851/Bureau-of-Cemeteries

On January 9, 1877, the Common Council passed an ordinance authorizing the land that was recently purchased by the city on Tanner Creek north of Princess Anne Avenue to be set aside as a burial ground for Black citizens. It was to be named Calvary Cemetery. Calvary is a sixty-eight-acre cemetery that memorializes the history of African American citizens in Norfolk. For ninety-three years, this was the only option African American people had to bury their loved ones. The cemetery is still currently open for new burials.

Calvary Cemetery has numerous historic figures sleeping in its hallowed grounds. Eugene H. "Ace" Bailey, one of the top football players in the Central Collegiate Athletic Association and one of the first players to be inducted into the Virginia State University Athletics Hall of Fame, can be found at Block 7, Lot 257. David Byrd, a founding member of the National Medical Association,

the oldest and largest group representing African American physicians, can be found at Block 11, Lot 156; Byrd was elected president of this group in 1916. Emma V. Kelley, who formed the Daughters of the Elks Auxiliary to the Order of the Elks organization, the first of its kind in the United States, is interred at Block 12, Lot 200. By the time of her death, the auxiliary had grown into an international organization of thirty-five thousand women. Frederick Jones, one the leading hat designers in North America from the 1980s until his death, is buried in Block 12 with no headstone. Annetta Lane, founder of the United Order of Tents, an organization for African American churchwomen founded in Norfolk, Virginia, is located at Cavalry Section Row 54, Lot D. The United Order of Tents worked to care for the sick and the elderly, to help those in need and bury the dead.

Forest Lawn Cemetery

8100 Granby Street, Norfolk, VA 23505
(757) 411-1752 / https://www.norfolk.gov/851/Bureau-of-Cemeteries

Forest Lawn Cemetery was established in 1906 and originally named Evergreen Cemetery, which was changed in April 1908 by permission of the city council. The City of Norfolk purchased 165 acres of property from George S. Bunting to create the cemetery. For generations, the Langley family owned the land, and the burial ground located on it was included in this purchase. It remains a historical point of interest today, with interments dating to the 1700s. After the front gate and fences were erected and the design finalized, the first burial here took place in 1908. The cemetery contains specific sections for each religious affiliation, including a Hebrew section. Also on the property is the Seaman's Friend Society Lot, which is the final resting place for hundreds of foreign sailors who passed away at sea or upon arrival to Norfolk's shores. The Seaman's Friend Society purchased the lot and paid for interment expenses to ensure a final place of honor for those lost to the sea. Forest Lawn Cemetery is also the final resting place for 100 other Soldiers who survived both world wars, the Korean War and the Vietnam War. The area also inters Soldiers from Australia, Britain and Canada. The cemetery is still open to new burials as of this publication.

Forest Lawn has many historical men and women buried in its sleeping fields. Evelyn Butts is one of the most famous interred on the property. She was an important civil rights leader in the 1960s and can be located at Fir Lawn Section, Row 21. Also interred on the property is George Hughes, who

was a professional football player who played five seasons with the Pittsburgh Steelers, was in sixty career regular season games and achieved Pro Bowl selection two times in 1951 and in 1953; he was inducted into the Virginia Sports Hall of Fame in 1983 and can be visited at Crape Myrtle Lawn Section, Row 6, Lot 91. Also of note is Frances Martin, who wrote numerous children's books, including *No School Friday* and *Sea Room*. She can be found at Live Oak Section, Row T, Lot 20. Visitors can also find Davis Robertson, a Major League Baseball player who played as an outfielder for the New York Giants, the Chicago Cubs and Pittsburg Pirates at Block E, Lot 6. Joseph Weatherly, an American stock car racing driver who was inducted into the Motorsports Hall of Fame of America in 2009 after winning NASCAR's Grand National Series championships in 1962 and 1963, can be found at the East Center Lawn Section, Lot 40N. Finally, Jessie Townsend, founding member and former president of the Norfolk Equal Suffrage League and former president of Virginia Equal Suffrage League, is also interred here.

Riverside Memorial Park

1000 Indian River Road, Norfolk, VA 23523
(757) 441-1967 / https://www.norfolk.gov/851/Bureau-of-Cemeteries

Riverside Memorial Park was established by a private company in 1910 in the Campostella Heights area of Norfolk. It came into the hands of the City of Norfolk in 1971 when the city purchased it. The design of this cemetery is unique to any other cemetery in Norfolk, as it is designed like the spokes of a wheel extending outward from a central main circle, which creates pie slice–shaped sections. The Hendricks family created and owned this cemetery in its early days, and a monument company occupied the site as well. As stones were able to be sold on site, the old sections of the cemetery witnessed the rise of large family monuments. One example is the Langley Angel Monument, which is located in the Magnolia Section of the cemetery. Riverside once had a large bell tower in the main circle, which would chime when funerals were taking place in the cemetery. The U.S. Army used the bell tower as a lookout during World War II—it was the most advantageous point since Riverside is one of the highest points in the Tidewater area. Over the decades, the bell tower fell into disrepair and was finally demolished in the 1970s.

Riverside Cemetery is the final resting place for William ("Willie"), Earl and Norman Phelps, the brothers who made up the Phelps Brothers Band.

This trio was a very popular country-western band with hit songs including the ballad "I'm Beginning to Forget You," which they did for Elvis Presley. They later opened the Fernwood Farms recording studio and dance hall in Norfolk, Virginia, which was used by the likes of Patsy Cline, Jimmy Dean, Ernest Tubb, Hank Snow and Bill Monroe. Visitors can find the brothers at Sunset Section, Lot 267 and Lot 231. Florence Steigler, an actress who went by the stage name Mary Ainslee and was well known for having worked on several projects with the Three Stooges, can be located at Rhododendron Section, Lot 330. She starred in dozens of movies and shows from the late 1930s to the early 1950s.

St. Mary's Catholic Cemetery
3000 Church Street, Norfolk, VA 23508
(757) 627-2874 / http://www.stmaryscemeterynorfolk.com/index.html

The nearly thirty acres of land used for St. Mary's Catholic Cemetery was purchased in 1854 by Father Matthew O'Keefe. The cemetery is located at the intersection of Church Street and Monticello Avenue and sits next to the Virginia Zoological Park. Magnificent white marble statues of saints, angels and crosses, as well as huge granite monuments and vertical columns, are found throughout the cemetery. A large bronze crucifix was erected in 1922 in the center of the cemetery to honor Catholic servicemen who served in World War I. This crucifix is identical to a crucifix displayed at the Aquia Shrine, located on Route 1 between Richmond, Virginia, and Washington, D.C. It stands thirty feet high and is surrounded by large boulders. There are five family mausoleums on the property, including a garden mausoleum, a ninety-six-niche columbarium and a niche chapel mausoleum. St. Mary's Catholic Cemetery is still open for new burials, and you can find many of Norfolk's Catholic founding fathers interred on the property.

Hebrew Cemetery
1200 Tidewater Drive, Norfolk, VA 23504
(757) 441-2576 / https://www.norfolk.gov/851/Bureau-of-Cemeteries

Hebrew Cemetery was established in 1850 when prominent Jewish families banded together to purchase a lot at the corner of Princess Anne Road and Tidewater Boulevard. Before the opening of Hebrew Cemetery,

the members of the local Hampton Road Jewish community buried their loved ones at Power Point Cemetery, which was established on Washington Powder Point, a section of Berkley where the southern and eastern branches of the Elizabeth River meet. At an unknown date, the Jewish community moved Power Point Cemetery to Hebrew Cemetery. Between 1859 and 1880, there was conflict in the Jewish community about who owned Hebrew Cemetery, and in 1880, a community resolution was reached. The solution was the creation of the Hebrew Cemetery Company, which lasted until 1957, when the City of Norfolk took over ownership. The cemetery is still open to new burials.

Magnolia Cemetery

Lancaster Street and Berkley Avenue, Norfolk, VA 23523
(757) 441-1967 / https://www.norfolk.gov/851/Bureau-of-Cemeteries

Magnolia Cemetery was established in 1860 and run by a private cemetery corporation in the town of Berkley, located directly across the eastern branch of the Elizabeth River from Norfolk. On January 1, 1906, the town of Berkley was annexed by the City of Norfolk and became one of Norfolk's legally recognized neighborhoods. In 1911, the cemetery company decided to sell the cemetery to the City of Norfolk, which has operated the cemetery since that time. The cemetery is a grid pattern Victorian cemetery, with the majority of the stones made out of limestone. The cemetery is closed to new burials at this time.

Chapter 9

MORE TO SEE AND DO
FOR THE HISTORY LOVER

Barbara Gullickson

INTRODUCTION

This book has touched on many of the historical buildings in Norfolk—those that still stand and those that are now gone. Aside from the obvious historical sites in Norfolk, there is much more to see and do for the history lover in this historic town. The tourism group VisitNorfolk describes this best: "Norfolk, Virginia is a city on the water, but never watered down. Built on character, by characters, a melting pot of people, cultures, and ideas that welcome a challenge as freely as we welcome visitors to this one-of-a-kind community. We invite you to take a chance for a change. Find inspiration on our shores. Explore our neighborhoods. Share our love of art. Experience our local flavors. Walk in our history. And never be afraid to loosen your sails and go wherever the wind takes you—a little change will do you good."[77] Read on for more to see and do in the city and make the most of your trip.

SITE GUIDE

Explore by Foot or Bike

The Elizabeth River Trail

https://elizabethrivertrail.org
Free Admission

The ERT is a 10.5-mile pedestrian and bike trail that traverses along the Elizabeth River, through historic neighborhoods and past thriving business districts. The course begins near the landmark Norfolk State University, founded in 1935. The ERT was established in 1999 with a donation of an abandoned stretch of track from the Norfolk Southern Corporation. The trail will take you past Harbor Park, home to the Norfolk Tides AAA baseball team affiliated with the Baltimore Orioles. Norfolk's Amtrak Station, located next to Harbor Park, provides a clean, modern facility for viewing exciting art outside the door. Next on the trail is a clear view of the Portsmouth Naval shipyard located across the Elizabeth River. Jump aboard the Elizabeth River Ferry or catch a water taxi to visit Portsmouth's quaint historic town. Docked in the Waterside District are the *American Rover*, the *Spirit of Norfolk* by Hornblower Cruises and the *Victory Rover*, all of which offer the unique experience of viewing Naval Station Norfolk from the water. Town Point Park is the site of various events and festivals throughout the year. Next on the trail is Nauticus, the battleship *Wisconsin* and the Naval History Museum. Nauticus Pier is the site of the Peter Decker Jr. Half Moone Cruise and Celebration Center. This cruise center greets thousands of visitors per year and offers a great place to begin a cruise.

Follow the water past the Taiwan Observation Tower (Pagoda) and through cobblestone streets to the Hague neighborhood, past the Chrysler Museum of Art and Glass Studio and the Harrison Opera House. Farther down the trail, you'll come to Eastern Virginia Medical School and Norfolk's extensive medical facilities. Located along these shores is PETA headquarters and the Bea Arthur Dog Park. Locals know that this is the best place to watch the fireworks on the Fourth of July as they shoot out from barges along the Elizabeth River toward Town Point Park.

Be sure to have your identification ready to visit Fort Norfolk, which is in the National Register of Historic Places, with eleven buildings still standing built between 1795 and 1809. The facilities are not open to tour, but the markers located throughout the grounds explain the historical

significance. The Army Corps of Engineers currently manages the fort. Access is only granted with a photo form of ID. Take time to enjoy Plum Point Park near the Midtown Tunnel, one of the six significant tunnels that come into Norfolk.

The next neighborhood you'll travel through is Chelsea, which was once an industrial area with shipyards, piers and marine-based activity. It is now home to an eclectic mix of business, breweries, restaurants and even a small live performance theater. West Ghent is the home to the Wyanoke Bird and Wildflower Sanctuary, managed by the Cape Henry Audubon Society. This lovely even-acre park is open to the public daily.

Ghent is the most substantial part of the ERT. If you want it, you can find it in Ghent. It is a lively area with various types of businesses, from antique stores to bars, restaurants, housing and even a 1936 Art Deco theater called the Naro. This work discusses many of these buildings and homes at length in chapter 5.

Past Ghent, the trail opens up to Old Dominion University and the Larchmont-Edgewater neighborhood. The school, established in 1930 as the Norfolk Division of the College of William & Mary, was renamed in 1962 to Old Dominion College and eventually became Old Dominion University. With many generous benefactors, Old Dominion has continued to expand its course offerings and is now one of Virginia's largest universities. The neighborhood surrounding ODU is called Larchmont and is home to a beautiful residential community first settled in 1906. Only five miles from downtown Norfolk and a few miles from Naval Station Norfolk and NATO headquarters, Larchmont's proximity to Old Dominion University makes it a desirable neighborhood with a wide variety of residents. Jacques Cousteau's Cousteau Society headquarters, WHRO local television and the local PBS station found space in Larchmont. Another point of interest here is Quarantine Road, which features homes where the crews from ships docking in Norfolk often were placed under quarantine while fighting yellow fever. There is a yellow fever burial site at the corner of Hampton Boulevard and Princess Anne Road.

Crossing the Lafayette River brings into view the Norfolk Yacht Club and another beautiful residential neighborhood called Lochhaven. A treasure on the North Shore is the Hermitage Museum & Gardens, once the home of a wealthy industrialist built in the Arts and Crafts style. It has a nationally recognized art collection spanning five thousand years.

The trail comes to an end just before the Port of Virginia International Terminals. This port is described as follows: "Located on 567 acres along

the Elizabeth and Lafayette Rivers, Norfolk International Terminals (NIT) is the Virginia Port Authority's largest terminal. Served by 14 super Post-Panamax class ship-to-shore (STS) cranes, NIT has a total of 6,630 linear feet of berthing, dredged to 50', capable of handling the newest class of Ultra Large Container Vessels (ULCVs) now calling the East Coast."[78]

The Cannonball Trail

https://www.downtownnorfolk.org/go/cannonball-trail
Free self-guided walking tour

The best way to explore this four-hundred-year-old city is to walk the Cannonball Trail. Start your adventure by visiting the Norfolk Visitor Center, located at 232 East Main Street, to pick up an extensive brochure on the trail's buildings and history.

Plan about two hours to walk the trail through the city streets at a comfortable pace. With more than thirty historical sites noted, some interest points include St. Paul's Episcopal Church, where a cannonball from the Revolutionary War still rests. Take a moment to visit the cemetery there, which has gravestones dating back to the late 1600s. Located just two blocks off the Cannonball Trail is the Minor Basilica of St. Mary of the Immaculate Conception. Its tall spire is visible from many directions in downtown Norfolk. It is the oldest Roman Catholic church in the region. Other historic churches along the trail include the Freemason Baptist Church, the Second Presbyterian Church, Epworth United Methodist Church and the Freemason Abbey, which was initially the Second Presbyterian Church, completed in 1873. In 1902, the church was sold to the First Church of Christ, Scientist but later became a popular restaurant. The building is still recognizable as a church and is part of the unique charm of the neighborhood.

All these buildings on the trail are historically significant, but many have taken on new roles in this modern city. The Old Norfolk Academy had many roles in Norfolk's history, serving as a Union hospital in the Civil War. It is now home to the family-oriented Hurrah Players, a theater group in Norfolk. The MacArthur Memorial rotunda building, which you will also pass, was once Norfolk's city hall. MacArthur Center was once the City Market site, and the U.S. Customs House was a Civil War dungeon.

The Old Hampton Roads Maritime Association Building formerly housed a bank. It is the only bank building that survived the Civil War.

The Royster Building, constructed in 1912, recently was renovated and is home to the Glass Light Hotel & Gallery Autograph Collection. Another fascinating find in Norfolk is the Old Norfolk Public Library. Built with a grant from Andrew Carnegie of the Carnegie Steel Company in 1904, the old library was part of the network of nearly 1,700 public libraries that Carnegie built across the country. The building currently is a commercial property with no access to the public.

Norfolk's Freemason District boasts various historic homes built in the late 1800s and early 1900s. The Moses Myers House and the Norfolk History Museum at the Willoughby Baylor House are two maintained by the Chrysler Museum of Art. While there are a few others, the Hunter House Victorian Museum is the only home open for tours. The Purdie-Taylor-Whittle House remains vacant due to foundation issues but once housed the Junior League of Norfolk's headquarters and the Norfolk Historical Society. Most historic buildings are private businesses or homes in the Freemason District. There is a variety of architectural styles that make the walk a feast for the eyes. Be on the lookout for Norfolk's collection of mermaid statues along the way. The "Mermaids on Parade" are part of a public art project. Currently, there are more than two hundred located throughout the city. Spotting and taking photos with the mermaids are favorite pastimes of locals and visitors alike.

Pedego Tours
Fee Charged
https://www.pedegoelectricbikes.com/dealers/norfolk#anchor-3

Pedego is a self-guided tour along the Elizabeth River Trail by electric bike.

Norfolk Tour Company
https://toursofnorfolk.com
Fee Charged

Norfolk does have some guided tours available through Norfolk Tour Company. Check the website to participate in a guided tour through either the NEON District or the Norfolk's Art District; the Freemason walking tour is also available. There are other options and times specialized upon request.

Taste of Tidewater Tours

https://tastevirginia.com
Fee Charged

Taste of Tidewater offers both a Craft Brewery Tour and Historic Norfolk Food Tour.

Discover Coastal Virginia

https://discovercoastalva.com/services
Fee Charged

Discover Coastal Virginia is a full-service Destination Marketing Organization and can arrange tours, transportation and event management for Norfolk groups.

Get Out on the Water

One of Norfolk's biggest attractions is the variety of waterfront opportunities. With just a landmass of 42 square miles, Norfolk has 144 square miles of waterfront. Getting out on the Elizabeth River in downtown Norfolk is not to be missed.

Boat Tours

American Rover and Victory Rover

https://www.navalbasecruises.com
Fee Charged

One of Norfolk's boat tours is aboard the *American Rover*, a beautiful three-masted topsail schooner. It offers a few sailing options, with a one-and-a-half-hour cruise and a two-hour cruise from the Waterside Marina in downtown Norfolk. History lovers will enjoy the information shared by the knowledgeable crew. The *American Rover* offers tours conducted by the Norfolk Tour Company on several days. The *American Rover*'s sister ship is the *Victory Rover*. It also conducts two-hour tours along the Elizabeth River. Not only do they share historical facts, but by the time they sail past

Naval Station Norfolk, they also have updated information on the vessels in port. That information will include vessel names, the type of ships and a brief history of duty tours. Naval Station Norfolk is the most extensive Navy base in the world. The facility celebrated its 100th anniversary in 2019. The site where the naval station sits today was the original site of the Jamestown Exposition in 1907, held to commemorate the founding of Jamestown three hundred years prior. Twenty of the exposition buildings remain and are in the National Register of Historic Places. These historic buildings are known as Admirals' Row. Also located on base is McClure Field, home to the second-oldest brick baseball park. During the war, many major-league players enlisted and arrived in Norfolk for training. Athletes who have played McClure Field include Phil Rizzuto, Pee Wee Reese, Bob Feller and Dom DiMaggio.

The *Spirit of Norfolk*

https://www.spiritcruises.com/norfolk
Fee Charged

The *Spirit of Norfolk* by Hornblower offers a different type of cruising experience. The *Spirit* is a floating entertainment venue and a great way to enjoy either lunch or dinner on the Elizabeth River. It's not just a dining experience—there is also music, dancing and a musical revue to enjoy. Also, this experience offers a chance to catch a spectacular sunset and then dance or sit serenely on the top deck as the twinkling lights of downtown Norfolk and Portsmouth end your day.

Virginia Elite

https://www.spiritcruises.com/norfolk/virginia-elite-yacht
Fee Charged

For those wanting a private luxury cruising experience, the *Virginia Elite* is available for hire. The *Virginia Elite* is just what the name implies. Once rented, visitors can enjoy an individual luxury experience with a crew that pays attention to every detail or a small group experience with the same focus on luxury and personalization.

Sail Nauticus

https://sailnauticus.org
Fee Charged

Sail Nauticus is also a great way to see the historic Norfolk/Portsmouth waterfronts and offers private sailing. While you enjoy the sights and sounds of Elizabeth River, the crew does the work.

The Peter G Decker Jr. Half Moone Cruise and Celebration Center

https://nauticus.org/decker-half-moone-center
Fee Charged

Norfolk's Peter G. Decker Jr. Half Moone Center sits on the site of a fort built in 1673 called the Half Moone. The Cruise Center is unique because it is situated right on the Elizabeth River in the heart of downtown Norfolk. This location offers easy access to museums and attractions, shopping and the business district. Carnival has sailings from the port to the Bahamas and Bermuda. Norfolk is a favorite port of call for several different lines and welcomes thousands of passengers every year. With the proximity to Colonial Williamsburg, Jamestown and Yorktown, history lovers can explore Virginia's first settlements. For beach and entertainment lovers, Virginia Beach is the neighboring city to the east, offering the ideal beach city experience.

These options offer the city's best views, the history and the mystique of why settlers came to Norfolk more than four hundred years ago. Norfolk is part of a region known as Hampton Roads, which initially meant "safe harbor," with its proximity to the bountiful Chesapeake Bay and a deep-water harbor. It is still vital today for that very reason. The spot offers a protected waterfront with fifty-foot depths at some points. These are excellent conditions for repairing ships and welcoming cruise ships and river cruises.

Restaurants, Theaters and More

Preservation of Norfolk's old buildings while giving them a new life has been essential to Norfolk's vibrancy and character. While many are mentioned in this historical offering, there are so many more downtown and beyond.

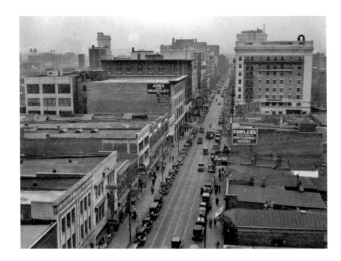

The 400 block of
Granby Street,
including Granby
Theater, 1933.
*Courtesy of Sargeant
Memorial Collection,
Norfolk Public Library.*

Granby Theater
https://granbytheater.com
421 Granby Street
(757) 907-5894
Fee Charged

Additional historic buildings include the Granby Theater, built more
than one hundred years ago as a vaudeville theater and closed in 1986.
It eventually was redeveloped into a nightclub and special events venue
popular with brides.

Tidewater Community College's Roper Performing Arts Center
https://virginiasymphony.org/tcc-roper-performing-arts-center-norfolk
340 Granby Street
(757) 822-1450
Fee Charged

The current TCC Roper Performing Arts Center was home to another
famous vaudeville and movie house from the 1920s. It eventually became
the Lowes movie theater, followed by a rock music club in the 1970s. It
was completely renovated and updated as part of Tidewater Community
College, located in the heart of downtown.

Governor's School for the Arts
https://www.downtownnorfolk.org/go/the-governors-school-for-the-arts
254 Granby Street
(757) 451-4711
Fee Charged

On the next block is the Governor's School of the Arts for high school students, which hosts various high school students who perform art shows, as well as international and nationally known acts. The Royal Shakespeare Company, Art Garfunkel and the Netherlands Dance Theater have all graced the building, just to name a few.

The Monastery Restaurant
https://www.443granby.com
443 Granby Street
(757) 625-8193
$$$

Located on Granby Street in downtown Norfolk is the Monastery, the oldest continually running restaurant in Norfolk. The owners came to America in the late 1960s from Czechoslovakia and originally owned a restaurant near Central Park in New York City. They moved to Norfolk in the 1980s and opened a restaurant on the bustling main street that has old-world charm.

Gershwin's Restaurant
https://www.downtownnorfolk.org/go/gershwins
332 Granby Street
(757) 226-0814
$$$

Travel along Granby Street to find other old buildings giving fabulous food a place to shine, like Gershwin's, located near Tidewater Community College. Tux-clad servers offer up cocktails in the vibe of Cole Porter and Frank Sinatra in a live piano bar atmosphere in Norfolk's theater district.

Byrd & Baldwin Bros Steakhouse

https://www.byrdbaldwin.com/about-us
116 Brooke Avenue
(757) 222-9191
$$$

Byrd & Baldwin Bros, located in what was once a real estate investment firm's building from 1906, offers fine steakhouse dining in an Italian Beaux Arts design. The building's façade was the only thing left in good condition after sitting empty for more than thirty years. Completely restored past its original beauty, the building itself adds to the experience of the food.

Norfolk Tap Room

https://www.norfolktaproom.com
101 Granby Street
(757) 961-0896
$$

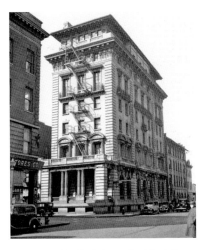

The Norfolk Tap Room found its place inside the Virginia Club building at Granby and Main Streets downtown. The building, constructed in 1902, is in the Classic Revival style. It was a bank building, and eventually, the lower floor became the Norfolk Tap Room, which has twenty-four beers on tap and offers more than one hundred different beers.

The Virginia Club (now the Norfolk Tap Room), 1935. *Courtesy of Sargeant Memorial Collection, Norfolk Public Library.*

Brick Anchor Brewhouse

https://www.brickanchor.com
241 Granby Street
(757) 431-7064
$$

Brick Anchor Brewhouse is located in another twentieth-century building given new life. This restaurant promotes the local food and craft beer scene. Brick Anchor is completely restored and renovated, with most of its

original beauty still intact. It currently has sixty beers on tap and has won local culinary awards.

Doumar's Cones and Barbeque

https://www.doumars.com
1919 Monticello Avenue
(757) 627-4163
$

Not to be forgotten in the food world is Doumar's, which was fashioned as a 1950s drive-in restaurant. If you remember the old days of the carhops on roller skates taking your order by memory and bringing out classic diner food, you'll find Doumar's equally nostalgic. It is centrally located about ten minutes from downtown. It is famous among locals for its North Carolina–style chopped vinegar-based barbeque. Doumar's is best known for making the first waffle cones for the Jamestown Exposition in 1907. It still rolls out the old waffle cone machine and makes four cones at a time. Al Doumar made ice cream cones daily up until his nineties. His son, Thad, carries on the tradition today. Doumar's is as famous for its ice cream as for its food. It's just a fun place to visit, especially for children and the young at heart. Doumar's is something of a local celebrity hot spot, and you may have seen it on Guy Fieri's *Diners, Drive-ins and Dives* and the Rachel Ray television show.

Waterside District

https://watersidedistrict.com
333 Waterside District
(757) 426-7433
$-$$$

Part of the movement to redefine and redesign the downtown Norfolk waterfront, Waterside Marketplace was a restaurant, retail and nightlife spot of the 1970s. By the mid-2000s, the Waterside District was declining, and a refresh was needed. It was closed and remodeled as the Waterside District in 2017. Waterside District now connects Harbor Park, the Portsmouth Ferry Terminal and full-service downtown hotels with an extensive city park. It adds a vibrancy to the downtown district in a twenty-first-century

fashion. Waterside, as it is known to locals, is the hub for nightlife, nationally recognized restaurants and local favorites such as Cogan's Pizza. The Fudgery, a confectionery in the facility, was reimagined for today's lovers of sweet food and treats. Waterside hosts outdoor concerts, trivia nights, inside live stage music and specialty ticketed events. The back deck is a great place to watch the action of the marina and also provides access to the ferry to Portsmouth. Waterside has additional private space on the second floor to accommodate group events. With a walkover pedestrian bridge from a major hotel chain, the Waterside District provides a safe place to enjoy the Norfolk nighttime waterfront beauty.

Norfolk is currently home to nine local breweries throughout the downtown and many Norfolk neighborhoods and districts; tapping into local brews is never far away. Some of the breweries are located in the Railroad District and can hold outdoor markets and craft show events. Also, many have small indoor space for live music.

The Mermaid Factory

http://www.mermaidfactory.com/pricing.html
919 A West Twenty-First Street
(757) 233-0733

If you like painting and designing, check out the Mermaid Factory on Twenty-First Street in the Ghent district. The Mermaid Factory is the perfect place to hold a bridal shower, baby shower or birthday party or just hang out with friends. These small clay mermaids' shapes are like public art statues around Norfolk. The Mermaid Factory owner licensed with Norfolk to offer the mermaid form that mermaid lovers could paint or decorate to make it their own. It has currently expanded to provide other sea creatures that anyone would love to decorate and take home. The Mermaid Factory has a cute gift shop where you can buy many mermaid-themed gifts.

Shopping and Collecting

Some of the most eclectic shops in Norfolk include its wide array of consignment and antique stores.

The Village Mermaid
https://www.facebook.com/thevillagemermaid
3900 Granby Street
(757) 752-4316

The Village Mermaid has some of the best consignment shopping in Riverview. The corner shop is jam-packed with your next treasure waiting to go home with you.

Mrs. Pinkadot
https://www.mrspinkadot.com
1914 Granby Street
(757) 995-2205

Mrs. Pinkadot offers not only consignment items but also good advice on how to spiff up your finds and create something uniquely your own. She has a lot of repurposed antiques and furniture in stock regularly, as well as vendors who specifically sell antique costumes and jewelry.

Attic Treasures
https://www.facebook.com/attictreasuresnorfolk/?rf=149717081735071
1918 Granby Street
(757) 622-5342

Attic Treasures near Mrs. Pinkadot is just what you imagine your grandma's attic would be like. There is always a treasure waiting for a new home from art to textiles, glass and dinner wear.

Second Act Consignment
https://2ndactconsignments.com
110 West Twenty-First Street
(757) 622-1533

Second Act Consignment has an extensive collection of furniture and apparel. You don't know what you'll find, as this space is more significant than you think.

The Vintage Rooster
https://www.facebook.com/pages/category/Gift-Shop/Vintage-Rooster-454459154666703
308 West Twenty-First Street
(757) 333-3304

The Vintage Rooster, tucked into a small shopping complex known as the Palace Shops on Twenty-First Street, has new and consigned items.

Ghent Antiques
http://ghentantiques.com/estate-sales
1414 Colley Avenue
(757) 623-3311

Ghent Antiques on Colley Avenue invites you in with its displays of authentic antique pieces. Once you hear the history of an article that catches your eye from the engaging owner, you'll want to negotiate and bring a bit of history home.

Michael Millard-Lowe Antiques
https://www.millard-lowe.com
242 West Twenty-First Street
(757) 776-9046

Michael Millard-Lowe Antiques on West Twenty-First Street is where you'll find seventeenth-, eighteenth- and nineteenth-century English and European antiques. These are the real thing and command the prices you would expect for fine antiques.

Researching History

The Sargent Memorial Collection at the Slover Library
https://www.norfolkpubliclibrary.org/learning-research/local-history-genealogy
235 East Plume Street
(757) 431-7429

The Sargent Memorial Collection at the Slover Library is located in a historic building connected to a bright new building. The structure holding the

Sargent Memorial Collection is part of history itself. The Sargent Memorial Collection contains the largest repository of regional history. It connects to the state-of-the-art Slover Library, which owes much of its groundbreaking technology to a generous gift from the Batten Foundation and Norfolk. The Slover leads to the Selden Market, another historic building initially known as the Selden Arcade. At the time of its construction, the meaning of *arcade* was a building of arches. The Selden Market connects to the Main by Hilton, completed in 2017. The Hilton boasts significant pieces of artwork throughout its public spaces, totaling in value of more than $1 million.

Prince Books

https://www.prince-books.com
109 East Main Street
(757) 622-9223

Here you can purchase all of The History Press's books on Norfolk's history. Look for the old bank clock and stay for lunch inside at the Lizard Café. Prince Books is an independently owned bookstore that offers excellent customer service and helps visitors locate just the right book.

The VisitNorfolk Visitor Center

https://www.visitnorfolk.com
232 East Main Street
(757) 664-6620

The VisitNorfolk Visitor Center, located on Main Street, should be the first place you visit after settling into Norfolk. Although it may feel shiny and new with its bright, modern, recently remodeled space, do not be fooled. Ask the knowledgeable staff about the original design of this space, with portholes, ships' lanterns, a front desk shaped like a ship and the old wooden doors. They have many stories to tell and are an excellent resource.

NOTES

Introduction

1. Royall, *Black Book*, 1:264.
2. Wertenbaker, *Norfolk*, 64–65.
3. Wilkinson, *Harry Byrd*, 313.
4. *Norfolk*, vol. 21, 1959.

Chapter 1

5. McPhillips, *Historic Photos of Norfolk*, 132.
6. Ibid., 194.
7. National Archives and Records Administration, Monticello Arcade Historic Register Application, May 21, 1975.
8. Different sources say different things. The last developer said fifteen; older sources say twelve "above ground."
9. McPhillips, *Historic Photos of Norfolk*, 50.
10. Ibid.
11. National Archives and Records Administration, Wells Theatre Historic Register Application.
12. Ibid., Historic Register Paperwork; Tucker, *Norfolk Highlights*.
13. National Archives and Records Administration, Wells Theatre Historic Register Application.

14. Ibid.; Tucker, *Norfolk Highlights*, 83–84.
15. Tucker, *Norfolk Highlights*, 82.
16. National Archives and Records Administration, Wells Theatre Historic Register Application; Tucker, *Norfolk Highlights*; Forrest, *Historical and Descriptive Sketches*.

Chapter 2

17. Special thanks to lifelong Freemason resident Al Roper for his editing of this chapter for content and clarity.

Chapter 3

18. Robbins, "History Matters."
19. Colston, *Century Illustrated Monthly Magazine*, 763–66.
20. Greene, "Eye-Witness Account of the Battle."
21. Selfridge, *Memoirs of Thomas O. Selfridge Jr.*, 65.
22. Working on this chapter was a true pleasure, and I'm so thankful and appreciative of my family, friends and colleagues for supporting me always. In particular, I would like to thank Elijah Palmer, Tim Orr, Marcus Robbins, Donald Darcy, and Matthew Headrick for their advice and input. I would also like to thank Laura Orr, Maura Hametz and Michael Gorman for helping show me the way. And a big thank-you goes to Mario Orlikoff, Betsy Orlikoff and, Raven Hudson for always having my back.

Chapter 4

23. *Ledger-Dispatch*, "Building News and Review."
24. *Ledger-Dispatch*, "Granby Street Has Grown in Marvelous Manner."
25. *Norfolk Ledger-Dispatch*, "Oil Company Breaks through Office Area."
26. National Register of Historic Places, Auto Row Historic District Registration Form.
27. See Yarsinske, *Lost Norfolk*, 160–61.
28. Frost-Kumpf, "Cultural Districts," 7.
29. Code of Virginia 15.2-1129.1: Creation of Arts and Cultural Districts.

204

30. Old Dominion University News Archives, "University Gallery Reopening."

31. *Virginian-Pilot*, "Norfolk Puts Focus on Granby St."

32. *Virginian-Pilot*, "Better Block Spurs Change."

33. *Virginian-Pilot*, "Muralists Dress Up Walls."

34. *Virginian-Pilot*, "Apartments, Swimming Pool Planned."

35. National Register of Historic Places, Ghent Historic District Nomination Form.

36. Chrysler Museum of Art, "Walter Chrysler, Jr."

37. *Virginian-Pilot*, "All's Ducky in Norfolk."

38. National Register of Historic Places, Auto Row Historic District Registration Form.

39. *Virginian-Pilot*, "What's in a Name? Harrison Opera House."

40. Fort Tar Lofts, "Building History."

41. Inge, *Sargeant's Chronicles* 4, no. 4.

42. *Inside Business*, "Loft-Style Apartments in Norfolk."

43. See Yarsinske, *Lost Norfolk*, 160–61.

44. *Virginian-Pilot*, "Norfolk's Very Own Golden Triangle."

45. *Virginian-Pilot*, "Art Deco Bus Terminal."

46. Mondo Newspapers, "Highest Circulation Virginia Newspapers."

47. National Register of Historic Places, Auto Row Historic District Registration Form.

48. *Virginian-Pilot*, "Oct. 1937: Opening Our New Newspaper Building."

49. *Virginian-Pilot*, "Virginian-Pilot Says Goodbye."

50. *Virginian-Pilot*, "Apartments, Swimming Pool Planned."

51. *Broadcasting*, "WTAR-TV Marks Its First Year," 62.

52. *Virginian-Pilot*, "D'Art Center Finds New Home."

53. National Register of Historic Places, Auto Row Historic District Registration Form.

54. *Port Folio Weekly*, "With New Blood in the Artistic Director's Chair."

55. *Whurk* 33, "Glass Wheel Studio."

56. *Virginian-Pilot*, "Hurrah Players Has New Building."

57. See Yarsinke, *Lost Norfolk*, 82.

58. *Virginian-Pilot*, "Bress Pawn Shop, a Norfolk Icon."

59. *Virginian-Pilot*, "Norfolk Furniture Store."

60. Grow, "Transparent Seas."

61. *Virginian-Pilot*, "Duckworth File."

62. Bob's Gun Shop website.

63. *Virginian-Pilot*, "Muralists Dress Up Walls."

64. National Register of Historic Places, Auto Row Historic District Registration Form, 24–25.
65. *Inside Business*, "Star Is Reborn."
66. Interview with Meredith Rutter by author, July 2020.
67. *Inside Business*, "Improv Group to Call Norfolk Arts District Home."
68. Interview with Cheryl White by author, July 2020.
69. *Virginian-Pilot*, "Auction Company Founder Calvin Zedd Dies at 80."
70. National Register of Historic Places, Auto Row Historic District Registration Form.
71. *Virginian-Pilot*, "Alchemy NFK Draws Attention in Norfolk Arts District."
72. Interview with Joshua Weinstein by author, July 2020.
73. Norfolk Printing Company, "About Us."
74. National Register of Historic Places, Auto Row Historic District Registration Form.
75. Ibid.

Chapter 5

76. Special thanks to Lawrence Morton for his editing of this chapter and others for content and clarity.

Chapter 9

77. VisitNorfolk website.
78. Port of Virginia, "Norfolk International Terminals (NIT)."

WORKS CONSULTED

Introduction

Norfolk: Official Publication of the Norfolk (Va.) Chamber of Commerce. Norfolk, VA, 1950–61.

Royall, Anne Newport. *The Black Book, or, A Continuation of Travels in the United States.* 3 vols. Washington, D.C.: printed for the author, 1828.

Wertenbaker, Thomas J. *Norfolk: Historic Southern Port.* 2nd ed. Edited by Marvin W. Schlegel. Durham, NC: Duke University Press, 1962.

Wilkinson, J. Harvie, III. *Harry Byrd and the Changing Face of Virginia Politics, 1945–1966.* Charlottesville: University Press of Virginia, 1968.

Chapter 1

Forrest, William. *Historical and Descriptive Sketches of Norfolk and Vicinity and Vicinity: Including Portsmouth and the Adjacent Counties, During a Period of Two Hundred Years; Also Sketches of Williamsburg, Hampton, Suffolk, Smithfield, and Other Places, with Descriptions of Some of the Principal Objects of Interest in Eastern Virginia.* Philadelphia, PA: Lindsay and Blakiston, 1853.

McPhillips, Peggy Haile. *Historic Photos of Norfolk.* Nashville, TN: Turner, 2008.

National Archives and Records Administration. Monticello Arcade Historic Register Application, May 21, 1975. https://catalog.archives.gov/id/41682127.

————. Wells Theatre National Historic Register Application, April 8, 1980. https://catalog.archives.gov/id/41682191.

Tucker, George Holbert. *Norfolk Highlights, 1584–1881*. Norfolk, VA: Norfolk Historical Society, 1972.

Chapter 2

Cook, Emma Blow Freeman. *Histories, Recollections and Anecdotes of Old Norfolk*. Edited by Arthur H. Riddick. Norfolk, VA: Ye Olde Towne Press, Particular Printer, 1937.

Freemason Abbey. "The History of Freemason Abbey—Norfolk, Virginia." http://freemasonabbey.com/history.

Freemason Street Association Walking Tour Guide, 1993. Published by the Hunter House Victorian Museum and the Freemason Street Area Association, Norfolk, Virginia.

Friends of the Pagoda and Oriental Garden Foundation. https://www.pagodagarden.org.

Omar's Carriage House. "About Omar's Carriage House." https://omarscarriagehouse.com.

Spainhour, Jaclyn. *Gilded Age Norfolk, Virginia: Tidewater Wealth, Industry, and Propriety*. Charleston, SC: The History Press, 2015.

Tazewell, C.W., ed. *Vignettes from the Shadows: Glimpses of Norfolk's Past*. Virginia Beach, VA: W.S. Dawson Company, 1990.

Tucker, George Holbert. *Norfolk Highlights, 1584–1881*. Norfolk, VA: Norfolk Historical Society, 1972.

Virginia Department of Historic Resources. https://www.dhr.virginia.gov.

Chapter 3

Colston, R.E. *The Century Illustrated Monthly Magazine* 29 (November 1864–April 1885): 763–66. New Series. Century Company, New York, F. Warne & Company, London.

Greene, Samuel Dana. "An Eye-Witness Account of the Battle Between the U.S.S. Monitor and the C.S.S. Virginia (formerly U.S.S. Merrimack) on March 9th, 1862." Naval History and Heritage Command, September 12, 2017.

Hallahan, John M. *The Battle of Craney Island: A Matter of Credit*. Portsmouth, VA: St. Michael's Press, 1986.

Hattaway, Herman, and Archer Jones. *How the North Won: A Military History of the Civil War*. Chicago: University of Illinois Press, 1991.

Howarth, Stephen. *To Shining Sea: A History of the United States Navy, 1775–1991*. New York: Random House, 1991.

Leeke, Jim. *Manila and Santiago: The New Steel Navy in the Spanish-American War*. Annapolis, MD: Naval Institute Press, 2009.

Library of Congress. Statutes at Large. https://www.loc.gov.

Linder, Bruce. *Tidewater's Navy: An Illustrated History*. Annapolis, MD: Naval Institute Press, 2005.

Naval Station Norfolk. "History of Naval Station Norfolk." n.d. https://www.nsnbg.com.

Norder, Steve. *Lincoln Takes Command: The Campaign to Seize Norfolk and the Destruction of the CSS* Virginia. El Dorado Hills, CA: Savas Beatie, 2020.

Parramore, Thomas C. *Norfolk: The First Four Centuries*. Charlottesville: University Press of Virginia, 1994.

Robbins, Marcus. "History Matters: 157th Anniversary of the Battle of Hampton Roads." History Matters: The Official Blog of Norfolk Naval Shipyard, March 9, 2019. http://www.usgwarchives.net.

———. "Norfolk Navy Yard, Portsmouth, Virginia." History Matters: The Official Blog of Norfolk Naval Shipyard, n.d. http://www.usgwarchives.net.

Selby, John E. *The Revolution in Virginia: 1775–1783*. Charlottesville: University of Virginia Press, 1988.

Selfridge, Thomas O. *Memoirs of Thomas O. Selfridge Jr*. New York: Knickerbocker Press, 1924.

Soundhaus, Lawrence. *The Great War at Sea: A Naval History of the First World War*. Cambridge, UK: Cambridge University Press, 2014.

Stein, Douglas. *American Maritime Documents, 1776–1860, Illustrated and Described*. Mystic, CT: Mystic Seaport Museum, 1992.

Stewart, William H. *History of Norfolk County, Virginia, and Representative Citizens: 1637–1900*. Chicago: Biographical Publishing Company, 1902.

Symonds, Craig L. *Lincoln and His Admirals*. New York: Oxford University Press, 2008.

———. *World War II at Sea: A Global History*. New York: Oxford University Press, 2018.

Weaver, John R. *A Legacy in Brick and Stone: American Coastal Defense Forts of the Third System, 1816–1867*. McLean, VA: Redoubt Press, 2001.

Yarsinske, Amy Waters. *The Navy Capital of the World*. Charleston, SC: The History Press, 2010.

Chapter 4

Bob's Gun Shop. https://www.bobsgunshop.com.

Broadcasting. "WTAR-TV Marks Its First Year." April 30, 1951, 62.

Chrysler Museum of Art. "Walter Chrysler, Jr." https://chrysler.org.

Fort Tar Lofts. "Building History." http://forttarlofts.com.

Frost-Kumpf, Hilary Anne. "Cultural Districts: The Arts as a Strategy for Revitalizing Our Cities." Americans for the Arts, 1998.

Grow. "Transparent Seas." https://thisisgrow.com.

Inge, William B. *Sargeant's Chronicles* 4, no. 4 (Summer 2010). Norfolk Public Library. http://smcdigital.norfolkpubliclibrary.org.

Inside Business. "Improv Group to Call Norfolk Arts District Home." June 24, 2014.

———. "Loft-Style Apartments in Norfolk Examples of Attractive Re-Use." September 6, 2018.

———. "A Star Is Reborn: Norfolk's Texaco Building to House Art and Apartment Space." January 17, 2014.

Interview with Cheryl White by author, July 2020.

Interview with Joshua Weinstein by author, July 2020.

Interview with Meredith Rutter by author, July 2020.

Ledger-Dispatch. "Building News and Review." April 15, 191.

———. "Granby Street Has Grown in Marvelous Manner." May 16, 1914.

Mondo Newspapers. "Highest Circulation Virginia Newspapers." Wayback Machine. https://web.archive.org.

National Register of Historic Places. Auto Row Historic District Registration Form.

———. Ghent Historic District Nomination Form.

Norfolk Ledger-Dispatch. "Oil Company Breaks through Office Area; North Granby Buy Starts Realty Revival." July 21, 1917.

Norfolk Printing Company. "About Us." https://norfolkprintingcompany.com.

Old Dominion University News Archives. "University Gallery Reopening at New 21st Street Location January 15." January 2000. https://www.odu.edu.

Port Folio Weekly. "With New Blood in the Artistic Director's Chair, Virginia Ballet Theatre Looks to the Future." September 11, 2008.

Virginia Decoded. Code of Virginia 15.2-1129.1: Creation of Arts and Cultural Districts. https://vacode.org.

Virginian-Pilot. "Alchemy NFK Draws Attention in Norfolk Arts District." May 28, 2014.

———. "All's Ducky in Norfolk as Sun, Art and Pics Converge." May 19, 2014.

———. "Apartments, Swimming Pool Planned for the Virginian-Pilot's Downtown Headquarters." October 8, 2019.

———. "An Art Deco Bus Terminal Once Occupied the Site of the Greyhound Station in Norfolk." March 19, 2018.

———. "Auction Company Founder Calvin Zedd Dies at 80." August 28, 2012.

———. "Better Block Spurs Change on Norfolk's Granby St." August 7, 2013.

———. "Bress Pawn Shop, a Norfolk Icon, Is Closing Its Doors." October 7, 2018.

———. "D'Art Center Finds New Home in Norfolk's Arts District." January 7, 2016.

———. "The Duckworth File." August 20–26, 2007.

———. "Hurrah Players Has New Building with Classrooms, Dressing Rooms and 180-Seat Theater." May 30, 2017.

———. "Muralists Dress Up Walls in Norfolk Arts District." April 11, 2014.

———. "Norfolk Furniture Store Has Done Customers 'a Solid' for 80 Years." September 21, 2019.

———. "Norfolk Puts Focus on Granby St. North of Brambleton." February 25, 2013.

———. "Norfolk's Very Own Golden Triangle." June 6, 2011.

———. "Oct. 1937: Opening Our New Newspaper Building." October 25, 2016.

———. "Virginian-Pilot Says Goodbye to Downtown Edifice." May 3, 2020.

———. "What's in a Name? Harrison Opera House." September 21, 2009.

Whurk 33. "Glass Wheel Studio" (November 2015).

Yarsinske, Amy Waters. *Lost Norfolk.* Charleston, SC: The History Press, 2009.

Chapter 5

Chataigne's Directory of Norfolk, Portsmouth & Berkley. "Alphabetical List of Names." 1894. Norfolk Public Library, Sargent Memorial Collection.

Christ and St. Luke's Episcopal Church. "Our Early Beginnings." https://www.christandstlukes.org.

Chrysler Museum of Art. "Two Women, One Remarkable Gift." https://chrysler.org.

First Presbyterian Church of Norfolk. "Our History." https://www.fpcnorfolk.org.

Freemason Street Association Walking Tour Guide, 1993.

Kimberlin, Joanna. "That's All a Wish Is, Simple Hope: Wishing Tree in West Ghent Shows We're More Alike than We Are Different." *Virginian-Pilot*, August 11, 2016.

King, Lauren. "Parts of Ghent Once Were Described as Slums." *Virginian-Pilot*, December 30, 2013.

Naro Theatre. "Naro Cinema in Norfolk, Virginia." 2019. https://narocinema.com.

Norfolk and Portsmouth City Directory. "Alphabetical List of Names." 1909. Norfolk Public Library, Sargent Memorial Collection.

Parker, John A. *Thirteen Blocks: A Social History of Early Ghent in Norfolk, Virginia*. Norfolk, VA: self-published, 2011.

Ross, Cheryl. "What's in a Name? Norfolk's Ghent Neighborhood." *Virginian-Pilot*, August 22, 2008.

Stefansky, Krys. "A Home Fit for a President in Ghent." *Virginian-Pilot*, November 9, 2009.

Taylor, Robert T. "The Jamestown Tercentennial Exposition of 1907." *Virginia Magazine of History and Biography* 65, no. 2 (1957): 169–208. http://www.jstor.org.

Wilson, Richard Guy. "Fred Heutte Horticultural Center." Society of Architectural Historians, University of Virginia Press, October 1, 2020. https://sah-archipedia.org.

————. "Royster House." Society of Architectural Historians, University of Virginia Press, October 1, 2020. https://sah-archipedia.org.

Woman's Club of Norfolk. "The Martin Mansion Circa 1909." https://womansclubofnorfolk.com.

Yarsinske, Amy Waters. *Ghent: John Graham's Dream, Norfolk, Virginia's Treasure*. Charleston, SC: Arcadia Publishing, 2006.

————. *Lost Norfolk*. Charleston, SC: The History Press, 2009.

Chapter 6

Billboard. "Norfolk's Ocean View Dolls Up Front, Back; Adds Fishing Pier." May 13, 1957. https://books.google.com.

———. "Progress at Ocean View and Seaside." February 23, 1957. https://books.google.com.

Blake, Nelson. *William Mahone of Virginia: Soldier and Political Insurgent.* N.p.: Garrett and Maisie Publications, 1933.

Farrington, M.C. "Seventy-Five Years Ago: Vacation Plans Dashed by the Navy, for the Duration." Hampton Roads Naval Museum, August 9, 2017. https://hamptonroadsnavalmuseum.blogspot.com.

Guagenti, Toni. "Proponents Say East Beach Has Astounded from Start." *Virginian-Pilot.* https://pilotonline.com.

Harris, Nelson. *Norfolk and Western Railway.* Charleston, SC: Arcadia Publishing, 2003.

Harrison, Don. "Landmark Hotel Burned to Ground." UPI Archives, November 24, 1980. https://www.upi.com.

Messina, Debbie. "Norfolk's East Beach Revives Prime Real Estate." *Virginian-Pilot.* https://pilotonline.com.

Minium, Harry. "What's in a Name? Ocean View, Norfolk." *Virginian-Pilot.* February 22, 2010. https://www.pilotonline.com.

Norfolk History Publishers. "Norfolk and Ocean View Railroad, 1879." Norfolk Deeds, Billheads, Links & More. http://www.norfolkhistory.com.

Ocean View Museum Station. https://ocean-view-station-museum.business.site.

O'Hara, Vincent. *Torch: North African and the Allied Path to Victory.* Annapolis, MD: Naval Institute Press, 2005.

RCDB. "Figure 8." https://rcdb.com/2107.htm.

Schaad, Tom. "The Hidden History behind Norfolk's 'City Beach.'" WAVY, February 16, 2018. https://www.wavy.com.

Striplin, E.F. Pat. *The Norfolk & Western: A History.* N.p.: Norfolk and Western Railway Company, 1981.

Swenson, Ben. "Sand and Spectacle." *Virginia Living,* January 4, 2011. http://www.virginialiving.com.

Variety. "Rollercoaster." December 31, 1976. https://variety.com.

Virginia Department of Transportation. "Hampton Roads Tunnels and Bridges." http://www.virginiadot.org.

Virginian-Pilot. "Norfolk's East Beach Named One of the Nation's Top Restored Beaches." https://pilotonline.com.

Walter, Alice Granbery. *Captain Thomas Willoughby 1601–1657: Of England, Barbadoes and Lower Norfolk County, Virginia: Some of His Descendents 1601–1800*. N.p., 1978.

Wellford, Beth. "You've Probably Never Heard of This Amazing Beach Park Hiding in Virginia." Only in Your State, February 4, 2019. https://www.onlyinyourstate.com.

Chapter 7

Andrews, Kate. "All in the Family." *Virginia Living Magazine* (2019). http://www.virginialiving.com.

Annas, Theresa, "What's in a Name? Powhatan Avenue, Norfolk." *Virginian-Pilot*, August 30, 2010. https://www.pilotonline.com.

Bookman, Steven. "Old Larchmont School." Old Dominion University. https://sites.wp.odu.edu.

Brady, Colin. *Hermitage Museum and Gardens*. Images of America. Charleston, SC: Arcadia Publishing, 2013.

Chesapeake Bay Foundation. "Birdsong Wetland Restoration at the Larchmont Library—Norfolk's First 'Living Shoreline.'" https://www.cbf.org/document-library/sea-level-rise/birdsong-wetlands-case-study.pdf.

The City of Norfolk. "Neighborhoods: Norfolk 1923 Annexation." https://www.norfolk.gov.

DiBari, Sherry, ed. "Census Data." Elizabeth River: A Historical Geography Project, 2015. https://theelizabethriver.wordpress.com.

———. "The Lafayette." Elizabeth River: A Historical Geography Project, 2015. https://theelizabethriver.wordpress.com.

———. "Larchmont-Edgewater." Elizabeth River: A Historical Geography Project, 2015. https://theelizabethriver.wordpress.com.

Hanbury Evans Newill Vlatas and Company. Historical Architectural Survey of the City of Norfolk, 1997. https://www.dhr.virginia.gov/pdf_files/SpecialCollections/NR-38_Norfolk_Historic_Architecture_Survey_1997.pdf.

Hays, Jakon. "Addressing Norfolk Traffic Congestion—101 Years Ago." *Virginian-Pilot*, May 18, 2017. https://www.pilotonline.com.

Larchmont-Edgewater Civic League. "Neighborhood Features" and "Neighborhood History." http://larchmontedgewater.org.

Larchmont Elementary School. "Larchmont History." https://www.npsk12.com.

Larchmont United Methodist Church. "History and Building." https://www.larchmontumc.org.

McPhillips, Peggy Haile. "United States Marine Hospital." Norfolk Public Library. https://www.norfolkpubliclibrary.org.

National Register of Historic Places. Boush Tazewell House Nomination Form. Wayback Machine. https://web.archive.org/web/20130813193725/http://www.dhr.virginia.gov/registers/Cities/Norfolk/122-0002_Boush-Tazewell_House_1974_Final_Nomination.pdf.

Naval Facilities Engineering Command. "About Us." https://www.navfac.navy.mil.

Norfolk Public Library. "The History of Norfolk Annexations." https://www.norfolkpubliclibrary.org.

———. "Larchmont Branch." https://www.norfolkpubliclibrary.org.

Roady, Sue. "Our History." Norfolk Yacht Club. https://www.norfolkyacht.com.

Shean, Tom. "Portsmouth Native Known for Preserving History Dies." *Virginian-Pilot*, April 30, 2011. https://www.pilotonline.com.

Statler-Keener, Teresa, and Karen Vaughan. "Norfolk Division 1930." Building the University, ODU digital exhibition. http://exhibits.lib.odu.edu.

Tennant, Diane. "What's in a Name? Magnolia Avenue, Norfolk." *Virginian-Pilot*, December 19, 2008. https://www.pilotonline.com.

Virginia Department of Historic Resources. "122-0002 Boush Tazewell House." https://www.dhr.virginia.gov.

Walker, Carroll. *Norfolk: A Pictorial History*. Brookfield, MO: Donning Company/Publishers Inc., 1975.

Chapter 8

City of Norfolk Bureau of Cemeteries.

Sargent Memorial Collection Archives. Slover Library, Norfolk, Virginia.

Smith, Jeffrey. *The Rural Cemetery Movement: Places of Paradox in Nineteenth-Century America*. Lanham, MD: Lexington Books, 2017.

Chapter 9

The Port of Virginia. "Norfolk International Terminals (NIT)." http://www.portofvirginia.com.

VisitNorfolk. https://www.visitnorfolk.com.

INDEX

ABOUT THE AUTHORS

PEGGY HAILE MCPHILLIPS is the recently retired historian for the City of Norfolk.

AMANDA WILLIAMS is the acting director of the MacArthur Memorial in Norfolk, Virginia.

JACLYN SPAINHOUR is the director of the Hunter House Victorian Museum in Norfolk, Virginia.

ANTHONY J. ORLIKOFF is the education specialist–lead (Chickasaw Management Services) at the National Museum of the Army in Fort Belvoir, Virginia.

RACHEL MCCALL is the director of strategic initiatives with the Downtown Norfolk Council.

RAVEN HUDSON is a development associate at the National Sporting Library and Museum in Middleburg, Virginia.

MATTHEW WHITLOCK is an instructor of history at Old Dominion University in Norfolk, Virginia.

JENNIFER LUCY is the marketing and design manager for the Hermitage Museum & Gardens in Norfolk, Virginia.

SHANNON STAFFORD is the lead tour guide for the Norfolk Society of Cemetery Conservation.

BARBARA GULLICKSON is the director of visitor experience with VisitNorfolk in Norfolk, Virginia.

Visit us at
www.historypress.com